"Anne Fitten has been the trusted source for reliable information about brewing in the western part of the state for as long as I can remember. This piece of literature will be a significant contribution to the North Carolina beer community."

—Win Bassett, executive director, North Carolina Brewers Guild, social media and beer education director, *All About Beer* magazine

"The story of Western North Carolina's brew scene is a rich and colorful tale that needs to be told. This book brings it all together in one place."

—Tony Kiss, *Asheville Citizen-Times* entertainment editor and beer columnist

"Anne Fitten is as involved in her subject matter as one can be—which isn't to say she's deep in her cups. Rather, she has managed to be both on the ground floor and backstage as the brewery scene in North Carolina has exploded. Having worked with Anne Fitten in various capacities in my career, I know that there are few people that can match her knowledge and wit in the arena of brews news."

—Mackensy Lunsford, food editor, *Asheville Scene*

"The depths to which Anne Fitten has gone to get the background story on beer history has me convinced that this will be a page turner for beer aficionados, curious Asheville locals, newcomers, wannabe residents and regular history buffs."

—Oscar Wong, president and founder, Highland Brewing Company

ASHEVILLE

BEER

An Intoxicating History of
Mountain Brewing

Anne Fitten Glenn
Foreword by Zane Lamprey

AMERICAN PALATE

Published by American Palate
A Division of The History Press
Charleston, SC 29403
www.historypress.net

Copyright © 2012 by Anne Fitten Glenn
All rights reserved

Cover image by Bill Rhodes.

First published 2012

Manufactured in the United States

ISBN 978.1.60949.631.9

Library of Congress CIP data applied for.

Contents

Foreword

One day…nine Asheville breweries…nine Asheville beers. Okay, it was more like fifteen Asheville beers. It's not like I could have gone to each brewery and tried only one of its beers. I'm only human.

While shooting an episode of *Drinking Made Easy* in the summer of 2011, we (my stunt drinker, Steve McKenna, and I) drank our way through nine Beer City, USA breweries on one long day of shooting. I met the author of this book the next day at the Thirsty Monk Pub. I challenged Steve to see which of us could correctly identify the nine different beers we'd tasted the day before. Steve won the challenge. It was devastating, but I digress.

A few months later, Anne Fitten Glenn interviewed me for her "Brews News" column in Asheville's newsweekly *Mountain Xpress*. Then she asked me if I'd write a foreword for her book, which is what you're reading right now. I said yes. Just seeing if you're paying attention.

Despite all the shenanigans we get up to on *Drinking Made Easy*, we really do care as much about the education (information) as we do the entertainment (shenanigans) while making the show. Beer not only tastes good, and enables me to tolerate Steve even better, but it also has a rich history, and we're in the midst of a burgeoning revolution. We're in a second coming in American beer history. And a lot of that history is happening in Asheville, North Carolina.

Anne Fitten's book covers the history of beer and brewing in the "Asheville beer region." She writes about the late 1800s, when downtown saloons were the favored hangout spots for both outlaws (Steve) and businessmen

(me). She then tells the tale of the temperance crazies and how prohibition lasted a long, long time around Asheville—shedding light on the fact that "dry" counties and towns still exist in Western North Carolina. Then there was the Dark Age itself, prohibition, which ironically gave a boost to the moonshining subculture, which, according to the author, helped pave the way for Asheville brewers. I've learned not to argue with Anne Fitten, lest she stop paying me in beer.

Much of this book recounts the "golden age" of Beer City, from Highland Brewing's start in a downtown basement in 1994 to the expansion of craft beer giant Sierra Nevada. It explains how Asheville grew from a craft beer wasteland to find its place on the map as "Beer City, USA."

Anne Fitten has been writing about beer and the beer business as a freelance journalist for several years, and this book is the culmination of her hopped and fermented passion. It's a great read, especially if you've got a nice frothy pint of some Asheville-brewed beer (and there are plenty to choose from) by your side. This book will make you thirsty, so you'd better grab one. And while you're at it, I'll take one, too.

Cheers,
Zane Lamprey
Host of *Drinking Made Easy* and author of *Three Sheets*

Acknowledgements

So many people helped and supported me throughout the journey of writing this book. Thanks to each and every one of you.

Special thanks to the fabulous book lovers at The History Press, especially Jessica Berzon for pitching me on the idea of this book and Adam Ferrell for his enthusiastic and professional editorial shepherding of it.

Huge thanks to my interns Rhey Haggerty and Nick Recktenfeld, both of whom provided essential and helpful historical research. Thanks to Pam Alexander for helping clean up the "Guide to Asheville Beer" appendix and to Erik Lars Myers for providing a goodly portion of the glossary.

Cheers to Zane Lamprey for writing the foreword and putting up with my fan girl glee about his contribution.

I'd like to give a shout-out to everyone in the Western North Carolina beer community—from brewers to distributors to retailers to beer lovers to everyone in between. Special thanks to every single one of the beer industry people who spent time talking to me.

Thanks to local historian and writer Rob Neufeld for sending me down some interesting paths and to Tony Kiss, the guy who's been writing about the Asheville beer scene the longest, for telling me stories no one else remembers and even digging through the *Asheville Citizen-Times* morgue for me.

Particular thanks go to the beer folks whom I count as friends—who support me, share beer with me and (almost) always return my phone calls: Julie Atallah of Bruisin' Ales, Win Bassett of the North Carolina Brewers Guild, Jason Caughman of Pisgah Brewing, Andy Dahm of French Broad

Brewing, Mary Eliza McRae of Budweiser of Asheville, Mike Rangel of Asheville Brewing, Jimi Rentz of Barley's Taproom, Tim Schaller of Wedge Brewing, Dennis Thies of Green Man Brewing and Oscar Wong of Highland Brewing.

Thanks to the photographers and businesses who graciously donated images for the book, especially Bill Rhodes, who shot the amazing cover photo, and the folks at *Mountain Xpress*, who also have let me pen a regular beer column for more than three years. Particularly deserving of gratitude are my colleagues Rebecca Sulock and Mackensy Lunsford, who were patient when my "Brews News" column was a little late.

I could not have written this without the knowledge and dedication of the staffs at University of North Carolina–Asheville's Ramsey Library Special Collections and Pack Memorial Public Library's North Carolina Collection. Special thanks to Colin Reeve and Heidi Penner at UNCA for going above and beyond. Also thanks to Jon Elliston for the library "date," where we geeked out on historical research in the North Carolina Collection.

Thanks to Timmons Pettigrew, author of *Charleston Beer*, for recommending me as the writer of this book and for giving me feedback on the process.

For superior editing help, thanks to Anne McNeal and Sean McNeal— an extraordinary mother/son team. Also thanks to dear friend Gordon Smith for editing the introduction.

Big love to my amazing kids, Annabelle and Cador, who spent most of their summer watching me write this book but who still think it's cool that their mom knows so much about beer. Thanks to *all* my family and friends who've patiently listened to me obsess about this project for months and have cheerleaded me through the process (you know who you are).

Extra-special thanks to my primary beer drinking partner, Sean McNeal, for being there for me with a friendship as complex and heady as a Belgian, as rich and nuanced as a barrel-aged stout and as intoxicating as a double IPA. He also took the author photo (which was more work than it should have been because of a difficult subject).

I owe all of you a beer.

Introduction

We have a long history of making our own hooch in these mountains.
 —Mike Rangel, president and cofounder of Asheville Brewing Company

I f you're reading this, you're likely one of the many who already believe
that the history of beer and brewing is a worthwhile pursuit. If not,
perhaps this book will make you a believer.

I tackled this project for a couple of reasons. First, because interesting
stories rarely start with, "I was drinking some water, and then..." Also, I've
been writing about beer and the beer business for a number of years, and
I feel that I've been writing Asheville's beer history as it happens. Some of
the facts and stories in this book were first published in my "Brews News"
column for Asheville's newsweekly and elsewhere, though I've rewritten
them for these pages.

I wanted to delve more deeply into what beer means (and has meant)
to Asheville and Western North Carolina (WNC) culturally, economically
and socially. (Western North Carolina refers to the seventeen westernmost
counties of North Carolina, of which Asheville is the largest city). Thus, this
story begins with the founding of Asheville in 1798, when the site of the
town was changed at the last minute due to the cunning of a tavern keeper
and his home-brewed "mountain dew." As the Blue Ridge Mountains are
famous for the distillation of moonshine (we even have a legal white lightning
distillery now), it was not much of a stretch for WNC to become a brewing
mecca, although it did take almost two hundred years.

Beer has been a part of everyday life in America since the Pilgrims ran out of beer and landed at Plymouth Rock. While WNC was sparsely settled until the late 1800s, many of the hardy Scotch, Irish and German immigrants who carved small farms out of these deep forests brewed their own beer. And by the turn of the twentieth century, Asheville had become a rollicking crossroads town where plenty of beer flowed, especially in the few blocks known as "Hell's Half Acre," where most of the town's eighteen saloons thrived.

The backlash hit when Asheville became the first city in the Southeast to vote for prohibition, in part influenced by the murdering rampage of a drunken desperado in 1906. Prohibition would last here, in various forms, for forty years. And to this day, "dry" counties and towns are still sprinkled throughout Western North Carolina, although that number decreases with almost every vote.

Yes, Asheville came to the craft beer scene later than many U.S. towns. Our local beer scene only blossomed in the late 1990s, when the South started to catch up with the beer revolution already taking place in much of the rest of the country.

Despite its rather dismal early days, Asheville has become one of the brewing centers of the East Coast, if not the nation. Since Oscar Wong started Highland Brewing in a downtown basement in 1994, seventeen other breweries have popped up within a one-hundred-mile radius. And more are on the way. Writing about Western North Carolina breweries, then, is like shooting at a moving target. While not one of the breweries that has opened in Asheville since 1994 has closed, more are announcing plans to open, practically on a monthly basis. From the day this book was commissioned until I completed the manuscript, no fewer than four new breweries had opened for business in the region, and at least nine (that I know of) announced that they want to open here over the next few years.

Any day in downtown Asheville, you can visit, by foot, at least six operating brew houses. You can easily drive to several others. When foreword writer, Zane Lamprey, was in town, he told me he was thrilled at how easy it was to film at nine breweries in one day. This is still a small town. Yet on any day here, you can walk into most any bar or restaurant and order at least a few of the up to one hundred different locally brewed beers.

How exactly does a town of about eighty-six thousand souls support so many breweries and beer bars? Tourism has been and continues to be an important part of the region's history, growth and economic vitality. Beer tourists—those who visit specifically to taste our beers and experience the

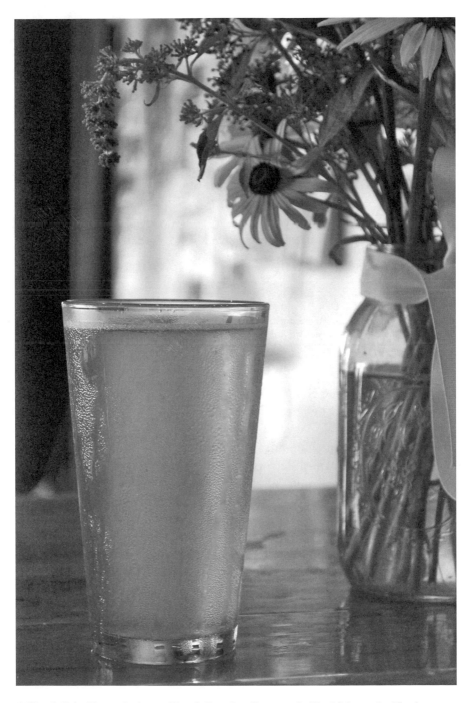

A Pisgah Pale Ale on the bar at Pisgah Brewing Company in Black Mountain, North Carolina. *Photo by Anne Fitten Glenn.*

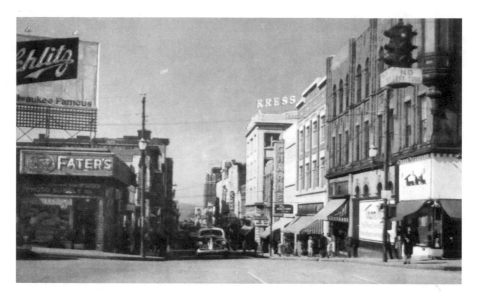

A postcard from 1953 looking west down Patton Avenue from the Vance Memorial downtown. The shop underneath the huge Schlitz sign, Fater's, was a tobacconist and magazine stand. *North Carolina Collection, Pack Memorial Public Library, Asheville, North Carolina.*

burgeoning beer scene—are a recent addition to the mix of folks coming here for outdoor activities, healthy living, eclectic restaurants or the spiritual vortex that the city of Asheville supposedly straddles. And why not? For centuries, beer has been the drink that people gather around—after work; during meals; at times of fellowship, celebration or sadness; and when fomenting plans and revolution.

I've been accused on more than one occasion of romanticizing craft beer in my writing. I'll say I'm guilty as charged in parts of this book. This is one of the dangers of being a southern storyteller. That said, I've written as well about some of the warts of the beer business without getting too much into the "he said/he said." (There still aren't that many women working in beer around here.) Our WNC breweries employ a colorful cast of characters—many of whom have worked for more than one brewery or who've had a hand in a number of beer business startups—but all of them do their work for the love of beer. Thus, I've attempted to paint a realistic portrait, and it's not all hops and roses.

I hope that those who told me their stories—the good and the bad—don't regret doing so. I claim any and all mistakes as mine. Also, deadlines and word count prevented me from telling the stories of everyone in the WNC

beer industry. I know I've missed some, and I apologize for that. If any of you have beery tales that should be told, please e-mail me at annefittenglenn@ gmail.com or regale me with them on my Brewgasm Facebook page.

Also, while much of the book focuses on the craft brewvival of the past twenty years, I cover the early appearance of the first national brands of beer in the region as well. It's worth remembering that the multinational domestic breweries—such as Anheuser-Busch, Schlitz, Pabst and Miller—all once were craft breweries. They were started by maverick brewers as small, independent American businesses using traditional brewing methods.

This book is mostly, but not entirely, chronological. For example, in the chapter on the city's writer and artist beer drinkers, it seemed necessary to cover a period from the days of Asheville's most famous writer, Thomas Wolfe, up to the founding of Wedge Brewing in Asheville's River Arts District. And while the chapters build on one another in some ways, each one can be read on its own. One of my goals has been to make this an easy book to pick up and put down, to thumb through or read voraciously.

As always, my primary goal is to tell entertaining stories. I've written a goodly number of these with a local craft beer in hand, and I invite you to do the same.

Cheers, y'all!

Early Thirsty Days
in the State of Buncombe

There aren't many references to that nectar known as beer in the rather meager historical records that survive about Western North Carolina before 1900. In fact, there are few mentions of beer after that until the 1990s, when the first Asheville breweries started opening their doors. But there's no doubt that beer was here in the early days of Asheville's history. The drink was just so ubiquitous that its existence wasn't worth writing much about. Beer was a common household item, and because its alcohol content was typically low, it didn't rouse the fiery rhetoric that its stronger cousin, "demon whiskey," often did.

While there were no breweries in Asheville before the late twentieth century (no legal ones, at least), beer definitely was here. Initially, it was brewed in the home and traditionally was a woman's job. Until consistently clean water was available, most everyone, even children, consumed beer on a near daily basis. Both the boiling process and the alcohol kill harmful bacteria and protect against water-borne illnesses that can prove fatal. Even though WNC's rock-filtered mountain water was (and still is) naturally pure, European immigrants brought their daily beer drinking habits here with them. Early on, much home-brewed beer was "small" beer or "table" beer and would have had an alcohol content of only 2 or 3 percent. Thus, it could be consumed with minimal consequences and with every meal.

In the late 1700s, most of the western part of North Carolina was known as the "State of Buncombe." Only later, as the region was explored and

slowly settled, would it be divided into smaller counties, although Buncombe remains the county home of Asheville and a number of other smaller towns.

Just to be clear, there are differing definitions of exactly which counties fall into the area called Western North Carolina. In the Southeast, as in other regions of the country, it all depends on whom you're talking to. If you Google the term, Wikipedia will tell you that WNC encompasses twenty-six counties and includes the town of Hickory. Other books and documents, both historical and modern, define the region as anywhere between sixteen and twenty-nine counties. I've lived in Asheville since 1997, and most folks who are from here don't include the foothills counties in their definition of WNC, so for the purpose of this book, I'm sticking with the seventeen or so westernmost counties when I refer to Western North Carolina. While there's great craft beer being brewed in Hickory (as well as throughout the rest of North Carolina), there's so much beer and brewing history to write about just in this far corner of the state that I couldn't possibly do justice to the breweries in another ten or more counties. (Instead, see *North Carolina Craft Beer & Breweries* for a guidebook to almost all of North Carolina's breweries—only "almost" because a few more have opened since the book was published in the spring of 2012.)

But let's get back to beer in those early thirsty days in the old State of Buncombe.

WHO WERE THE FIRST ASHEVILLE BEER DRINKERS?

Long before a few hardy Europeans settled here, the Blue Ridge Mountains were peopled by Native Americans. While there is evidence that some southwestern-based tribes brewed a corn beer as far back as one thousand years ago, there's no evidence that eastern tribes did the same. (Clay shards don't hold up as well in our wet, humus-rich soil as they do in the dry, sandy soil out west.) However, according to descriptions of North Carolina from the early 1700s, Native Americans along the coastline were brewing beer with cedar berries, corn, birch and molasses. Western North Carolina was primarily home to two tribes, the Cherokees and the Catawbas. Depending on which historian you read, Asheville was either the site of a fierce battle between these two tribes or neutral hunting grounds for both. Regardless, many of our roads today follow the ridgeline paths that were worn down by buffalo and then used by these tribes. Yes, there were buffalo roaming these

mountains until the late 1700s. Since those days, many kegs of beer have traveled these well-used routes, following the path of the buffalo.

Today, the Eastern Band of the Cherokee Nation is located in part of the tribe's traditional homelands in Western North Carolina. The Qualla Boundary lands, as they are called, are dry, allowing no sales of beer, wine or liquor, except at Harrah's Cherokee Casino and Resort. As recently as May 2012, the Eastern Band again voted down a ballot that would have allowed alcohol sales within the reservation. That said, a good bit of WNC-brewed beer currently is sold in the casino.

It is unclear whether a type of beer was brewed by the Native Americans in the region, either for regular use or ceremonial purposes. But given that throughout history and around the world, humans have figured out how to make fermented beverages using sugar sources in their habitats, it seems likely.

Settler Days: The Late 1700s

Most early beer was brewed in WNC on the homesteads of the settlers, who began carving small, self-sustaining farms out of the forests in the late 1700s. (The first white settler came to the Swannanoa Valley, a few miles east of Asheville, in 1784.) Getting to these mountains wasn't easy, and thus, they were settled a lot later than the coastal and piedmont regions of North Carolina.

While those living in the flatlands of North Carolina enjoyed imported beer and beer transported from northern breweries, heavy liquid-filled kegs would have been transported into the WNC wilderness rarely, if at all, during colonial times. There's evidence that breweries were operating in Salem and Fayetteville, but it's doubtful that any of that beer made it all the way to the town that would become Asheville, which one visitor in 1795 described as a collection of rude log huts infested with so much vermin and lice that he preferred to sleep outside.

By the turn of the eighteenth century, the State of Buncombe was still mostly unexplored "Indian Territory," with a tiny county seat called Morristown (later renamed Asheville). Records are sketchy, but most of the recorded names of those who lived here then were Scotch-Irish, with a few German, English and French Huguenot names thrown in. You can be sure that these folks who hacked their way in, looking for independence and a little bit of land, brought their home countries' beer recipes and brewing skills with them.

Even so, the climate in the South was not considered good for growing either barley or hops, two of the primary ingredients in beer, in those days. Especially early on, southern home brewers had to make do with what was at hand. Beer was often made using persimmons or locust pods, both of which are native and prevalent in the region. My small yard in downtown Asheville has weedy locusts popping up all over the place, if anyone's interested in trying to re-create locust beer.

One historical recipe collection, *North Carolina and Old Salem Cookery*, features recipes for persimmon, locust and seed beers. The recipe for locust beer, brewed with the broken black locust pods, notes, "Some of the old makers would start with a layer of straw in the bottom of a keg. When the beer was drawn out through the bottom, the straw acted as a filter." The recipe goes on to say, "Drink soon as it does not keep too well."

Another cookbook that contains historical recipes, John T. Edge's *A Gracious Plenty*, recommends clean corn shucks to line the wooden keg when making persimmon beer. The recipe then suggests, "If you put a piece of cornbread in a cup and fill up the cup with persimmon beer, you'll have something highly satisfactory. Indulge cautiously until you learn your capacity."

Early settlers also used corn as a primary ingredient in beer because they grew it, and what they didn't eat often wasn't worth the cost of transporting to market on the steep, rocky roads. That said, most corn was distilled into something stronger—moonshine—which also brought a higher price than either fresh corn or beer. The first stage of making moonshine requires boiling sugar, cornmeal and corn malt in water and then letting it ferment. The resulting product is called "beer," and some folks did drink it. Some still do.

Also brewed in mountain homes was a drink known as "Mountain Lager Beer." While it may have been called beer, it sounds like this homebrew more resembled a honeyed wine. John Arthur, in *Western North Carolina, A History (1730–1913)*, wrote, "Mountain Lager Beer or Methiglen, a mildly intoxicating drink, made by pouring water upon honeycomb and allowing it to ferment, was a drink quite common in the days of log rollings, house raisings and big musters. It was a sweet and pleasant beverage and about as intoxicating as beer or wine."

"Methiglen" actually is an old Welsh word for mead. Mead, typically made from honey and water, is another fermented beverage that has long been brewed in the mountains around here and currently is enjoying a commercial revival. In 2008, Fox Hill Meadery started fermenting and selling a variety of spiced and flavored meads from Marshall, North Carolina, in Madison County. Fox Hill meads are bottled and sold at a number of Western North Carolina restaurants and specialty retailers. Madison County is still a "dry"

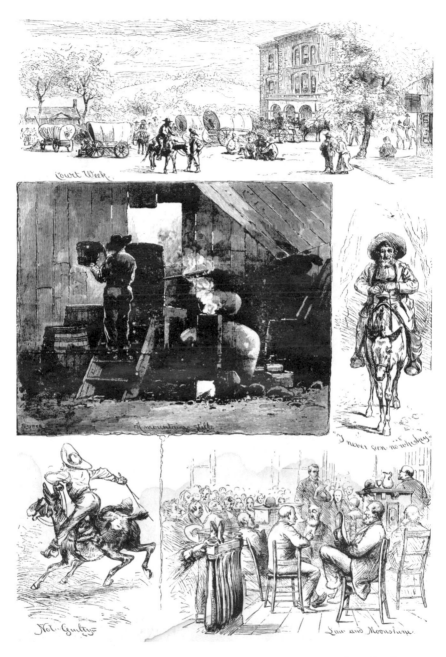

This engraving, titled *Law and Moonshine—Crooked Whiskey in Western North Carolina*, appeared in *Harper's Weekly* in 1879. After the Civil War, U.S. marshals and Internal Revenue agents tried to enforce the new whiskey tax laws. As portrayed by this political cartoon, this was not very popular. *North Carolina Collection, Pack Memorial Public Library, Asheville, North Carolina.*

county, although individual towns have self-determination, and Hot Springs, Marshall and Mars Hill all allow the sale and consumption of beer and wine but not liquor. Mead, even though it can have an alcohol content of up to 18 percent, falls into the wine category. While liquor is not allowed to be sold or consumed elsewhere in Madison County, some of the best illicit moonshine originates there even today. Or so I hear.

Helen Wykle, Special Collections librarian at the University of North Carolina–Asheville's Ramsey Library, remembers her grandmother making Methiglen. She says it was pretty awful tasting, and her brother has tried to replicate the recipe but hasn't had much luck.

Thus, the early settlers used what they had—whether honey, persimmons, molasses or locust pods—to make beverages that probably none of us today would call beer. Yet the world's near universal production of fermented beverages likely was influenced by the resultant alcohol's analgesic, disinfectant, relaxing and mind-altering effects. All of these properties would have been appreciated by the early settlers of the isolated WNC mountains.

A TAVERN MARKS THE SPOT

According to one of the more colorful stories around Asheville's inception, the town was almost located three miles south of where it actually is today. The first *Asheville City Directory* (1883–84) notes that when the first Buncombe County commissioners were appointed to select a location for the county seat in 1797, they originally chose a site roughly where Biltmore Village now sits.

However, the commissioners were swayed by a taste of the local "mountain dew" at a small tavern near what's now Asheville's Pack Square Park. "Mellowed by the soothing influences of the liquor, they unanimously changed their minds, and, acceding to the wishes of the tavern-keeper, decided 'the best place for a town to be, was where good whiskey was plenty,'" reads the account.

There is a "Charter of Asheville," dated 1797, that includes "an act of establishing a town at the courthouse in the County of Buncombe." The name of the town was changed from Morristown to Asheville to honor North Carolina's popular governor at the time, Samuel Ashe. Whether or not a wily tavern keeper truly swayed the commissioners, it's a good story. And a town that was founded "where good whiskey was plenty" would be destined to become a city where good beer is plenty, too.

FROM THE 1800S TO THE 1880S

Chartering the town didn't change much in Asheville for a good long time. It was still a struggling frontier town, with a few taverns offering to quench a dry man's thirst. While taverns often also served as restaurants and even inns for travelers, "ladies" typically didn't drink in public. When women stayed at the inns, however, they were allowed to drink in their rooms.

Traffic to and through the area started to increase once the Buncombe Turnpike was completed in the 1820s. The turnpike was wide enough to accommodate stagecoaches and large droves of livestock. The seventy-five-mile-long road connected Greenville, South Carolina, to Greenville, Tennessee, and passed directly through Asheville. The turnpike opened Asheville up to the rest of the South, to both more trade and more travelers. Thus, more taverns sprang up along the turnpike to accommodate weary travelers and drovers. And because bigger wagons could now navigate their way to Asheville, we can assume that a keg or two of beer made it through as well, though most of the beer imbibed here likely was still home brew.

The nearest commercial brewer was a man named Thomas Holmes of Salisbury, who ran a number of advertisements for his public house in the *Western Carolinian* newspaper in the 1820s. That Salisbury's newspaper was called the *Western Carolinian*, given that Salisbury is 118 miles east of Asheville, goes to show just how far removed the true western part of the state seemed at that time. Interestingly, Holmes advertised that he would buy local barley and hops and said that his establishment kept "a constant supply of Beer and Porter." Most likely, all of Mr. Holmes's beer was sold in Salisbury, though some of it may have wended its way to Asheville.

The bartering culture that survives today in parts of these mountains was alive and well in the early days. Asheville's first newspaper, the *Highland Messenger*, contains an advertisement from 1843 for a cabinet shop that offered to take "all kinds of country produce, except promises, tobacco and whisky or brandy," in exchange for furniture. Beer didn't make the list, but you have to wonder if a keg of beer could've been traded for a chair or a small table.

By 1850, Asheville had become a hamlet of about sixty buildings, with a population of 415 people, according to the U.S. Census for that year. While still small, it had grown partially to accommodate travelers, who were drawn to the area's natural beauty or to the cooler climate, which was touted as a curative.

The War Between the States, as southerners like to call it, definitely disrupted trade, including the movement of beer. During the war, the

Southern states also restricted imported beer. While this probably didn't affect WNC as much as it did the rest of the Old North State, the Civil War was an unmitigated disaster for this region. There was mixed sentiment here about the war, yet a huge amount of public money and energy was diverted for the effort. (You can read Charles Frazier's *Cold Mountain* for one story of how the war tore Western North Carolina families apart.) During the war, most people continued to get their beer by brewing it themselves.

The Confederate Receipt Book, published in 1863 in Richmond, Virginia, offers several beer recipes that recommend local ingredients, including recipes for "Table Beer," "Spruce Beer" and "Ginger Beer." Only one of these recipes calls for hops, which were difficult to come by (often still the case in this part of the country). All use molasses and/or brown sugar as fermentable sugars, indicating that malted grains weren't easy to find either. The spruce beer recipe tells the brewer to "take three gallons of water, blood warmth, three half pints of molasses, a tablespoonful of essence of spruce, and the like quantity of ginger, mix well together with a gill of yeast, let it stand overnight, and bottle it in the morning. It will be in a good condition to drink in twenty-four hours." If you're wondering, "blood warmth" isn't an ingredient but rather a temperature direction.

Also during the Civil War, the North Carolina General Assembly prohibited making liquor and beer from grain, supposedly to protect the state's food supply. Folks who had been making their own whiskey and beer in these mountains for a few generations were not happy about this prohibition. It contributed to hoarding of corn and sugar in order to produce beer and liquor, which now had to be traded illicitly (unless it was some of that yummy-sounding locust brew). Soon after the war, the U.S. Internal Revenue Service starting taxing alcohol, which in WNC only served to increase its illegal production and sales.

More than 150 years later, Asheville's Craggie Brewing Company regularly brews Antebellum Ale, a beer based on an 1840s recipe. The original ingredients were water, yeast, molasses, ginger and spruce tips. The recipe seems similar to the spruce beer recipe in *The Confederate Receipt Book*, although the recipe Craggie adapted came from co-owner Jonathan Cort's family and had been handed down through the generations. "I wanted Antebellum to taste like an old-fashioned beer but still be accessible to modern palates," said Craggie co-owner Bill Drew. Thus he added hops and malted barley to the mix. Even so, if you'd like to get as close a taste as possible to what mountain folks were brewing and drinking around here in the 1800s, head down to Craggie Brewing and ask for an Antebellum Ale.

Wild, Wild Western
North Carolina

Taverns and saloons started popping up like foam out of a warm keg in the late 1800s in Asheville. By the turn of the twentieth century, at least eighteen saloons and bars would be serving beer and liquor to Ashevillians, mostly from an area of town that came to be known as "Hell's Half Acre" for its rowdy licentiousness.

From 1850 to 1880, the population of the town more than quadrupled. From 1880 to 1890, it increased from more than 2,600 to almost 12,000 souls. What caused both the number of people and the number of watering holes to increase so sharply in such a short time? The answer is the advent of the railroad, which finally connected Asheville to the rest of the world in the early 1880s.

The railroad also made the transport of goods from far-off cities easier. Getting bottled and kegged beer from places such as St. Louis, Milwaukee and Cincinnati became possible. These cities were strongholds of German immigration and had started large-scale brewing operations in the mid-1800s. Advances in brewing technology, refrigeration and pasteurization made higher production and wider distribution possible. These breweries introduced German lager-style beers to America, and the light, fizzy beer became popular quickly, soon pushing out some of the numerous small producers of English-style ales.

In addition to new residents, by 1890, the railroad was bringing about fifty thousand tourists per year to Asheville, which was touted as "the healthiest city in the world." Some of these tourists, such as George Vanderbilt, E.W.

The White Man's Bar in the background was on the corner of South Main and Eagle Streets (now Biltmore and Eagle Streets) in the area known at the turn of the twentieth century as Saloon Row. This photo was reprinted as a postcard. *North Carolina Collection, Pack Memorial Public Library, Asheville, North Carolina.*

Grove and Colonel Frank Coxe, brought great wealth with them. These men would forever change the city's infrastructure, as well as pave the way for an expanded tourist industry that in turn would improve the odds of small breweries surviving here in the late twentieth century.

In the 1870s, there were more than four thousand small breweries in the United States (none of them in Western North Carolina). Most drinkers were still liquor drinkers, but beer was definitely making inroads. Per capita consumption of beer in America increased on par with the production of beer. While the average American only drank four gallons of beer annually in 1865, by the early 1900s, that number had risen to twenty-two gallons per year.

While the majority of Asheville saloon customers drank whiskey and rum (which made its way up from the coast), as beer became more available, it became more popular. The Gay Nineties were a heady, rowdy time to be in Asheville, especially if you liked to lift a pint or two.

ADVERTISING TELLS TALES

Saloon and bar owners were listed among the most prominent city residents in the 1890 *Asheville City Directory and Business Reflex*. "The importance of the liquor trade in our city can hardly be over estimated, employing as it does hundreds of dollars, and occupation of many deserving men, and should be appreciated, which shows by a clientage of some of our most influential and wealthy citizens," wrote Harry Fulenweider in the directory's introduction.

The directory contains detailed descriptions of a number of downtown businesses and their owners. Whether these were early advertorials is unclear, although several, but not all, of the saloon and alcohol merchants were prominently featured. These were all, not surprisingly, of European descent. There were "colored" saloons and billiard halls, most notably the Buffalo Saloon. Most of the saloons in town were clustered along either side of South Main Street, now Biltmore Avenue, near Eagle Street (the strip where Barley's Taproom now resides). Thus, Hell's Half Acre, also known as Saloon Row, was merely a stone's throw from the city's courthouse and town center.

Mr. W.O. Muller claimed to be the first person to introduce Anheuser-Busch Pale Lager Beer to Asheville. His "liquor house of W.O. Muller" was established as "one of the representative business houses of Asheville" in 1879, per the 1890 directory. He's described as "Agent and authorized

W. O. MULLER,

DISTILLER OF

PURE "MOUNTAIN DEW" CORN AND RYE WHISKIES,

WHOLESALE AND RETAIL DEALER IN ALL KINDS

BRANDIES, WHISKIES, WINES, LAGER BEER, CIGARS, &c.

AGENT FOR THE CELEBRATED

FOSS & SCHNEIDER CINCINNATI LAGER BEER.

SOUTH MAIN ST. AND PATTON AVE., ASHEVILLE, N. C.

This saloon advertisement ran several times in the first *Asheville City Directory and Gazetteer of Buncombe County*, published in 1883. A few years later, Mr. Muller would claim to be the first person to introduce Anheuser-Busch Pale Lager beer of St. Louis to Asheville. *North Carolina Collection, Pack Memorial Public Library, Asheville, North Carolina.*

Scene from an unnamed Asheville pool hall and saloon, circa late 1890s. The large posters above the bar feature drawings of breweries, one of which is Henderson Brewing Company of Henderson, Kentucky. Henderson Brewing brewed a beer called Old Kentucky Export. *North Carolina Collection, Pack Memorial Public Library, Asheville, North Carolina.*

Bottler of the Celebrated Anheuser-Busch St. Louis Pale Lager Beer and Original Budweiser Export Beer."

I don't think that Muller actually bottled the beer on his premises, as the description of the business notes that the beer was "received in car load lots in a refrigerator." Car loads refers to rail cars, not automobiles, which would have been rare curiosities at the time. Adolphus Busch of Anheuser-Busch had recently pioneered the use of double-walled railcars and networks of icehouses to keep this company's beer cold for nationwide distribution. Most beer was delivered in bottles or in small kegs. Bottles were preferred, because barkeeps could just keep a few at a time on ice, while kegs, which usually sat right under the taps, needed to be kept frosted and required a steady supply of ice. Also, without added carbonation, keg beer went flat pretty quickly after it was tapped.

Muller, thus, was likely the first Asheville distributor of a national beer brand. As the Anheuser-Busch agent, he would have taken orders from other saloons and delivered beer to them daily. There was a cold storage house near the train depot for beer, and it was delivered from there directly to the saloons via horse- or mule-drawn delivery wagons.

Muller claimed to have "a special department devoted to family supplies." This is likely a reference to beer, which could be delivered to households

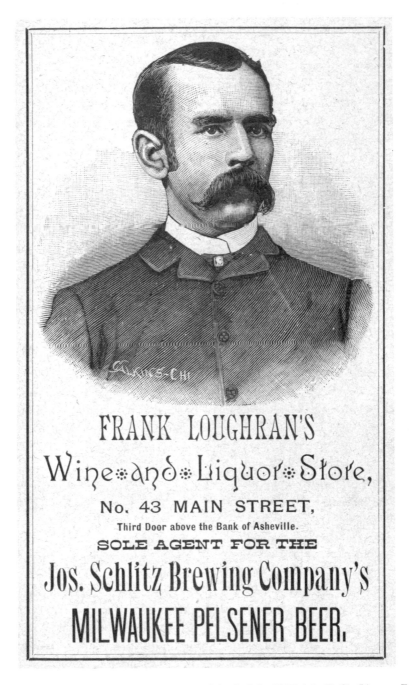

This full-page advertisement ran on the front flyleaf of the 1887 *Asheville City Directory*. Frank Loughran was likely the first local distributor of Schlitz beer. *North Carolina Collection, Pack Memorial Public Library, Asheville, North Carolina.*

or picked up from the back of the saloon for the home, often by children. Alcoholic beverages were also marketed as "medicinal"—of course, alcohol does kill many germs and bacteria on contact. Most saloons of the day were also retailers. Laws regarding the sale and consumption of alcoholic beverages were minimal at the time.

Muller's saloon, located at College and Water Streets (now Lexington Avenue), also sported a "splendid Billiard and Pool Hall."

An 1887 *Asheville City Directory* ad for Frank Loughran's Wine and Liquor Store touts him as the agent for "Jos. Schlitz Brewing Company Milwaukee Pelsener Beer." Thus, if the ads are·true, Schlitz and Anheuser-Busch were likely the first national beer brands to be distributed in Asheville. Frank's brother, James Loughran, was also in the business and owned the White Man's Bar at 46 South Main. Both men are listed in the directory as having resided at the same addresses as their businesses.

The description of the White Man's Bar notes that the establishment offered "alcoholic malt beverages" that were "free from adulteration." This is a reference to corn whiskey, which was often mixed with lye and other toxic adulterants to increase the alcohol content. A number of Asheville saloons did have distilling licenses and probably made corn whiskey in the basements of their establishments. Loughran also offered a variety of both imported and domestic wines, liquors and beers. The bar's description also notes, "With the name implied 'The White Man's Bar' allows this concern an enviable position among its compeers." Just behind the White Man's Bar on Eagle was Frank Jackson's business, touted as the "Only Colored Billiard and Pool Parlor in the City."

In a few years, the White Man's Bar would gain a new manager, while James Loughran would open the Acme Wine & Liquor House just up the street. He would advertise the sale of Bartholomy Rochester Beer of Rochester, New York.

Also on South Main was George A. Sorrells's Eagle Saloon. A "popular dealer in…ale, porter, beer on draught and also in bottles, for family use," Sorrells's saloon opened in the early 1880s on South Main. He was described as "a gentleman of the strictest probity" in the directory.

Many of these early advertisements, in both newspapers and city directories, use the words "ale" and "porter" separately. As is true today, most of the small breweries made ales, using top-fermenting yeast strains that ferment more quickly than lagers. Today, most porters are ales. However, probably influenced by Russian brewers, many breweries started brewing porters with lager yeast in the second half of the nineteenth century. Thus,

it seems, the word "porter" may have been used to describe an old-fashioned Baltic lager–style beer. The word may also have described English-style porters, which were popular at the time, especially across the pond.

In an 1898 *Asheville Citizen* ad, Carolina Wine and Liquor Store offers "Ales and Porters: White Label, Dog's Head, and Burke's and Ross' bottlings." The ad has a separate "Beers" list, which includes Budweiser, Pabst Blue Ribbon, Schlitz and Dixie. Thus, saloons and retailers were already differentiating between the small ale-heavy brewery brands and the bigger lager-focused national brands.

Another saloon that's written about in highfalutin prose in the 1890 directory was the Boston Saloon. Described as one of the newest saloons in town, it was started by "Messrs. Jno. O'Donnell & Co.," two "popular young men" who had previously worked at the nearby Carolina Saloon. This goes to show that even in 1890, enterprising employees were breaking off to start their own competing enterprises.

Fulenweider clearly was much taken with the O'Donnells, writing, "There is no branch of mercantile life in which such great energy, patience and superior knowledge of how to conduct a successful business is involved than that of a saloon dealer, in consequence of which we unhesitatingly pronounce these gentlemen artists in this particular line." Despite Fulenweider's protestations of the probity and patience of the saloon owners, their businesses would soon mostly disappear in the wake of the temperance movement and lots of angry teetotalers.

Many local hostelries and hotels of the time also offered bars, including the Glen Rock, Berkeley and Battery Park Hotels in Asheville. The Grand Central Hotel, operated by S.R. Chedester and his son on North Main Street, featured an Irish pub that sold Bass & Company's Dublin Pale Ale, Guinness Extra Foreign Stout and Dublin Porter in the 1890s.

Like the reference to beverages "free of adulteration," saloon and beer retail advertisements of the times reflect much of what was going on with the "drinking class." An 1890 ad for the White Man's Bar states, "No free lunches are served, or any kind of wild animals are on exhibition to attract the attention of the lower trade." This is probably a reference to the blind tiger or blind pig speakeasies that cropped up around the country in the late 1800s. Blind tigers were places that sold alcohol illegally. The customer would be charged to see an attraction, such as a blind pig or tiger, and then they would be served a complimentary alcoholic beverage. Because the establishments weren't actually selling the product, they couldn't be taxed on it. Blind tigers, of course, increased greatly in number during prohibition, even though as alcoholic beverages were illegal, taxation was no longer relevant.

In 1900, Bonanza Wine & Liquor in Asheville ran an ad in the *Asheville Citizen* that read, "The athletic and healthy girl of today...finds that after a spin on her wheel, or a game of golf, or in the daily routine of home life, there is nothing that will act like a charm restoring new life and vigor when weary as a bottle of our pure and wholesome beer."

Today, brewers, both craft and domestic, are eager to entice female beer drinkers. Clearly, this has been the case for more than one hundred years (well, subtracting the prohibition years—for a long time, anyway). Just as several saloons advertised beer for family and medicinal use, the Bonanza ad reveals that many of these businesses wanted to seem respectable and wholesome. This tack didn't work, however, as women would be the ones to turn the tide in many places, but most definitely in Asheville, from "wet" to "dry."

And yes, while this is a book about beer, this may be the place to mention that alcohol abuse has ruined many lives and devastated families over the centuries. In the 1900–1901 *Asheville City Directory*, it's interesting to note that adjacent to the Bonanza Wine & Liquor ad, which runs in the margins of the volume every sixteen pages, there's a doctor's advertisement that claims, "Whisky and Opium Habits cured at your home without pain."

THE NEAREST BREWERIES AT THE TURN OF THE TWENTIETH CENTURY

Just across the state line, in Knoxville, Tennessee, eight breweries sprang up in the 1870s and '80s. Most of them didn't survive for long, but there's evidence that both the Knoxville and East Tennessee Brewing Companies distributed beer in Asheville. East Tennessee Brewing ran ads in 1906 and 1907 in both the *Asheville Citizen* and the *Asheville City Directory*. The ad in the 1907–8 directory describes them as "Brewers and Bottlers of Pure Beers. Our leading brands in bottles: 'Palmetto' and 'Shamrock Special.'" The brewery even had a local "representative," Captain Charles H. Russler.

Another southern brewery that distributed in Asheville was Pinnacle Lager Beer, made by the New South Brewery & Ice Company in Middleborough, Kentucky. Pinnacle was sold by the Asheville Wine, Liquor and Soda Water Company at "cafes, saloons, buffets and hotels," per a 1906 newspaper ad. Like the saloons, this brewery was fighting the oncoming prohibition storm, quoting "Beer is Liquid Bread" from the "address of a German scientist"

and proclaiming that "science in its relation to food and drink points the way by declaring beer to be heavy in malt extract, light in alcohol, and in effect a genuine temperance beverage."

While a few of the Saloon Row businesses made do as billiard and pool halls after Asheville voted to become "dry" in 1907, most didn't survive. Frank Loughran, who had diversified and owned the Hotel Berkeley, among other real estate, commissioned the construction of the Loughran Building in 1923, a six-story commercial building at 43 Haywood Road. Clearly, he wasn't too hurt by prohibition. However, most of the saloons shut down quickly. A few became retailers of other goods, such as groceries, tobacco or magazines. Later, Hell's Half Acre would become home to several appliance, plumbing and construction materials shops. Only in the 1990s did that area start to revitalize, and the past few decades have witnessed huge changes in old Saloon Row, including Barley's Pizzeria & Taproom, Mast General Store, the Aloft Hotel and a number of upscale restaurants, from Limone's to Curate.

Patent Medicines and Alcohol

Just above the 1906 East Tennessee Brewing ad is a large advertisement for Thedford's Black-Draught (Liver Tonic), which claims that it "Makes Your Liver Smile." Many patent medicines at the time were made mostly from alcohol, and just as today, they were often abused, especially during prohibition. Small amounts of alcohol were still allowed for medicinal purposes throughout prohibition, but they required a prescription. One Asheville doctor claimed that he always knew when a local still had been busted up because requests for prescriptions would increase precipitously. That said, the medicine whose sales built a number of Asheville landmarks contained nary a drop of alcohol.

One of the most prominent early benefactors of Asheville, E.W. Grove, became a multimillionaire by manufacturing a malarial medicine called "Grove's Tasteless Chill Tonic." Grove was a strict prohibitionist, and the active ingredients in his medicines were suspended in a flavored sugar syrup. Supposedly, Grove frowned on the drinking that went on at his famous Grove Park Inn (GPI), which was opened in 1913 (after prohibition started in Asheville but when it was still easy to bring bottles from elsewhere). Clearly, Grove would have been shocked to learn that the city he so loved and shaped architecturally would later become Beer City, USA.

THE ASHEVILLE CLUB

The influx of wealthy patrons to Asheville brought a new classism to the area. Those who didn't deign to frequent Saloon Row often preferred to tipple at hotel bars or at membership clubs. The original Asheville Club had its clubrooms on the present site of the Miles Building. W.J. Fitzgerald, an officer of the club, said in a 1933 newspaper interview, "Asheville was not a big beer town. Mostly liquors were consumed." However, the club hosted "Beer Day" on the first Friday of each month. More than three hundred members of the club would attend the "buffet supper and beer festival." The beer served for "Beer Day" was Wurzberger, a German Pilsner that was secured by a New York City importer. Two or three kegs of the beer would be consumed every "Beer Day." The precursor to the Country Club of Asheville, started in 1894, had its "Town Club" next to the Battery Park Hotel downtown at the time; it was another site for members-only carousing.

BILTMORE FORESTRY SCHOOL'S SANGERFEST

The most famous privately owned home in America, Biltmore, was completed in 1895 by George and Cornelia Vanderbilt in the middle of the Gay Nineties, also appropriately known as the Gilded Age. While the home and surrounding estate are remarkable, one of Vanderbilt's most lasting legacies to this region (and to the United States) was in forestry.

You're probably wondering what Biltmore's trees have to do with beer, right? In 1895, Vanderbilt hired Dr. Carl Schenck of Germany to care for the estate's extensive forests. In 1898, Schenck established America's first forestry school there. In addition to knowledge about forest management, Schenck also brought from his homeland a traditional singing and beer drinking festival called Sangerfest.

Wrote James P. Barnett in an article for the *Piney Woods Journal*:

> *The students were considered a lusty group, and their exploits in the local bars were loud and long. After repeatedly bailing out students that were thrown in jail, Schenck started Sangerfests, singing and drinking sessions. His thought was "If you're going to do your drinking, let's all do it*

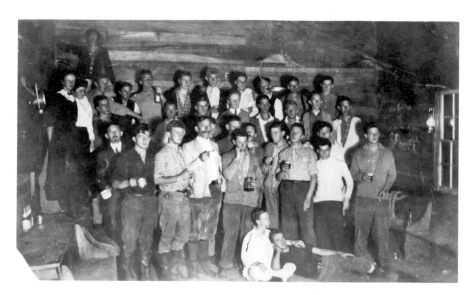

Biltmore Forestry School students held a monthly singing and beer drinking celebration called Sangerfest in the 1900s. The director of the school, Dr. Carl Schenk of Germany, introduced Sangerfest as a way to keep his students out of the local bars. Front row, third from the left is Doc Schenk himself. The ladies in the photo were his guests. *E.M. Ball Photographic Collection (1918–1969), D.H. Ramsey Library, Special Collections, University of North Carolina at Asheville.*

together." Schenck would provide two kegs of beer and they would sing the school's alma mater, "Down under the Hill," and other drinking songs in the school space.

From the photos of strong young men carrying barrels of beer, it's clear that the students often supplemented Schenck's kegs with a few extras. Thus, Sangerfests were Asheville's first beer festivals. By the time the Biltmore Forestry School closed in 1913, it had produced more than 70 percent of all forestry graduates in the nation, most of who, it can be guessed, had learned to appreciate a good drinking song and a stein of beer.

Dark Years
Prohibition Pain

Prohibition, also known as the Noble Experiment, was a dark time for our nation in many ways. Many of the consequences were the opposite of those intended. Outlawing alcohol created outlaws of people who otherwise would not have been criminals. It increased the power of many who were already working outside the law, such as the mafia and other organized crime groups. Also, poisonings and deaths from the consumption of unregulated and adulterated alcohol increased. Last but not least, prohibition devastated a number of legitimate small businesses, and most importantly (from the perspective of this book), it all but destroyed the beer and brewing industries.

Here in the mountains, prohibition gave a boost to the illicit moonshine trade. Moonshine was already well entrenched, and beer became an afterthought. Beer was much less profitable than corn whiskey and required some ingredients that were still difficult to find (hops and malted barley). Also, as is still the case today, the lower alcohol content of beer offers less bang for the buck. A twelve-ounce mason jar of shine can intoxicate a lot of folks. The same can't be said for a twelve-ounce brew. (Sure, there have been some crazy super high alcohol by volume beers produced in recent years, but no one was doing that one hundred years ago—most beer was 4 percent or less ABV.)

Thus, thousands of small American breweries, often owned and run by immigrants from beer-loving countries such as Germany and England and producing a diversity of beers, disappeared like the dodo bird once the nation went dry. Writing that just made me realize there's a *Jurassic Park* metaphor for the story of American beer in the twentieth century.

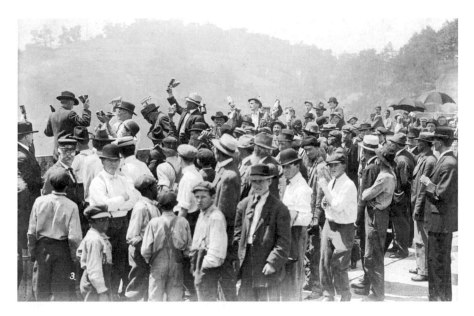

A prohibition rally, where men standing on a bridge are holding up bottles as if about to throw them over. Believed to be the bridge over the French Broad River at the old Riverside Park, it is now Pearson Bridge in Asheville. *North Carolina Collection, Pack Memorial Public Library, Asheville, North Carolina.*

Luckily, craft beer was resurrected with less damaging consequences than the Tyrannosaurus rex.

Back to Asheville, which would be the first city in North Carolina to vote for prohibition, while North Carolina would be the first state in the nation to do so soon after. The vote went down in Asheville twelve years before the Eighteenth Amendment was ratified nationally.

In Asheville's defense, when a drunken desperado shot up the town one dark night, killing five people, including two police officers, it wasn't surprising that there was a backlash against "demon" whiskey. It's just unfortunate that the demon took beer down with him.

THE MURDEROUS RAMPAGE

In the first decade of the twentieth century, seventeen men died violent deaths in Hell's Half Acre. Five of those deaths occurred one November night in

1906, when a drunken ne'er-do-well, a man named Will Harris, took his Savage rifle to the streets. This one bloody night propelled the prohibition vote in both Asheville and North Carolina, according to historian Bob Terrell, who wrote an entire book about the Will Harris murders.

Harris was a native of Charlotte and had supposedly been imprisoned on numerous occasions, both for theft and murder, before he arrived in Asheville, but neither prisons nor chain gangs could hold him. He had escaped both the state penitentiary in Raleigh and a Mecklenburg County chain gang.

There are extensive accounts of the night, but the short version of the tale is that a "desperate Negro" bought a quart of bourbon at the Buffalo Saloon on South Main. He was carrying his rifle, which he'd purchased the previous day at Finkelstein's Pawn Shop. (Finkelstein's on Broadway is still in business, making it one of the oldest continuous businesses in Asheville.) Harris went from the Buffalo to the nearby basement apartment of Pearl Maxwell on the corner of Valley and Eagle Streets, carrying his bourbon and his rifle with him. Harris was giving the woman trouble, so a friend of hers ran to the nearby police station for help. The responding officer was shot and killed, after which time Harris wandered the streets of Asheville, shooting at pretty much anything that moved. He killed another police officer, as well as three other men who were unlucky enough to be out on the street. Then Harris ran, though he was spotted the next morning near Biltmore estate.

The next day, a posse tracked him to Fletcher, about twelve miles from Asheville, and after engaging in a short exchange of gunfire, shot the outlaw more than one hundred times. Harris's bullet-riddled body was brought back to Asheville and put on display at an undertaker's on South Main. More than two thousand people viewed the body over the next few days, but even the Mecklenburg County sheriff, who traveled to Asheville for that purpose, never positively identified the deceased as Harris. Even so, Harris was never heard from again.

Not surprisingly, the murders had a huge impact on the town's residents. The story was front-page news for a few weeks; one headline claimed, "City Settles to Quiet Life After Horror and Suspense." All of the saloons and bars in the city were closed the day after the murders and again after word came that Harris was dead, for "precautionary measures," according to an article in the *Asheville Gazette*.

The murders would provide impetus for the "drys" to put an end to the dirty streak of lawlessness running through Hell's Half Acre.

Leading the Fight: Women and Children

The women of America, followed closely by their progeny, led the fight for prohibition nationwide. From a feminist perspective, I admire temperance radical Carrie Nation's hell-raising zeal. After all, not many women would be so moved as to take a hatchet to actual buildings in order to vent their wrath. Nation, who was arrested about thirty times between 1900 and 1910 for leading her lady followers on swathes of saloon destruction, became the face of the national prohibition movement.

Many of America's wives and mothers were angry, and rightly so. It was considered unseemly for "ladies" to be in saloons. (Only certain types of women visited those establishments.) Hotels would often have a special room where women "might drink to avoid the eyes of the curious," as one newspaper article put it. Asheville's Battery Park Hotel had a special room for women called the "Red Room." For the most part, back then, women drank their beer at home and had bottles delivered there directly from the saloons.

Much of the time, women were left at home while their spouses spent time and money in the saloons and then sometimes came home drunk—thus being little help around the house or with the children. In worst-case scenarios, the drunken men were abusive. As a woman who drinks freely wherever I want, I can't imagine how restricted women at the turn of the twentieth century must have felt. That said, some of the shenanigans they came up with to shame and hector men to voting "dry" were pretty over the top.

There was an entire *Lysistrata* movement of women claiming that "lips that touch liquor shall not touch ours," which included posters of rather stern-looking matriarchs pursing their mouths into grim lines.

However, it should be noted that the Woman's Christian Temperance Movement, founded in 1874, took a number of important stances—from supporting women's suffrage and prison reform to calling for world peace. It's ironic that the movement's most famous member, Carrie Nation, would be remembered primarily for her violence.

While, in many ways, prohibition didn't work, it did provide a platform from which to empower women. And it did, indeed, help clean up Asheville's Saloon Row.

ASHEVILLE'S WOMEN AND CHILDREN RULE THE DAY...AND THE VOTE

On August 16, 1907, a local temperance organization requested that the Asheville Board of Aldermen call a special election to vote on "the liquor question." About nine hundred people signed the petition, and an election was called for October 8. The ballot offered two issues: whether intoxicating liquors should be manufactured in Asheville and whether bars or saloons should be maintained in the city.

The night before the vote, the "wets" took over the opera house and "whooped it up." The "drys" gathered their forces, including women and children, and organized a great torch-lit parade through town. Photos of the "children's parade" would be front-page news the next day. After parading, the "drys" took over the old city auditorium and were whipped into a frenzy by several speakers, including Reverend Ham, a "professional" prohibitionist from Kentucky who came to Asheville just for the occasion.

The next morning, hundreds of the women and children of Asheville were at the polls by daybreak, harassing the town's menfolk to vote "dry." There were only eight voting precincts at the time. The "drys" basically guilt-tripped the "wets" into voting "dry." The "wets" wore red ribbons and the "drys" white ones, and each side was allowed to print their own "ticket" or ballot. The children would literally rip the red ribbons off the men's jackets as they approached the precincts. Plus, voting regulations were looser then, and anyone near the polls could see which ballot a voter chose and heckle them.

At what was then Precinct 4 (Brown's livery stable), "One gentleman on the anti-Prohibition committee bravely faced the ordeal of the women and children, but when he reached the box, the children sang a naughty song which incorporated the names of all his children in it and he came away dazed—and unvoted," per one newspaper article. In another strange twist, John O'Donnell, barkeeper of the White Man's Bar, after being besieged at the Cotton Mill Precinct, pinned a white ribbon on his jacket and handed out "dry" tickets for the rest of the day. "The ladies won the election," he was quoted as saying in the newspaper.

The next day's *Asheville Citizen* headline reads, "Asheville Goes 'Dry' by Astounding Majority of 848. Remarkable Scenes Enacted at the Polls. Many Women and Children Capture Various Precincts." The article noted that "the women and children absolutely captured the city. There never was a moment from light to dark when they did not control the situation." Some

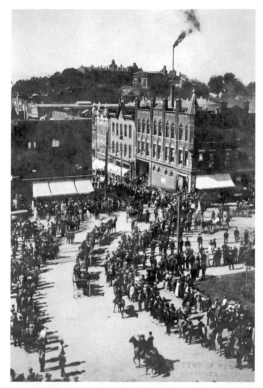

Left: Prohibition parade crossing Pack Square in October 1907 before the citizens of Asheville voted to outlaw the manufacture and sale of alcohol within the city limits. This was eleven years before the United States ratified the Eighteenth Amendment. *North Carolina Collection, Pack Memorial Public Library, Asheville, North Carolina.*

Below: Members of the Women's Organization for National Prohibition Reform's parade float in Asheville's Rhododendron Festival in 1933. Sadly for them, it would be almost two more years before North Carolina would vote with the rest of the nation to repeal the Eighteenth Amendment. *E.M. Ball Photographic Collection (1918–1969), D.H. Ramsey Library, Special Collections, University of North Carolina at Asheville.*

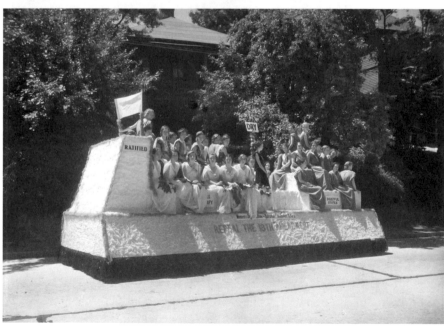

1,700 total ballots were cast, and both saloons and alcohol manufacturers were voted out of the city.

Several months later, in May 1908, the people of North Carolina voted in favor of prohibition in a statewide referendum. Buncombe County was a strong supporter, voting 4,263 in favor to 593 opposed. Then the Eighteenth Amendment (and the Volstead Act) was passed by U.S. Congress in 1920, and the Turlington Act of 1923 made the nation bone dry. Prohibition was repealed thirteen years later, and control of alcohol was handed back to the states. Franklin Delano Roosevelt was elected president primarily because of his repeal platform.

PROHIBITION LOOPHOLES

Despite the closing of the licensed taverns in Asheville, in the days before the nation went the same way, the laws were largely ignored.

"This state went dry three years ago. But we are told there are a great many 'Blind Tigers' here and we see many empty bottles along the roads and in the streets, parks and elsewhere. We visited Asheville police court one morning and of 14 cases on the docket 12 were plain drunks and were given $3.00 and costs," wrote W.A. Shafor of Ohio in a 1911 letter that was printed in the Hamilton, Ohio newspaper. The letter was later discovered and hand-delivered by a friend of Mr. Shafor's to the editor of the *Asheville Citizen* and reprinted there in 1941.

Continued Mr. Shafor, "As is the case everywhere there is a difference of opinion in regard to the liquor question. Some tell us there is more drinking and crime since the state went dry than before and that a steady stream of money is going out of the state for liquor that may as well be made here and the money kept at home. Others say there is less drinking and crime and that there is less temptation, especially for boys, since the open bar was abolished."

Asheville also lost one of the city's most well-known residents after voting for prohibition. John A. Roebling, son of the man who built the Brooklyn Bridge, lived in Asheville for about ten years. He owned twenty-five acres adjacent to Biltmore. Roebling got so angry when the city voted for prohibition that he donated his land to the Episcopal Church of Asheville and moved back to New Jersey, prompting an article in the *New York Times*.

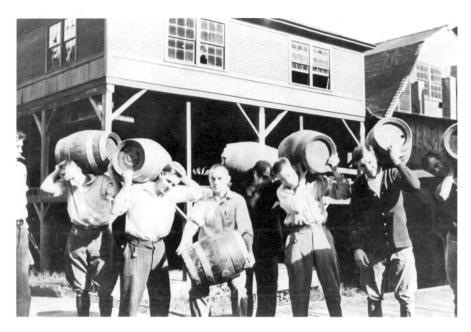

Biltmore Forestry School students carrying kegs of beer to prepare for the monthly Sangerfest, a traditional German singing and beer drinking celebration, circa 1910. Although Asheville had voted in prohibition at this time, kegs of beer could be ordered from other states for personal consumption. *E.M. Ball Photographic Collection (1918–1969), D.H. Ramsey Library, Special Collections, University of North Carolina at Asheville.*

One of the holes in prohibition in both Asheville and North Carolina was that only the local manufacture of liquor was illegal. As Mr. Shafor mentions, this proved a boon to nearby states where manufacture was still legal, at least for a few years (similar to the current situation that exists near a number of county lines and city limit lines in WNC). In other words, folks could get their beer from elsewhere and bring it here. Also, in 1915, the North Carolina General Assembly passed an act that allowed delivery of one quart of whiskey per address every two weeks.

There's a full-page ad on the second page of the 1916 *Asheville City Directory* for the Martin Lynch Company of Bristol, Virginia, offering whiskey and beer shipping. The company offered 100 percent pure "Cherokee Corn…made by the old North Carolina Sweet Mash process in copper still," as well as apple and peach brandies (which were very popular at the time). It also offered the following beers: Pabst Blue Ribbon; Pabst Red, White and Blue; Chattanooga Brewing Company's Magnolia; Amber Bottled Beer; Royal Pale; and Jung's Cincinnati. PBR was the most expensive beer, priced at $1.25 per dozen, while

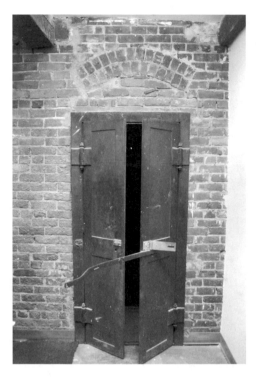

Left: Double steel doors guard the entrance to a tunnel under Pack's Tavern. The building was known as a center of bootlegging during prohibition. Although Pack's co-owner Ross Franklin has tried to drill through the plaster covering the entrance to the tunnel to see where it leads, he gave up after encountering dirty water. *Photo by Anne Fitten Glenn.*

Below: Asheville's Hayes & Hopson building was, during the 1920s and '30s, ostensibly an automotive store, among other things. But there was a network of tunnels that snaked from underneath the building to other buildings throughout downtown that bootleggers used during prohibition. The building is now home to Pack's Tavern, whose owners are starting a small brewery in the old jailhouse adjacent to it. *E.M. Ball Photographic Collection (1918–1969), D.H. Ramsey Library, Special Collections, University of North Carolina at Asheville.*

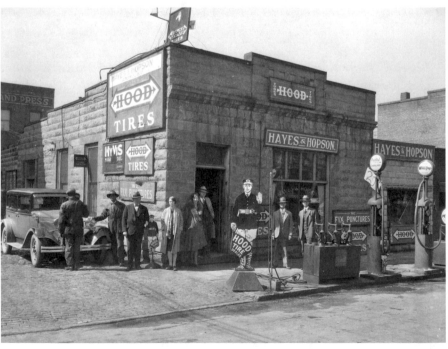

the rest are $1.00 for twelve. (This seems ironic given that PBR currently is the inexpensive throwback of choice in Asheville.) Martin Lynch also offered an eight-gallon keg of the Magnolia beer for $2.25. Kegs required a $2.00 deposit, which would be refunded when the cask was returned. This is probably how the Sangerfest boys got ahold of their party kegs.

Basically, prohibition boosted the production and trade of moonshine in these mountains. Supposedly, entire networks of tunnels were dug under Pack Square Park in the center of Asheville for the purpose of transporting illicit liquor. In the basement of the Hayes & Hopson building, there are rusted double steel-hinged doors with extensive locks leading to what once was a tunnel running under South Spruce Street and connecting to further tunnels and adjacent buildings. Throughout prohibition, that building, which now houses Pack's Tavern, was a known source for the distribution of illicit alcohol. Current co-owner Ross Franklin said that he drilled into the thin layer of mud patching the hole behind the old doors, but all he got was some dirty water leaking into his building, so he patched it back up. The tunnel likely leads across the street to the basement of the Asheville Police Department, which has been located in that spot since 1926. Franklin said that he's asked, but the PD won't let him into the basement to see if there's a blocked tunnel on that side of the road.

After prohibition, the Hayes & Hopson building housed an automotive supply company before becoming Bill Stanley's Barbecue and Bluegrass Restaurant, which was a popular beer drinking spot for many years. Pack's Tavern completed renovations and opened in 2010. The Tavern now offers more than thirty taps of a wide variety of interesting brews. In addition, Franklin is currently setting up a three-barrel brewing system in the old jailhouse behind the building. The old wooden boards of the Tavern definitely have seen their share of beery tales and will continue to do so.

Wet, Dry or Moist

Prohibition has lingered throughout North Carolina, in varying forms and under complex, confusing and even contradictory laws. In Western North Carolina, several counties are still dry, while most have some restrictions regarding alcohol sales. These "moist" counties include Buncombe County, which still has a Sunday blue law restricting all sales of alcohol from 2:00

a.m. until noon on the seventh day. Henderson County, just south of Buncombe and soon to be home to the second Sierra Nevada Brewery, only recently passed laws allowing beer to be sold at the place of manufacture (the brewery), as well as in unincorporated areas of the county. The owners of that county's first brewery, Southern Appalachian Brewing, helped spearhead a number of changes to laws in both the city of Hendersonville and the county in order to relocate its brewery there from Fletcher, North Carolina, in 2011.

The dividing line between "wet" and "dry" sometimes pitted neighbors against one another, as was the case in 1979 when Peabody's Discount Store began selling beer from its location at the junction of Buncombe and Madison Counties. At that time, beer sales were allowed in Buncombe, but not in Madison. A group from the nearby Forks of Ivy Baptist Church held a protest rally against the store's sales, but a number of students from Mars Hill College showed up to declare their support for the beer outlet on old U.S. Highway 19/23. The problem was that it wasn't clear whether the store was in Madison or Buncombe. The state had to appoint a boundary commission to determine where the county line in the disputed area lay. The commission, which consisted of two Buncombe men and one Madison resident, ultimately decided that the package store was in Buncombe—although barely. The county line was ruled to run through the store, but the package area was entirely inside Buncombe, while "an old garage-type addition to the building was found to be in Madison." Thus, the college students were able to continue to buy beer by driving across the county line.

It's been a long, slow recovery for beer in this country from the dark years of prohibition. And in the southern strongholds of Asheville and WNC, that recovery has been even slower than in many other places. Yet despite an unusually prolonged prohibition period, Asheville managed to evolve from a whiskey-sodden frontier town to Beer City, USA. Our beer now is better possibly because of the years of deprivation. After all, not all beer is great beer. Just because a beer is made locally by a small, traditional brewery doesn't mean it's great (or even good) beer. And I'm sure that was the case one hundred years ago as well.

Writers, Artists and Beer Drinkers

The inspirational natural beauty and relaxing atmosphere of the Paris of the South have long attracted creative types to the area. Many writers, artists and musicians have visited the region, and a goodly number of them have stayed on, especially since the city started to revitalize in the 1980s and '90s.

Even before that, though, George and Cornelia Vanderbilt brought many world-class artisans to help build and decorate Biltmore. Famous writer O. Henry lived in Asheville for a short time; after he died, he was buried at the town's Riverside Cemetery. Elsewhere in WNC, renowned schools for artists and freethinkers opened in the late 1920s and early '30s, including Black Mountain College and Penland School of Crafts.

So what does all this have to do with beer? For one, Asheville's most famous native, Thomas Wolfe, whose boyhood home draws tourists from all over the world, penned some scintillating prose about beer. Plus, one of most famous tourists to visit, F. Scott Fitzgerald, spent most of his time here drinking massive amounts of beer. Then there's the River Arts District, currently the working home to a few hundred artists and one brewery. It's soon to be the locale of another brewery (and a biggie), New Belgium Brewing. Affectionately called the RAD by locals, this part of town includes Depot Street, where Asheville's main train passenger station once stood. The nineteenth-century warehouses that stored the beer (as well as other goods) that arrived on the railroad now house artists' studios and Wedge Brewing Company. Read on, preferably while sipping on a Wedge Brewing or New Belgium craft beer.

ASHEVILLE'S NATIVE SON

There's no doubt that Thomas Wolfe is the most famous native Ashevillian and, in fact, one of the most well-known North Carolinians period. The great writer's story has been told in many other books already. But his relationship with beer, as far as I can parse it, hasn't been delved into deeply. That the man, like many writers both before him and after, had a complex relationship with alcoholic beverages can be assured.

In Wolfe's highly autobiographical *Look Homeward, Angel*, the character of Oliver Gant is based on Wolfe's father, W.O. Wolfe. The character struggles with alcohol abuse throughout his life, as did the elder Wolfe.

In the novel, just at the moment before meeting Eliza (his future wife), Oliver daydreams of beer: "He thought of the loamy black earth with its sudden young light of flowers, of the beaded chill of beer, and of the plumtree's dropping blossoms." If you're picking up on some pretty potent fertility symbolism in that snippet of prose, yes, I am too.

Later in the book, Wolfe described what likely was his own first taste of beer as a child. Eugene Gant, the character believed to be Wolfe himself, goes with his parents to a watering hole called "Delmar Gardens." He offers this gem of a description: "He gazed thirstily at the beaded foaming stein: he would thrust his face, he thought, in that chill foam and drink deep of happiness. Eliza gave him a taste; they all shrieked at his bitter surprised face…he wondered if all beer were bitter, if there were not a period of initiation into the pleasures of this great beverage."

Also in the novel, Wolfe describes Oliver as drunkenly threatening to kill wife Eliza. As F. Scott Fitzgerald would later learn, the real Mrs. Wolfe would not ever again suffer drunkards in her boardinghouse. Also of interest, Wolfe wrote a short story called "Child by Tiger," which likely was based on the murderous rampage of Will Harris that occurred in Asheville when Wolfe was an impressionable six-year-old and living mere blocks from the site of the murders.

In honor of Wolfe, brewer Gordon Kear and his business partner Ben Wiggins named their brewery in West Asheville Altamont Brewing Company. In *Look Homeward, Angel*, Wolfe's name for Asheville is Altamont. "We wanted a name and a logo that represents Asheville," Gordon said. "Plus there are great stories behind the name—from Thomas Wolfe to California. And the word sounds like the mountains. It literally means 'high mountains.'"

Author Thomas Wolfe stands in the doorway of his childhood home in 1937. This was his first visit to Asheville after the publication of his book *Look Homeward, Angel* in 1929. *North Carolina Collection, Pack Memorial Public Library, Asheville, North Carolina.*

Gordon recently returned to Asheville to start Altamont Brewing after living for several years in Flagstaff, Arizona. Thus, in some cases, you can go home again.

F. Scott Fitzgerald on Thirty Beers a Day

Possibly the most well-known writer to consume vast quantities of beer within Asheville's city limits was writer F. Scott Fitzgerald.

Fitzgerald lived in rooms 441 and 443 at the Grove Park Inn in north Asheville during the summer of 1935 and for several months in 1936. During his first summer here, his wife, Zelda, was being treated in a sanitarium in Baltimore, but the next summer, Fitzgerald brought his mentally unstable wife to Asheville and installed her in the nearby Highland Hospital, a well-regarded treatment facility in Montford.

Ostensibly, the famous writer was in town to escape mounting debt and the pressures of chasing critical and commercial success. However, it seems that mostly he was here to consume lots of beer and watch the comings and goings of female guests from the fourth-floor windows of the GPI.

Not long after arriving in town, Fitzgerald—searching for a restroom and "awash with beer"—stumbled into a small bookstore owned and operated by Tony Buttitta located in the Grove Arcade in downtown Asheville. The two formed a friendship, and Buttitta would eventually pen a memoir titled *After the Good Gay Times: Asheville—Summer of '35, a Season with F. Scott Fitzgerald*. From Buttitta's account, however, it doesn't sound like hanging with Fizty at that point in his life was a whole lot of fun. In fact, Fitzgerald's mercurial moods and heavy drinking dominated the friendship. Upon meeting Buttitta, the author admitted that he was inebriated, despite also being on the wagon. Apparently, for Fitzgerald, being on the wagon meant that, while abstaining from hard liquor, he allowed himself beer—and beer aplenty.

Buttitta, using the discarded bottles in Fitzgerald's hotel room for reference, estimated that Fitzgerald consumed up to thirty beers per day based on the cache of empties scattered there. What kind of beer he was imbibing is anyone's guess, though it can be assured that it wasn't particularly strong, as only beer up to 6 percent alcohol was legal at that time in North Carolina. Fitzgerald's secretary in 1936, Marie Shank, later wrote about Fitzgerald's rooms at the GPI, "I haven't ever, before or since, seen such quantities of beer displayed in such a place. Each trash basket was full of empties. So was

the tub in one of the baths. Stacks of cases served as tables for manuscripts, books, supplies of paper."

Unfortunately, she didn't mention what brand Fitzgerald preferred, though it likely was most any kind he could get his hands on. Despite being on the wagon, Fitzgerald was not always keen to stick with malt beverages, and he often sent Grove Park Inn employees to procure him bottles of gin and illicit Carolina moonshine. Toward the end of the summer, Fitzgerald's drinking became so disruptive that the manager instructed his employees to ignore the author's requests for anything stronger than beer or they would be fired. When Fitzgerald protested, citing the supposed medicinal qualities of gin as remedy for his ailing health, the manager held his ground, demanding a prescription from Fitzgerald's doctor before he lifted the booze embargo. Fitzgerald claimed that he was experiencing flare ups of his long-dormant tuberculosis, but Buttitta wrote, "I learned that the disease was more romantic and imaginary than real, and Fitzgerald had at times used it as a cover up for personal disaster, failure, or excessive drinking." Fitzgerald checked out of the Grove Park shortly after being cut off from his "medicinal" needs.

Though he had previously spent time in Lake Lure and at the Skyland Hotel in Hendersonville, North Carolina, Fitzgerald, with Buttitta accompanying him, then decided to inquire about a room at the boardinghouse owned by Thomas Wolfe's mother. Fitzgerald knew Wolfe personally, telling Buttitta, "Tom and I had a drinking bout in Switzerland when I was there watching over Zelda…Tom expected unqualified admiration for everything, something I couldn't give even to Ernest [Hemingway]." After giving the men a brief tour, however, Mrs. Wolfe, a notorious teetotaler who had been married to another famous alcoholic, realized that Fitzgerald was drunk, denied him a room and slammed the door in his face.

Despite this, Fitzgerald would show up one day at Asheville's Sondley Library, then in city hall, to scold the librarians for mistreating Thomas Wolfe and ignoring the importance of the book he had written about his hometown. (*Look Homeward, Angel* was banned in Asheville for seven years after its 1929 publication, mostly because the residents whom Wolfe had "fictionalized" in his book were none too happy about their portrayals therein.)

Fitzgerald left Asheville for a bit but returned and charmed his way back into the Grove Park. He then remained on his beer-only wagon for the duration of his stay. Buttitta's memoir paints a fairly sympathetic portrait of a tortured artist who produced more in the way of extramarital affairs and empty beer cans than short stories during the summer of 1935. Fitzy did pen

"Dixieland" was author Thomas Wolfe's fictional name for his childhood home, the boardinghouse Old Kentucky Home, while "Altamont" was his name for Asheville. Wolfe's mother once slammed the front door in F. Scott Fitzgerald's face when the drunken Fitzgerald asked to stay there. *North Carolina Collection, Pack Memorial Public Library, Asheville, North Carolina.*

a short story, appropriately titled "The Crack-Up," which was published in February 1936, and the next year, he worked on *The Last Tycoon*, his never-to-be-completed final novel, while at the GPI.

The notoriously private author granted an interview to the *Asheville Citizen-Times* in which he discussed the decreasing quality of the American novel and some of his own struggles with writing. The article describes "the distinguished vacationist" as "a prominent member of the summer colony at Grove Park Inn." Clearly, both times and newspaper writing have changed, as there's no mention of the shenanigans that Buttitta and others noted.

However, Fitzgerald's affinity for Asheville and the Blue Ridge Mountains was strong. After leaving Asheville, he spent several months in Tryon, North Carolina, living at Oak Hall, after which he set out for Hollywood to try to make a dent in his ever-growing debts.

Unknown to Fitzgerald, who died in 1940 of a heart attack, his decision to put Zelda in Highland Hospital was an ill-fated one. Though she left the hospital a few times for short periods, she died in a fire while locked in her room there on March 10, 1948. Eight other women died that night as well. She had left the hospital several times, sometimes for years and other times

only for months, but returned in 1947. Ultimately, Asheville was not a happy place for the Fitzgeralds.

Despite this rather melancholy tale, the Grove Park Inn Resort & Spa (as it later came to be called) collaborated with Asheville's oldest brewery, Highland Brewing, and launched a beer called GPI's Great Gatsby Abbey Beer in 2010. This beer is brewed on a contract basis at Highland but with a recipe developed over two and a half years by a team from the GPI, Highland Brewing and Skyland Distributing (Highland's local distributor), according to Chad Willis, beverage manager at the GPI. The abbey-style brown ale was initially brewed just for the hotel in kegs and bottles, but because of requests, it was later packaged and sold in twelve-packs around town. The tasting team may revamp the recipe to make the beer more accessible, said Chad. Locally brewed beer does seem a fitting tribute to Fitzgerald, although as the Abbey ale's ABV comes in at about 7 percent, it's probably not wise to drink more than a few a day, much less thirty.

BILTMORE BREWING: CEDRIC'S BEERS

Biltmore has put a big toe into the brewing business as well, again with help from Highland Brewing. Biltmore's Antler Hill Village, built in 2010, includes Cedric's Tavern, a gastropub featuring two Biltmore Brewing Company beers. The beers, an English-style pale ale and a traditional English brown, are only available on the estate, either on draft in the restaurants or as six-packs from the gift shops.

Biltmore teams with Highland Brewing in what's termed an alternating proprietorship (also called contract brewing). Biltmore staff designs the beer-taste profiles and oversees brewing of the beers while using Highland's brew house. Cedric's Tavern general manager Bryan McIntosh was instrumental in selecting the beer styles. "I wanted something that appeals to a lot of people but that's somewhat unique," he said. The beer styles chosen are very English, to reflect the heritage and tone of the estate. Cedric's beers may one day make their way into local specialty stores (as Biltmore wines have done), according to Bryan. More than one million tourists a year visit Biltmore.

"We're listening to feedback on these beers," said Chuck Whitehead, vice-president of sales for Biltmore Wine Company. "We have one of the best test

markets in the world." Oh, and Cedric was the Vanderbilt family's beloved St. Bernard dog, whose portrait graces the beer labels.

THE RIVER ARTS DISTRICT'S SUDSY EXPLOSION

You can't swing a cat in Asheville without hitting an artist, writer or musician—at least in this century. On any given afternoon, a goodly number of these creative types (including yours truly) can be found drinking craft beer at Wedge Brewing Company in Asheville's River Arts District. This area will soon see the addition of a second brewery when New Belgium Brewing Company starts building its second brewery just across the river from Wedge in 2014.

While there will be more about Wedge and New Belgium in later chapters, it seems fitting to end this one with a couple of notes about the importance of both beer and artists in the transition of this still slightly seedy, formerly mostly industrial part of town.

Asheville sculptor John Payne purchased the Wedge Building in 2001. The building became a haven for working artists and an important center for the local arts community. In early 2008, part of the lower level of the building became home to Wedge Brewing, after Wedge founder Tim Schaller and Payne spent many mornings discussing brewery plans over coffee at the Clingman Café. (Clingman is arguably the heart of the RAD, as well as one of the few places to get Wedge Brewing beer on draft outside its taproom.) Payne's sudden death soon after the Wedge's soft opening shook up both the district and the young brewery. In his honor, Tim named one of the first brews after Payne. Payne's Pale Ale remains one of the Wedge's year-round beers and a popular afternoon thirst quencher in the RAD.

"John had a hand in everything we did at first, because he was always here," Tim said. "He used to say, 'Everything's an opportunity. There's a simple way to do things, and then there's a way to do things in a way you'll be proud of them for a long time.' We've taken that to heart and kind of made it our motto."

Payne's memory lives on at the brewery not just via the beer named in his honor but through the unique metal sculptures that he built surrounding the brewery and its courtyard. "I opened my business in the River Arts District

The metallic sculptures surrounding the patio of Wedge Brewing Company were created by artist John Payne. Payne was instrumental in bringing the brewery to Asheville's River Arts District in 2008. *Photo by Anne Fitten Glenn.*

because it's funky and affordable for artists. I hope we can preserve this area and keep growing it as an arts district," Tim said.

Thus, Wedge Brewing has continued the tradition of naming beers after local community icons. Julian Price Pilsner is named for the deceased philanthropist credited with revitalizing downtown Asheville in the 1990s by investing and giving away millions of dollars. Price also helped get Jack of the Wood pub started, which would later become home to Green Man Brewery.

Most recently, Tim named Wedge's Raspberry Russian Imperial Stout in honor of deceased Asheville artist Vadim Bora. "Vadim was much more than an artist. He was an important part of the community," Tim said. "All these beers are an excuse to keep people talking about these guys who were so important to Asheville."

Writers and artists thus have shaped and influenced the beer scene in the region, and they will, I'm sure, continue to do so—with creativity and deep sips of locally made brew.

Thunder Road
Moonshine to Wholesalers

The sixty years from 1935 to 1993 were a fairly dull time for Asheville beer, even though prohibition was (mostly) over. While the previous sixty years had been a time of vibrant growth and change in the city, these years were fairly stagnant. For one, Asheville suffered greatly during the Great Depression and didn't claw its way out of its debt from the 1920s and '30s until 1976. The upside of the city's economic struggle was that the "revitalization" that had happened elsewhere, which often consisted of tearing down historic buildings and putting up steel and concrete skyscrapers in their place, didn't happen much in downtown Asheville (the BB&T building, completed in 1965, being one exception). While many of downtown's historic buildings were boarded up for years, most survived, slightly dilapidated, just waiting for a visionary bar or restaurant owner or retailer to renovate them to their former glory.

Moonshine continued to rule, and in fact, the height of still busting took place in the late 1950s. Moving alcoholic beverages evolved from the ridge runners with their souped-up cars (credited with birthing NASCAR) to refrigerated trucks owned by distributing companies, which often had to wend their way through dry counties or towns to deliver their goods. In fact, Asheville's first professional baseball team, founded in 1897, was called the Asheville Moonshiners. The team would be renamed the Asheville Tourists, however, in 1915, and remain the Tourists today.

The history of moonshine and the laws governing alcohol are jumbled up with the beer industry's growth, so a bit about both seems worth relating.

Certainly, having a culture where "making your own hooch" as a way of life has supported the culture of drinking locally, whether it be white lightning or Highland Gaelic Ale.

THE LONG ARM OF THE LEGISLATURE

The laws governing alcohol in North Carolina changed multiple times after the state finally decided to follow the nation and repeal prohibition in 1935. The General Assembly passed the Alcoholic Beverage Control statute in 1937, which allowed ABC stores to open. Even so, Asheville wouldn't approve ABC stores until a city-only vote in 1947, which overturned a countywide vote in '39. The sale of mixed drinks in restaurants and bars wasn't legalized in Asheville until 1979.

Within six weeks of the '47 vote, four ABC stores opened in the city, which "officially, had been 'dry' 40 years," per one newspaper account. I reckon that low alcohol beer (3.2 percent by weight, about 4 percent by volume), which had been legal since 1933, wasn't considered particularly intoxicating. North Carolina's ABC stores aren't allowed to sell beer anyway.

A 1950s-era wine and beer menu from Asheville's Sky Club, located on Beaucatcher Mountain, lists a variety of wines. However, under beer, there are only the words "Imports .75" and "American .50." Although restaurants couldn't serve liquor, patrons were allowed to bring their own bottles and pay a "storage fee" to leave them at the club.

The ABC system did bring in cash and a good bit of it, according to *Asheville Citizen-Times* reporter Bob Terrell. By 1970, the system had brought almost $13 million into city coffers and more than $4 million to the county in its twenty-six-year existence. "Before that, there were no liquor stores—at least no legal ones—in Asheville, but the boys who wanted it never had any trouble finding a bottle or two, or at least a fruit jar full," Terrell wrote.

Proponents of ABC stores promised that the stores would bring an end to bootlegging, which didn't happen. Because there was a federal tax of $10.50 on every gallon of liquor plus local taxes, moonshine, which was sold at about half that price, continued to flourish. In addition to the Sky Club, many Asheville establishments had a "bring your own" policy and would turn a blind eye to a mason jar being tipped under the table.

MOONSHINE DAYS (AND NIGHTS)

Moonshine production increased sharply during prohibition and continued to climb into the 1950s. A 1942 article in the *Asheville Citizen* explains, "Asheville housewives, limited to two-pound purchases of sugar, might well paraphrase the old song to 'That's where my sugar goes...'" The story goes on to say that sheriff's deputies found scores of empty sugar sacks at the sites of three captured stills. Sugar was being rationed because of scarcity during World War II, but neither rationing nor prohibition got in the way of moonshiners.

A 1974 article in the *Asheville Citizen* describes the first part of the whiskey-making process, noting, "The blockader lets the mash stand for a week or 10 days. It becomes beer. When the beer is working well, it is thinned down with water until it is about as thick as buttermilk." Then the beer goes into the still for the first distillation.

From the 1940s until the 1970s, the job of the law enforcement arm of the ABC (before it was renamed the Alcohol Law Enforcement Agency) mostly

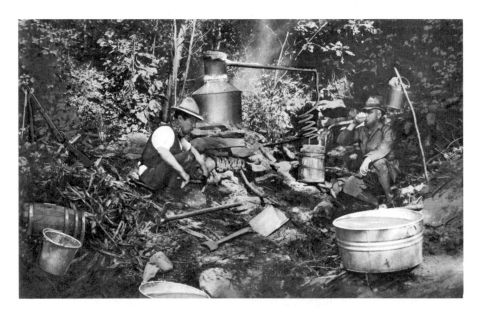

This postcard of men working a moonshine still in Western North Carolina was taken around 1930. It was probably posed as you can see the men's faces. The image is credited to Japanese-born photographer George Masa, who took a great many photos of the region between 1915 and 1933. *North Carolina Collection, Pack Memorial Public Library, Asheville, North Carolina.*

consisted of running around the mountains chopping up stills. Officer Al Dowtin spent twenty-five years as chief of the Asheville ABC system before retiring in 1973. Upon his retirement, he told the *Asheville Citizen-Times* that he took part in the capture of 6,463 "moonshiners and ridge runners in Western North Carolina and surrounding states" during his tenure.

In 1958, 105 illegal stills were destroyed in Buncombe County, while only 6 were "chopped up" in 1977. The year 1958 also saw the release of *Thunder Road*, a quasi-romantic movie portraying good-looking blockaders running from revenuers. Much of the movie, starring Robert Mitchum, was filmed in and around Asheville, including in the River Arts District. Wedge Brewing Company projects *Thunder Road* on the side of a delivery truck every summer to celebrate the brewery's birthday.

Though it was their job to break up stills, the local revenuers weren't without pity for the moonshiners. "People don't realize this was a matter of making money for these folks," said Charlie Giglia in 1975. He was an Asheville ABC law enforcer for twenty-eight years. "There'd be whole families working, fathers handing down the business to their sons. Nobody could get jobs back then. It was a good way to put food on the table."

Stills weren't just out in the woods either. A few illicit distilling operations were uncovered in homes in Asheville. One was busted in a basement on Chatham Road in north Asheville in the 1940s. In 1962, officers discovered a sixty-gallon still behind a wall panel at 6 Piedmont Place in north Asheville. "Officers theorized that someone had evacuated the area just ahead of the raid, since a bottle of cold beer was found on the basement steps," according to a newspaper report. The house's owner, Mrs. Shirley Higgins Hunt, was later arrested for possessing an unregistered distillery. Mrs. Hunt was the former owner of the Red Robin Tavern on Weaverville Highway. Supposedly, the officers discovered the still above the house because "the buzzards in the sky got so crocked they couldn't fly…from the intoxicating aroma arising" from "the joy-juice operation."

The production of moonshine fell off after the early 1960s for a number of reasons, two being that quality decreased and that drinking preferences started to shift from distilled beverages to beer and wine. Stills were destroyed as recently as 1987 in north Buncombe, though they were discovered while agents were searching for another illegal substance—marijuana. It's worth noting that a number of folks switched from making illicit booze to growing illicit weed in the '70s and '80s. Like moonshine before it, marijuana became a huge, though illegal, source of cash for people living in the hollers; they often planted on national forest land, which made it more difficult for law enforcement to trace.

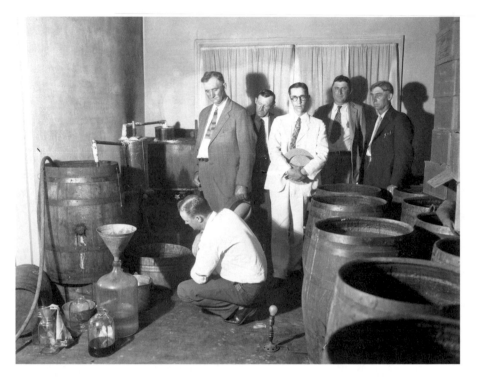

Sheriff and deputies busting a basement still in the 1940s at 166 Chatham Road in Asheville. The still's owner is the man in the black jacket. *E.M. Ball Photographic Collection (1918–1969), D.H. Ramsey Library, Special Collections, University of North Carolina at Asheville.*

After disabling one still in '87, agents left a cheery note that read, "Wish you better luck next year! Courtesy of the Metropolitan Enforcement Group, the county sheriff's department and the N.C. Alcohol Law Enforcement Agency."

Despite the fact that folks now can buy legal shine, the nontaxed trade survives (even though the legal stuff is often lower in alcohol content than the real McCoy). At most any (non-church) party around town, someone will produce a mason jar filled to the brim with the clear, searing liquid, often sweetened with a little sugar and lemon. Much of it is still made in the counties, some of which, such as Madison, were dry or are still mostly dry until fairly recently. Moonshine still provides income to some folks living in the mountains.

"Moonshining is an important part of our history," said Oscar Wong, founder and president of Highland Brewing Company, "and we must remember that making beer is a step in the distilling process. Although that beer isn't very drinkable." In honor of this history, Wong invested in

Asheville's first legal moonshine distillery, Troy & Sons, which opened in a building adjacent to Highland Brewing in 2011.

This isn't to say that alcohol doesn't wreck lives or present dangers, especially when it's used to flout the law. A 1976 story in the *Asheville Citizen-Times* relates that a grocery store owner on Merrimon Avenue had his employees destroy several thousand dollars worth of beer and wine one Thursday morning. "It almost ruined my life, and I decided I won't have any part in ruining other people's lives by selling it," said Gay M. Giezentanner, owner of the store, which was located at 219 Merrimon. He had his employees smash the beer and wine cans and bottles and dump them all into the garbage.

THE BEER WHOLESALERS

As elsewhere in the country in the post-prohibition years, distributing companies in WNC competed to become exclusive representatives for the few national beer brands that survived. As the number of breweries continued to decrease after World War II (hitting a low of forty-one in 1978), the remaining breweries rushed to fill the national void.

After prohibition, there are few advertisements for beer or beer businesses in the Asheville directories until the early 1950s. In 1953, an ad for Rock Haven Terrace on 1230 Haywood Road contains a drawing of Acme Pale Ale, which was brewed in San Francisco. A few local restaurant ads mention beer, although not many. It seems that temperance disapproval held sway for a long time.

Ads for distributors start appearing in the late '50s and '60s. In 1957, there's an ad for Skyway Distributors. Throughout the '60s, there are ads for Standard Beer Company, a distributor that sold Carling Black Label and Red Cap Ale "From the Brewery Next Door." This is likely a reference to Canada, where Carling Brewing Company was based, although most of the Carling beer distributed in the United States at that time was brewed in Cleveland, Ohio. Skyland Distributing Company started running ads soon after opening for business in south Asheville in 1965. Skyland still distributes in the area today and represents Highland Brewing Company.

In the '70s, beer distribution continued to increase. For the first time since the turn of the twentieth century, per capita U.S. beer consumption also

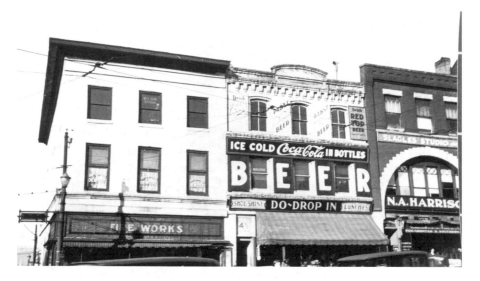

Pack Square North at the corner of Broadway soon after prohibition. Red Top Beer was brewed in Cincinnati, Ohio. *North Carolina Collection, Pack Memorial Public Library, Asheville, North Carolina.*

A Chevrolet truck used for Schlitz beer delivery in Asheville in 1939. *E.M. Ball Photographic Collection (1918–1969), D.H. Ramsey Library, Special Collections, University of North Carolina at Asheville.*

increased, to more than twenty-one gallons per year. In Asheville in the '70s, there were wholesale companies representing Pabst, Stroh's, Schlitz, Miller and Anheuser-Busch, according to Hubie Wood, owner of Budweiser of Asheville. However, at about the same time, beer drinkers started buying more imported beers. "Imports such as Heineken and Moosehead flooded the country," said Jerry Sigmon, Highland Brewing consultant and former distribution manager for Skyland Distributors. "Distributors were rushing to pick up imported brands, which were quickly becoming popular but didn't compete with their domestic brands."

Clearly, beer drinkers' tastes were beginning to change. Locally, Smoky Mountain Distributing had exclusive rights to distribute Schlitz in WNC for a number of years, while Budweiser of Asheville, obviously, had the same rights to Anheuser-Busch products; Skyland Distributing took care of Pabst.

In North Carolina, breweries that brew fewer than 25,000 barrels per year are allowed to self-distribute, which is different from many states that require all alcoholic beverages to be sold via a wholesaler. The three-tier system, where manufacturers must use a wholesaler to sell to retailers, can cost a pretty penny for small breweries starting out with minimal cash. That's one reason there are so many small breweries in the state (sixty-one at the time of publication). Not paying a middleman to distribute product can help the bottom line, especially at first.

In 1984, Anheuser-Busch helped finance Hubie to purchase the Budweiser of Asheville office he'd been managing since 1979. He was the first A-B employee to be financed in this way, he said. Thus, Bud of Asheville is independently owned by Hubie but still licensed to carry the Budweiser name. His son, Chad Wood, works for the business and plans to take over when his father retires.

In addition to selling beer, the local distributors spent time and money helping repeal blue laws in WNC. Most of the state west of Sylva and a good bit north of Asheville was still dry in the late '70s. "We would man the phone banks and call voters on election day," Hubie said. "We also put some money in to help publicize the votes. We were trying to get WNC as wet as we could. We continue to do so." Hubie said that his company helped with votes in Laurel Park, Hot Springs, Spruce Pine and Clay County, among other dry holdouts. "Our products are legal products. No one has to buy them if they don't want to."

Slowly, in the 1990s, distributors started picking up craft beer brands. That impetus was led locally by distributors that once had focused primarily on wine, such as Empire and Tryon, according to Jerry. Until about five

years ago, Budweiser of Asheville only represented A-B products, so while Budweiser came late to the party, Jerry said that InBev Anheuser-Busch and the Miller/Coors distributors now control most of the distribution of craft beer in this country.

"Craft beer became more and more popular, and we realized the market place was changing, and we needed to change to keep up," Hubie said. So Budweiser of Asheville started selling craft beer brands, such as Widmer Brothers of Oregon and Starr Hill of Virginia. But the company didn't initially represent any local brands.

Then in 2011, the wholesaler approached Asheville Brewing Company. "You'd have to have been under a rock not to embrace the whole local scene," Hubie said. ABC was in the process of installing a canning line and, after years of self-distribution, were ready for help.

"Initially, we were loath to work with a distributor," said Mike Rangel, president of Asheville Brewing. "But I wanted to focus on some of the fun, creative stuff instead of spending all my time running around selling and delivering beer."

Mike said that his restaurants stopped selling all Anheuser-Busch products several years ago when Budweiser of Asheville tried to become the sole beer retailer at Asheville's Bele Chere Festival, billed as the largest summer street festival in the Southeast. In response, Doug Beatty, then with Barley's Taproom, organized the A Taste of Asheville village, showcasing all local and independent restaurants and breweries.

When I asked Hubie about his company's sometimes combative relationship with local brewers, he laughed and said, "They give us fits in a lot of places, but we give them fits as well." In order to stay competitive, Hubie hired Mary Eliza McRae as the company's craft beer manager in 2011. McRae had previously worked for Highland Brewing and then Duck Rabbit Brewing, out of Farmville, North Carolina. The distributorship is now selling the heck out of Asheville Brewing Company's canned beers. Going with a distributor quadrupled ABC's accounts, and the brewery is having a hard time keeping up at present.

"I've seen a huge change in the product over the past several years," Hubie said. "There are many more competitors than in the past, and there are so many more styles and varieties of beer now. A lot more women are drinking beer now, too."

The distributor has been a longtime sponsor of many of Asheville's downtown festivals, including Bele Chere, Downtown After 5 and the Mountain Sports Festival. These days, however, you're more likely to see Bud

of Asheville trucks dispensing craft beers at these festivals than Budweiser, especially at the local-centric Downtown After 5 outdoor music festivals (held monthly from May to September).

A number of WNC breweries use local distributors to sell and deliver (most) of their beer, including Highland Brewing with Skyland Distributing, French Broad Brewing with Empire Distributors, Craggie Brewing with Tryon Distributing and Green Man Brewing and Nantahala Brewing with Next Generation Beer Company. Like Budweiser of Asheville, Next Generation is locally owned.

The business of transporting alcoholic beverages has definitely evolved—from horse-drawn wagons to train cars to souped-up Chevys to huge refrigerated trucks. Regardless, very few breweries could survive without a way to transport their product, whether they do it themselves or pay someone else to do so. So cheers to the folks who hump around all those kegs and cases so we can drink fresh craft beer.

The Brewvival Begins

Asheville experienced another Gay Nineties in the 1990s, only with local breweries opening in place of saloons.

We've seen that beer was being quaffed during Western North Carolina's first few hundred years of recorded history. Yet tales of moonshine and liquor overshadowed beer's story. In recent years, however, beer has eclipsed its stronger brethren. Thus, more than half of this book traces Asheville's twenty-year evolution from a craft beer wasteland to its prominence today as one of the most notable brewing centers in the country.

The first three Asheville brew daddies—Highland Brewing, Green Man Brewery and Asheville Brewing—all started brewing and selling beer in the 1990s, while Catawba Valley Brewing Company got going in tiny Glen Alpine, fifty miles east of Asheville, around the same time. The brewery that would become French Broad Brewing Company in 2001 started as the brewing operation for Green Man, so that brewery's story, too, has its genesis in the decade of fanny packs, Furbies, Viagra and award-winning Budweiser ads.

All of these entrepreneurial mavericks have scrappy stories of their early days jumping into the mash tun at the beginning of Asheville's brewvival, when any beer other than fizzy lager was suspect—and probably rightly so, at least at first; as any brewer will tell you, brewing five gallons at a time at home is different from doing the same on a seven or ten-barrel system.

To their credit, all five of these breweries are not only still standing but also have grown, and all have plans to continue to do so. They're all making damn fine beer. There was, however, one brewery that got started out in

One of two bottling lines at Highland Brewing Company in Asheville. *Courtesy of Highland Brewing Company.*

the country while most of the Asheville breweries were just gleams in their owners' eyes.

WESTERN NORTH CAROLINA'S FIRST

The first licensed brewery in WNC got its start near Waynesville, North Carolina, about thirty miles west of Asheville. In 1993, Rich and Gloria Prochaska and Gloria's brother, Matt Hunt, started Smoky Mountain Brewery in the one-thousand-square-foot basement of the Prochaskas' home. The trio spent a few years perfecting their beer recipes on home brew equipment and applying for licenses.

"It took a while," Rich said. "There weren't many breweries in North Carolina then, so we had to teach the state about what we were doing to get our permit."

In the spring of 1993, the brewery started selling its India Red Amber, named for the Prochaskas' daughter, India, in shops and bars around Asheville and Waynesville. It was more of a pale ale than an amber, wrote "Beer Guy" Tony Kiss in an *Asheville Citizen-Times* article. Regardless of its style, it was the first legal craft beer sold in Western North Carolina. The brewery later added Lionheart Stout and Kid Notorious Apricot Ale to its lineup.

Rich said that the brewers used malt extract, brewed in thirty-gallon vats and hand-bottled their beers. They never moved past the home brew equipment stage, not even to a SABCO Brew-Magic system, with which so many other local breweries have started (and a few still use exclusively). Even so, after a few years, Smoky Mountain Brewery was selling up to one thousand cases per month plus kegs throughout North Carolina and just across the state border in Virginia. The brewers did some self-distribution but also used distributors. "We had to educate them too, though," Rich said. "Yeast on the bottom of the bottle was a toughie." The brewery closed in early 1995, noted Rich, because "while we had a great time, it was tons of hard work, and we were ready to move on."

Rich then opened a wine shop in Waynesville and currently co-owns Vino de Vaso Wine Market, which sells closeout wines in Arden, North Carolina. His brother-in-law and former partner in brewing, Matt, now works at the Grove Park Spa & Resort. There currently are four Smoky Mountain Brewery brewpubs operating in east Tennessee, though that company has no relation to Haywood County's first brewery.

In a fun historic moment, Tipping Point Brewing in Waynesville served its first in-house brewed beer, an amber, in the summer of 2012, using one of Smoky Mountain's old kegs. Tipping Point co-owner Jon Bowman and Rich are old friends. "We weren't much, but we were the first brewery in the area," Rich said. "It was a blast."

ASHEVILLE'S FIRST: HIGHLAND BREWING

Not long after Smoky Mountain started up, a retired nuclear engineer with a second home in Asheville and a long-term interest in brewing stepped in to fill Asheville's craft brewery hole. And while it took about eight years for that brewery, Highland Brewing Company, to turn a profit, the brewery held the title of largest craft brewery in North Carolina for many years (until the

Oscar Wong, founder and president of Highland Brewing Company. *Courtesy of Highland Brewing.*

end of 2012, in fact, when Oscar Blues Brewery opened a facility in Brevard, North Carolina).

The granddaddy of Asheville brewing, Oscar Wong, started his career in beer by dumping thousands of gallons of the stuff into the city's sewers. The first three batches he and original brewer John McDermott brewed in the basement of Barley's Pizzeria and Taproom on Biltmore Avenue in 1994 were drinkable, Oscar said, but they weren't great. But the twosome finally got it right with their Celtic Ale, an amber that was later renamed Gaelic Ale and remains the brewery's best-selling beer.

As the years have gone by, Oscar said, "We pour less and less beer into the city's sewers." He emphasized that he doesn't have a problem doing so if necessary, however. "When something's wrong, we stop the line—we dump the beer. We're building a brand, and when the beer goes out the door, we need to be comfortable that it's great beer."

Tony Kiss was shopping in 1993 at Asheville's Weinhaus Wine Market, which at that time was one of the only places in town where folks could

buy a craft beer or two (the Weinhaus opened in 1977 on Patton Avenue downtown). According to Tony, Weinhaus owner Dave Mallett said, "Hey, Tony, I want you to meet this guy who's going to open a brewery here." Tony said he shook Oscar's hand and said, "God bless you, man."

Oscar is of Chinese descent but was born and raised in Jamaica. He jokingly claims he was weaned on Red Stripe Lager. Actually, per Chinese custom, he drank his first beer at a Sunday family dinner when he was seven or eight years old. For graduate school, Oscar attended Notre Dame in Indiana, where one of the college's custodians gave him and his roommate a home brew. The students asked for a copy of the beer recipe and set out to buy home brewing supplies that night.

"We had no hops, so the result was a kind of Champale," Oscar said. "We called it Tiger Paws after an old Exxon ad because it 'Put a Tiger in your Tank.'"

After graduate school, Oscar spent twenty-seven years working as a nuclear waste engineer in Charlotte, North Carolina, and beer appreciation became a sideline. He sold his engineering firm in 1990 and "retired." "I was driving my wife crazy. I needed a hobby and to get out of the house," he said. When Oscar met award-winning brewer John McDermott, history was in the making. John had been working at Dilworth Brewery in Charlotte but wanted to start his own brewery. The two decided to go into the brewing business together, but only if John agreed to do so in Asheville, where Oscar and wife Anna had a second home. "I didn't realize at that time that I was starting a whole second career," Oscar said.

Oscar and John leased the basement space on Biltmore Avenue, managed to get permits and cobbled together a brew house out of old dairy equipment. As was the case for Smoky Mountain, getting the state to understand what they were doing and issue permits was a challenge. But after some persuasion and lots of cleaning in the dusty basement, Highland became Asheville's first legal brewery. The name Highland was chosen to honor the Scottish heritage of the area. "The Scots have a history of making booze, and they have a history of making it here," Oscar said.

Asheville native and avid home brewer John Lyda was there the day they turned on the brew house and later became Highland's first employee. Tony Kiss was there as well. "I just happened to be there. I guess I'm the Forrest Gump of Asheville beer," he said, laughing.

"I kept stopping by after reading they were opening up a brewery and pestered them to hire me," Lyda said. "John 'hired' me in the summer of '94 as an unpaid intern, which I was more than happy to do as I needed three years professional experience in order to be accepted to the diploma

program at Siebel's. The unpaid gig went on for several months until Oscar got wind of it and started paying me."

While Lyda was off completing his brewing degree at Siebel Institute of Technology and World Brewing Academy in Chicago, Oscar and John McDermott were struggling to produce consistent beer. "John was an amazing brewer, but he liked to change the recipes," Oscar said. "At that time, we needed consistent, recognizable, quality beers. Now that the customer is more educated, they'll drink experimental beers, but not so much back then."

When Lyda returned to Asheville, Oscar asked him to become Highland's head brewer, a position he still holds, in addition to being the company's vice-president. The two bought out McDermott in 1997. "The plan after graduating from Siebel was to open up a cinema and brew pub at the exact location of Two Moons Brew & View, and I was extremely disappointed when I got back and plans were already underway to do just that," Lyda said. "But Oscar is a real joy to work with and for. He is a wonderful mentor and friend. I am very proud of the team that has made all this possible. Granted, it hasn't always been an easy ride and we still have our occasional hiccups, but that's what makes this business so interesting."

After eight years of plowing cash into the business with no return, Anna said to her husband, "I know you're having a lot of fun, but you can't afford to keep having so much fun." So, Oscar brought in three investors: real estate investor Jay Stewart; Frank Smith, owner of Hunter Banks Fly Fishing Shop; and Rick Eckerd of Eckerd Drug Stores. With the investors' help, the brewery was able to move from the downtown basement to the former home of Blue Ridge Motion Pictures, just a few miles east of downtown. Stewart still owns the building that housed Highland's first brewery, as well as the building where Pisgah Brewing Company opened in 2005. "Even though Jay no longer drinks, he's been a big benefactor to Asheville beer," Oscar said.

Until 1998, Highland beers were available only in kegs and hand-filled twenty-two-ounce bottles. Highland employees still fill liter bottles by hand today, but that year, the business added a bottling line and started packaging in twelve-ounce bottles, making Highland one of the first North Carolina breweries to do so. In 2002, a second used bottling line was installed, capable of filling 7,200 twelve-ounce bottles per hour. "I was initially reluctant to bottle," Oscar said, "but it seemed like the right thing to do at the time."

Highland maxed out at 6,500 barrels of beer in 2005 in its first home, but the company has seen steady production increases since moving to the huge warehouse, producing 23,000 barrels in 2011. The current 50-barrel brew house has a capacity of 30,000 barrels per year.

Moving one of Highland Brewing's early tanks out of the basement on Biltmore Avenue, where the brewery started. *Courtesy of Highland Brewing.*

During the move to the new brewery, which took several months, Highland brewed at Frederick Brewing Company in Maryland (now Flying Dog Brewery). "I was reluctant to contract out our brewing, but moving from the original space to the new, it was critical that we got it right," Oscar said. "Contracting temporarily allowed us to increase production and make sure we had time to get everything set up correctly here."

He noted that Lyda made frequent trips to Frederick to oversee the brewing of Highland's beers. The labels from those months in 2005 and 2006 read, "Brewed and bottled for Highland Brewing Company in Frederick, Maryland."

Oscar has two daughters, both of whom have been involved in the business at one time or another. He recently persuaded daughter Leah Wong Ashburn to leave her job with a yearbook company in Charlotte and become a full-time sales representative with Highland. His goal is to let her take the reins of the business as soon as they are both ready, although she said that her dad is showing no signs of slowing down. "I have big shoes to fill," Leah noted. "Being one of a few female brewery owners is very exciting. I often say, 'I'm so glad he didn't start a sock factory.'"

Highland offers several year-round beers and a number of seasonals. The Gaelic Ale continues to be one of the best-selling North Carolina–made beers in the state, and the Cold Mountain Winter Ale reigns as the best-selling seasonal. The brew initially was called Holiday Ale, then Winter Ale and then Cold Mountain, after the nearby peak. When the movie *Cold Mountain* (based on the Charles Frazier book of the same name) was released, it "gave us a jolt" in sales, Oscar said. Since then, Highland has started a tradition of naming its seasonal beers after local mountains, such as Little Hump Spring Ale and Clawhammer Oktoberfest.

The highly sought-after spiced Cold Mountain takes eight weeks to make, and the flavorings used change slightly from year to year but typically include vanilla, cinnamon, hazelnut and some kind of fruit, such as cranberry. "We can't afford to tie the tanks up for longer to make more," Oscar said. "It's never quite enough, but if it's hard to get, you gotta have it. We continue to try to make more each year, though."

Highland added a large new taproom in 2010 and a separate three-barrel experimental pilot system for the company's brewers to play with. Those small-batch beers typically are for sale in the taproom only. The

The one-liter bottles of Highland Brewing's seasonal Cold Mountain Ale are still bottled by hand. *Photo by Anne Fitten Glenn.*

Thunderstruck Coffee Porter, made with locally roasted coffee from Dynamite Roasting Company in Black Mountain, was born on the pilot system, but its popularity pushed it to seasonal status.

Thus, Asheville's first brewery has grown and, per Oscar, will continue to do so. The current location offers thousands of extra square feet to expand into as needed. Currently, the Highland brand is the most widely distributed WNC beer. It's sold in Alabama, Florida, Georgia, North Carolina, South Carolina, Tennessee and Virginia.

In 2012, the U.S. Small Business Administration honored Oscar as North Carolina's Small Business Person of the Year. It's been quite the journey for the former engineer who started Asheville's first brewery.

GREEN MAN BREWERY

At the end of a long day working in Laughing Seed Restaurant, Joe Eckert used to escape to the basement level of the restaurant with a few bottles of beer. He'd sit in the dirty, empty space under the room's only light bulb and try to relax. One day, he thought, "There should be a pub here." Thus, Jack of the Wood was born.

Joe and former wife Joan Cliney-Eckert opened Laughing Seed, Asheville's renowned vegetarian restaurant, in 1993. The couple had moved their family from an area of Philadelphia called Brewery Town to a farm in Madison County. The Seed started as a lunch counter at Asheville's YMCA and then was moved to its current location on Wall Street. At the time, the building was boarded up.

Once Joe had his light bulb–enhanced flash of inspiration, he started talking to Asheville philanthropist Julian Price, who at that time was operating a reading room in what is now the Seed's back dining room. Price liked the idea and was willing to invest in it, so the two started throwing around ideas. Joe said that he and his wife were "into the myth of the Green Man," an ancient Celtic spirit of the forest. Plus Joe has Irish roots, so an Irish pub seemed natural, especially as many of Asheville's early saloons were Irish-owned and managed. However, Joe said that although there weren't many businesses downtown at that time, several had primary colors in their names. So the Eckerts decided to use Jack of the Wood, a name synonymous with Green Man, and opened the pub in 1997. Soon after, they'd find a use for the name "Green Man" as well.

Green Man Brewery's Oktoberfest team members masquerade as their brewery's mascot. *Photo by Anne Fitten Glenn.*

Brewing wasn't initially part of the plan. At first, Jack of the Wood operated as a simple traditional Irish pub. Soon after opening, the business that's now City Bakery started baking in what's now the pub's kitchen, mostly to supply bread for Laughing Seed. One day, the baker told Joe that her boyfriend was a brewer in Atlanta, and another idea was born. "Everything I've done, I've done from necessity. You need fresh bread, you make it. You need fresh beer, you make it," Joe said. That's how Jonas Rembert, then the baker's boyfriend, started as Green Man's first brewer.

The Eckerts decided to use the Green Man name for the brewing arm of the operation. In hindsight, this was a wise decision, as it made selling the brewery less complicated, which the Eckerts did in 2010. Green Man beers are still the house brews at Jack of the Wood, along with an ever-changing selection of regional and national craft beers. But we'll get to the changing of hands soon enough.

As was the case for Highland and many other small breweries that started in the '90s, the first Green Man brew house was cobbled together using former dairy equipment. Jonas and Andy Dahm, owner of home brew store Asheville Brewers Supply, set up a seven-barrel brewery using old dairy tanks. The first beer was Green Man Gold, a blonde ale. Rembert would

Exterior of Jack of the Wood Pub during Asheville's annual Bele Chere street festival. *Photo by Anne Fitten Glenn.*

brew a double batch daily just to keep up with the pub and to send a keg or two upstairs to the Seed. The beer was pumped directly from the brew house, which was where the dartboards are now, to the taps. Joe said that the draft lines were about ninety feet long and a pain to clean.

Jonas left Green Man in 2001 to start French Broad Brewing with Andy. The next Green Man brewer was Mike Duffy, who had brewed for Harpoon Brewery in Boston. He didn't stick around for long. Next in line for the brewer position was Ben Pierson, who'd later helm the brewery at Lexington Avenue Brewery. He'd hold the position twice. "My first brewing gig in Asheville was with Green Man when it was still in the pub," said Pierson. "I was replaced in favor of a brewer from the Triumph Brewpub, in Princeton, New Jersey. Tom Stevenson lasted about two months. I was rehired, finished the reinstall to Green Man's current location and once again assumed brewmaster duties. Two years later, I was again replaced by Carl Melissas."

As Pierson noted, after having outgrown the back of Jack of the Wood, the brewery needed to move. Green Man Brewery moved to a warehouse on Buxton Avenue in 2005. Locals affectionately called the new taproom Dirty Jack's.

Carl had been brewing for Bullfrog Brewery in Philadelphia, but he wasn't happy, so he put his resume out there and Joe responded. Carl moved his wife and three kids down here and starting shaking things up at Green Man.

Dennis Thies, owner of Green Man Brewery since 2010, at Asheville's Beer City Festival. *Photo by Anne Fitten Glenn.*

"It was tough there for a while," Carl said. "I was working seventy-hour weeks, and some people who worked at Jack were angry that I'd replaced Ben. But I was really excited to be brewing in Asheville."

Carl had previously won silver and gold medals at the World Beer Cup for two of his Belgian beers and admits that focusing primarily on Green Man's English-style ales was tough for him. "Carl has a really good sense of balance. He's great with small batches, but it was clear he didn't always want to brew the beers I wanted him to," Joe said.

Carl noted, "I turned the Green Man Gold into a pilsner, and there was some friction over that." Carl and Joe continued to have conflicts over the next few years, and that relationship ended, rather famously, after a public brawl between the two at Dirty Jack's in 2007. However, all publicity is good publicity, and the incident only seemed to increase the maverick mystique of both men. "Joe's kind of a rogue, but that's okay," said Carl, smiling.

In the meantime, Carl had met Tim Schaller, who would become head brewer for Wedge Brewing several months later (yes, brewing jobs in this

town are like a game of musical chairs). After Carl left, John Stuart took over and remains Green Man's head brewer. The Eckerts sold the brewery in 2010 to Dennis Thies, a Floridian who grew up working in his family's beer distributorship.

After his family sold their Florida-based business, Dennis decided to move his wife and four children to Asheville. He spent a year working as marketing manager for Highland Brewing. One day, Dennis was having lunch with Jimi Rentz, owner of Barley's Pizzeria & Taproom. He was throwing around ideas for starting a distributorship when Jimi asked, "Have you considered buying a brewery? How about Green Man?"

So Dennis went by Dirty Jack's for a beer. "I thought, 'This is cool. Maybe I would like to own a brewery,'" he said. As it turned out, the Eckerts were interested in selling. The results of having sole ownership of a brewery, Dennis noted, have been lots of broken bones (fingers, toe and collarbone), lots of cash poured into the business and a lot of beers that he's extremely proud of. "I push our brewers," he said. "I always say, 'Let's take what we've got but give me more color, more flavor, more balance.'"

Thies has expanded the brewery a few times, adding a number of tanks. He's also started distributing Green Man beers within a 150-mile radius of Asheville. In the summer of 2012, Thies purchased the warehouse next door to the brewery and a thirty-barrel brew house to go inside it. The new space will house the new brewing system, offices and another tasting area. In an ideal world, the new brewery will be up and running by the end of 2012. The system will triple the capacity of the current fourteen-barrel brew house, which is on track to brew two thousand barrels in 2012.

"It's really humbling," Dennis said. "I'm thankful that people want to buy our beer." When he purchased Green Man, the beer was only being sold at the brewery and at Jack of the Wood. He also plans to add a packaging line for twelve-ounce bottles in the future.

Improvements to Dirty Jack's, which isn't so dirty these days, are also in the plans. The taproom has become the heart of the area's adult soccer league and the place to watch any and all international footballing on the big screen.

Green Man currently has a regular lineup of an IPA, a pale, a porter and an ESB, plus a rotating number of special releases and seasonals. "The Dweller" Imperial Stout was the first Green Man beer to be bottled in late 2011, by hand, in a limited number of twenty-two-ounce bottles. John said that one of his favorites is the Green Man Porter, "I've brewed that recipe for porter for about fifteen years, and I just never get tired of it." John brewed

at a variety of brewpubs around the Southeast and attended Siebel Institute before taking the Green Man position in 2007.

The taproom also regularly offers a cask beer plus a number of interesting creations, often dreamed up and brewed by avid assistant brewer Mike Karnowski. Mike also organizes in-house beer festivals, such as a strong ale fest and a session beer fest. He invites local home brewers to brew at Green Man and then includes their beers in the festivals, which always draw a crowd.

Dennis also has kept a hand in the distribution business. His wife, Wendy Metcalf Thies, owns Next Generation Beer Company, located conveniently in a warehouse one block away from Green Man and managed by Dennis. The wholesaler only sells craft and specialty imported beers and currently represents more than twenty breweries, including Green Man.

"Green Man is my baby," Dennis said. "I want to keep the baby in the family, not put it into foster care with another distributorship."

ASHEVILLE BREWING COMPANY

One of the more brilliant business mash-ups in the Asheville area is the combination second-run movie theater, pizza joint and brewery that became Asheville Pizza & Brewing Company. Handmade pizza and craft beer and cheap movies go together like, well, hops and barley and yeast.

The business got its start in 1998 as Two Moons Brew 'n' View with brewer Doug Riley at the helm. Riley remains head brewer, although as the business has expanded to two brewing locales and added a canning line, he now manages four assistant brewers.

A family-owned company out of Portland, Oregon, started the Brew 'n' View. Despite the seemingly good idea, in its first year the business lost thousands of dollars per week, mostly through mismanagement, according to Mike Rangel, now Asheville Brewing Company president and co-owner. The Brew 'n' View owners originally hired Mike as a restaurant business consultant, to either help sell the place or close it. He ended up buying the business with then spouse Leigh Rangel (now Leigh Lewis). The new owners kept brewer Doug Riley, who was already making beers in a room behind the bar that is basically the size of a walk-in closet.

"Doug was in the back scrubbing tanks, but the rest of the place was the Wild, Wild West," Mike said. The Rangels had opened a small pizza place

Doug Riley, Asheville Brewing Company's head brewer, in the original brewing space at the Merrimon Avenue location in 2009. That brewery is now mostly used for experimental and special-release beers. *Photo by Anne Fitten Glenn.*

farther north on Merrimon Avenue and were doing fairly well with that business, but they decided to take a risk and incorporate their pizza into the existing movie house and brewery space. "About the only thing this place had going for it then was a good brewer and good beer," Mike said. "We joked about making a T-shirt that said, 'The beer's so good, you'll forget how bad the service is.'"

The Rangels and Doug put up their homes as collateral to secure a loan for the business. They made an offer on Christmas Day and closed on New Year's Eve, less than a year after the Brew 'n' View first opened. After a mega cleanup of the space and a bit of renovation, the business reopened on January 20, 1999, as Asheville Pizza & Brewing Company.

A month later, as the Rangels were working ninety-hour weeks, Leigh discovered that she was pregnant. Soon after that, the building's HVAC system broke down. In a testament to the camaraderie between local breweries, Scott Pyatt of Catawba Brewing, John Lyda of Highland and Jonas Rembert of Green Man heard about the power loss and showed up with glycol to keep Asheville Brewing's beer cool. "We had three batches in the tanks," Mike said. "They saved our butts."

To raise money, Mike organized a fundraiser he called Heat Aid. Heat Aid probably would've failed miserably, he said, except that one well-heeled patron came in and said, "Hey, I'll give you $20,000 if you buy a new popcorn machine." Mike agreed and quickly purchased both a new HVAC system and a new popcorn machine.

Early beers at ABC included the Shiva IPA, Roland's ESB, Rook Porter (now Ninja Porter), Houdini Pale (now Escape Artist Pale), J.T.'s Oatmeal Stout and Pisgah Pale. The hoppy Shiva continues to be one of the brewery's best-selling beers, especially since it was introduced in cans in December 2011. The other beers continue to be brewed, except for the Pisgah Pale. Both J.T.'s and the Pisgah have interesting backstories.

On Mike's first day consulting at the Brew 'n' View, he spent a good part of the day hanging out with a bartender named Jason Taylor, who was much loved by staff and customers. Rangel stayed up late that night with a group of Brew 'n' View employees, including the guy everyone called J.T. The next morning, Rangel showed up, bleary-eyed, to continue his consulting with the failing business. He found shocked staff wandering aimlessly around the restaurant. After the previous night's festivities, J.T. had gone home and, handling a gun, had accidentally shot and killed himself. The oatmeal stout was thereafter named in his honor and is brewed once a year by his friend, Doug Riley.

If you're a regular WNC beer drinker, you might be surprised to learn that ABC brewed the region's first Pisgah Pale. After all, that's been the flagship beer of Pisgah Brewing Company since that brewery opened in 2005.

When ABC couldn't find Centennial hops at one point, Doug stopped brewing his Pisgah Pale, named for nearby Mount Pisgah. Supposedly, there was some heated debate between ABC and Pisgah when Pisgah started using the name, but the "he said/he said" of that conflict isn't particularly noteworthy. Rangel said that he didn't mind losing the name. "I thought it was a boring name anyway. Not very sexy." More interesting is that the conflict over the beer name ultimately resulted in the creation of the Asheville Brewers Alliance. After the brouhaha, Mike said that he starting talking with John Lyda about forming an alliance as a way for local brewers to work together more consistently and, hopefully, with fewer competitive conflicts and more shared opportunities.

"The brewing market was starting to get crowded," Rangel said. "We weren't Beer City yet, but we could see beer tourism on the horizon. And we knew that it would be good for all of us." Thus, the Asheville Brewers Alliance was formed in 2009, but more about that later, as this is still ABC's tale.

Over the years, various ABC employees have bought into the business, and the growing group of partners opened a second location on Coxe Avenue downtown in 2006, called just Asheville Brewing Company. That location still offers pizza and other menu items but no movies. Most importantly, there's a full second brewery in the back of the Coxe Avenue brewpub, which hugely expanded the company's brewing capacity.

Soon after opening the second location, ABC was ready to start selling its beer to other restaurants and bars. The brewery started distributing kegs throughout the region and some twenty-two-ounce bottles elsewhere in the state. Owning the name Asheville Brewing, especially once the Asheville beer scene exploded, was a coup for sure. That said, Mike has been known to change beer names on a whim. The Rook Porter now goes by the moniker Ninja Porter, while ABC's brown ale has had multiple names, from Scottish Ale to Boogie Down Brown to the current Stuntman Brown, which was named via a contest I ran on my Brewgasm website. Most every week, ABC's Coxe Avenue location offers an infuser night—running one of their beers through an interesting blend of fresh ingredients—such as fresh strawberries or mint. Those beers are named each week via a contest on the brewery's Facebook page, and vying for naming rights and an ABC T-shirt can be fierce.

One of the more intriguing ABC beer name changes occurred when the brewery dabbled with selling its beers in Tennessee. One of its flagships

was called Houdini Pale Ale after, obviously, the famous magician. Mike recognized that he might have a trademark issue on his hands. So he contacted the Houdini family, who had indeed registered the name for commercial use. He talked to the escape artist's great-niece, who told him that she didn't mind him using the name provided the beer wasn't sold across state lines, as that would be an interstate trademark infringement. Selling Houdini Pale in Tennessee would cost ABC $60,000 in licensing fees. Thus, Houdini was reborn as the Escape Artist. That turned out to be a lucky turn of events when Doug added jalapenos to the pale ale to produce a spicy brew. The obvious name for that beer? Fire Escape.

In late 2011, ABC became the first WNC brewery to add a canning line. The brewery also purchased enough tanks to triple its capacity and signed a distribution deal with Budweiser of Asheville. The first canned beers to roll off the line were the Shiva IPA and Rocket Girl Lager. The Ninja Porter will be available in cans in 2012. "We decided to go with cans instead of bottles for a lot of really groovy reasons," Rangel said. "It's both an environmental and a business decision." Cans are made from 100 percent recyclable materials and are less expensive to make than glass bottles. Also, Mike cited Asheville's love of outdoor recreation as a good reason to sell beer in shatterproof containers. "It's a way to differentiate ourselves in a crowded local craft beer market," he noted.

In 2011, Asheville Brewing Company produced about 1,300 barrels. The brewery may make it to what Mike called "the magic 5,000" in 2012. It will continue to make beer in both Asheville locations, but the smaller space on Merrimon Avenue will be reserved for more experimental special-release brews.

After years of producing basically the same lineup of eight brews week in and week out, ABC started getting funky in 2012. "I want to be the Pizza Port of Asheville," said Mike, referring to the famous award-winning pizza pub and brewery that has three locations in California.

ABC plans to allow each assistant brewer create up to four different beers a year, plus there will be new creations from Riley. Some of the beers released so far have included a rye pale, Samurye, a hoppy IPA (called IPA the Fool) and a wheat ale called District 12, after the Appalachian district and home of main character Katniss Everdeen in *The Hunger Games* book trilogy (and the movie of the same name that was filmed near Asheville).

"Experimentation makes these guys more creative," Mike said. "And we want to improve our beers constantly, even the ones we've been brewing here since 1997."

FRENCH BROAD BREWING COMPANY

French Broad Brewing has almost as many twists and turns to its story as the river for which it is named. That river flows through the middle of Asheville. One of the oldest rivers in the world, it has the added distinction of flowing in a northwesterly direction, which, combined with the city's winding mountain roads, can be mighty confusing for folks trying to find their way around. The brewery sits fairly close by the river, near Biltmore Village, in an area of town that has seen a number of significant floods, especially in 1916 and 2004.

After about thirty months of brewing for Green Man in the back of Jack of the Wood, Jonas Rembert and Andy Dahm sold out to the Eckerts, and the business partners signed a lease on the building that still houses French Broad Brewing on Fairview Road. That was in 2001. "We opened broke, and we've pretty much been broke ever since. But seven years ago, we were not making very good beer. Now we're making good beer," Andy said, taking a sip of his Gateway Kolsch.

In order to stay in business, French Broad has taken on investors and now can lay claim, like Asheville Brewing, to being a cooperative brewery. Currently, twenty-two shareholders own a piece of the business, including Andy, although there are only five voting members.

The company opened a tasting room "as soon as it was legal," Andy said. That happened in 2004, and the taproom has become a popular drinking destination, open six days a week. The small stage in front of the tanks offers live music anywhere from four to six nights a week.

A couple of years after opening the new brewery, Andy left, citing a variety of reasons. "There are lots of personalities in beer right here in this town," he said, smiling enigmatically. "I've gotten into arguments, but I've never burned bridges." Andy opened and ran a small beer distribution company in Tennessee for almost six years, but he returned and took the helm as French Broad's general manager in 2006. Throughout, he has continued to own and manage Asheville Brewers Supply, a home brew store that he opened in 1994. Jonas left French Broad several months after Andy returned to the brewery. He now lives in Taiwan, where he teaches English as a second language, although he remains one of the brewery owners.

Drew Barton came in as head brewer after Jonas left and stuck with French Broad for a little more than a year before moving back to his hometown of Memphis. Three brewers produced about five thousand

Drew Barton, former brewer at French Broad Brewing, under the brewery's tanks. *Photo by Anne Fitten Glenn.*

barrels in 2011: Chris Richards, who took over for Barton; Aaron Wilson; and John Silver. Silver had previously brewed for Catawba Valley and Pisgah Brewing. The year 2011 saw an almost 50 percent increase in brewing volume for French Broad from the previous year. Plans are also in the works to expand the tiny taproom.

That said, Andy stressed that the brewery pays a living wage and offers health insurance after a year of full-time employment. "We still dump beer. Anyone can talk themselves into selling beer that's in the tanks, even if it's not good. No one wants to pour money down the drain. But we still dump beer if it's no good. Highland does, too. More breweries should," he said. "It's a very interesting time for this business," he added. "Right now, we're feeling good about having a good product and enough kegs to fill."

French Broad has been distributing beer outside the state for a few years, although the company still self-distributes in Asheville, where most of its beer is sold. French Broad beer is sold in kegs and twenty-two-ounce bottles in four states, but Andy said that he wants to open up some new markets soon.

Early on, French Broad's Golden Rod Pilsner was one of the brewery's most popular beers. Today, the Gateway Kolsch has lots of fans, because, well, it's a gateway brew. It's the hardest of the French Broad beers to make, noted Andy, who has a soft spot for European-style lagers. The brewers make ales, of course—such as its 13 Rebels ESB, Rye Hopper Pale and an IPA that Chris started brewing in 2010—but Andy said that about 1,400 barrels of their production in 2011 were lagers, despite the fact that this style of beer has a longer fermentation time and takes up valuable tank space. "English-style dark beers can forgive and cover up a host of mistakes," he said.

Andy told a story that illustrates the influence of a craft-brewed lager. "A woman from Tennessee was here and asked, 'What is your lightest beer?' I gave her a Gateway Kolsch. She drank some. Then she drank some more. Then she started crying. She looked at me and said, 'I'll never drink Bud Light again!'" Andy paused and then added, "Of course, she'd had a few." He looked around at the wet concrete floor, the fish scale tanks reflecting the disco ball tied to the rafters and the spilled grain in the corner. He took a sip of his Kolsch and said, "This is the best business in the world to work in."

Catawba Valley Brewing Company

Brothers Billy and Scott Pyatt, with Scott's wife, Jetta, started Catawba Valley Brewing in 1999 in the basement of an old mill building that then housed an antique mall, in the town of Glen Alpine in Burke County. The Pyatt brothers are natives of Marion, North Carolina, and like so many before them, they started home brewing for fun back in the early '90s.

The idea to start a brewery was Billy's. Initially, Scott was just going to help out. Then Billy got a job offer that required he move to Philadelphia. Scott, who had just returned to the area from Colorado, didn't have a job, so he decided to get the brewery up and running. For years, Catawba Valley was a mostly one-man operation, with Scott doing all the brewing, sales and deliveries. "I've always been fascinated with any kind of manufacturing," Scott said. "I don't care whether it's beer or tampons. I don't care."

Scott chose the brewery's first location because it was an inexpensive space to lease and an easy fifty-mile drive door to door to Barley's Taproom—one of Catawba Valley's first accounts. In 2007, the brewery moved operations to an old warehouse in downtown Morganton, just down the road from Glen Alpine, and opened a taproom. Scott did most of the renovations himself while still mashing in on the ten-barrel system he'd engineered over the years. "It's like a redneck race car," he said about his brew house. "When I think about the equipment we first brought in, I'm lucky not be dead from asphyxiation or something exploding."

For a long time, the building Scott bought in Morganton had housed a Wild West nightclub called Slick Willy's. Though Catawba Valley's taproom has become a popular local hangout and live music venue, it's not quite as wild a spot as Slick Willy's was. The taproom and bar are open Wednesday to Fridays, and the space often hosts special events and parties on Saturdays.

Slowly, CVBC has expanded. "We've had very steady, controlled growth," said Scott. After more than a year of testing and tinkering, Scott released a few of his best-selling beers in cans in 2012. Firewater IPA, White Zombie Belgian White and Farmer Ted's Farmhouse Cream Ale are now available in the can. Instead of printing thousands of cans with the brewery's graphics, however, Scott uncovered a process where sticky labels are put directly on silver cans, making the CVBC cans fairly unique.

A couple years ago, after a few years of training under Scott, Warren Wilson College graduate Todd Boera took over as head brewer. Todd has

Scott Pyatt, co-founder and brewer of Catawba Valley Brewing Company, in his brewery. *Courtesy of Catawba Valley Brewing Company.*

been creating some fun, funky brews in the brewery's one small batch fermenter, from a sour stout to a Belgian Golden Strong brewed with local honeysuckle flowers. There's been tremendous buzz about some of Todd's special-release beers at local festivals, and CVBC will take some of its beers to the Great American Beer Festival for the first time in 2012. Todd will soon get the chance to do even more off-the-wall small batches when Catawba opens a second brewery in Asheville.

Billy, who moved back to the area several years ago, recently retired from his day job, and he's champing at the bit to get a second brewery and taproom up and running. Catawba has an entire seven-barrel brew house sitting in storage, and the boys are ready to roll—as soon as they find the right place to lease or buy.

The second brewery will produce all small batches, said Scott. "I hate being the guy that's doing what everyone else is doing. I've been aging beer in barrels for years, and now everyone's doing it. So I want to do something else." Catawba's core brands will still be brewed in Morganton and shipped to the new brewery and taproom. CVBC beers currently are distributed in the Charlotte and Knoxville areas. Catawba Valley will be the second WNC brewery, after Asheville Brewing, to have two breweries.

Thus did the brewvival begin, with four breweries in Asheville and one on the other side of the Swannanoa Pass opening in the first seven years after the long, dark time. Other beer-related businesses popped up as well during the Gay 1990s.

For the Love of Good Beer

More than one hundred years after Asheville embraced prohibition, its citizens once again saw an abundance of spots to slake their thirst. While today it seems that there's a bar or pub on most every downtown street corner, the majority of which offer at least a few local craft brews, beer lovers weren't always so lucky. Now, in addition to breweries, Asheville has beer bars and beer festivals galore. And the city has been named Beer City, USA four times in a row. (Okay, we tied for the honor twice, but still.) From a near beer wasteland to beer nirvana—that's how this town rolls.

Again and again, I hear two names come up when I talk to folks about Asheville's beer renaissance. One is Oscar Wong, who opened Asheville's first brewery. The other is Jimi Rentz. As I write this, I'm sitting upstairs at Barley's Pizzeria & Taproom on Biltmore Avenue. Jimi opened Barley's with business partner Doug Beatty in 1994. Soon after, the twosome started the Great Smokies Craft Brewers Brewgrass Festival, better known just as Brewgrass, which now ranks as one of the most well-known and well-loved beer festivals in the Southeast (three thousand tickets for the 2012 fest sold out in eight minutes online, while five hundred were sold to locals from Barley's a week later).

Right now, the upstairs taproom is deserted, as it doesn't open until 4:00 p.m., though I can hear customers downstairs eating pizza and quaffing midday beers. I'm here because Jimi offered me the space as a place to work on this book, away from the kids, clutter and canines that regularly invade my home office. Jimi and I have known each other since we worked on the

Jimi Rentz, co-owner and founder of Barley's Pizzeria & Taproom in Asheville. *Photo by Anne Fitten Glenn.*

same rag of a newspaper in college, and the fact that we both ended up as craft beer geeks in Asheville has cemented our friendship. I have yet to encounter any of the famous ghosts of Barley's, but I've been inspired by the diversity of tap handles I can see over my laptop behind the old wooden bar.

If Oscar Wong is the grandfather of Asheville beer, I think we can call Jimi Rentz the godfather. He's got that kind of "take no prisoners" attitude. Barley's opened mere months before Highland Brewing, in the same building, and like so many of the craft beer stories in this town, the tales of these two businesses are like our ever-present kudzu vines, intertwining, separating and continuing to grow despite whatever setbacks are thrown their way.

BEER BARS AND THE BIRTH OF BARLEY'S

One of the first Asheville pubs to serve craft beer was a spot called Chickadee's & Rye, which opened in 1988 at 46 Haywood Street. That

business evolved into the Bier Garden in '94, which still serves a variety of craft beers, including at least ten local taps.

Just before Barley's opened, there were a few other pubs serving draft beer in town. There was an alternative nightclub, Be Here Now, and Charlotte St. Pub just north of town. In 1997, Oscar Wong and chef Mark Rosenstein opened Asheville's first brewpub, the Blue Rooster, next door to Barley's, but Asheville wasn't quite ready for it, and the Rooster stopped crowing after about a year.

Nowadays, almost everyone serves local beer—from hotels to restaurants to locally owned coffee shops such as Clingman Café and the Dripolator. The French Broad Chocolate Lounge offers a few local drafts. The Fine Arts Theater does as well.

While filling growlers anywhere other than at the place of manufacture is still illegal in North Carolina, lots of convenience stores and grocery stores in town sell local beer in growlers, bottles and cans. In fact, Asheville Brewing Company's newish canned brews have been huge sellers at gas stations in the region, according to their distributor, Budweiser of Asheville.

But back to Barley's. Georgia native Jimi Rentz had been working in the restaurant business in Savannah since graduating from college. He decided to move to Asheville to open his own pizza restaurant. One day, he was hanging signs at Dinner for the Earth, the natural food store that would evolve into Earth Fare Supermarkets. Jimi's future wife, Dawn Kotajarvi, worked there, so he'd volunteered his help. There he met Doug Beatty, who was looking to start a bar specializing in draft beers in Asheville. Thus a partnership was born. The business partners looked at a number of spots downtown before finding the 42 Biltmore Avenue building owned by Jay Stewart. Though the building was built in the 1920s, it's in the same area as old Saloon Row.

Soon after Jimi and Doug met each other, they also met Oscar and John McDermott. Initially, the four were planning to partner on what would become Highland Brewing, but they then decided that it'd be better to have two separate businesses in the same building. However, Barley's was the first bar to sell Highland's first beer, Celtic Ale. Barley's still keeps at least a few Highland brews on tap at all times, and likely has sold more Highland beer than anyone other than Highland. In fact, several of the brewers in Western North Carolina—from Catawba Valley Brewing to Pisgah Brewing—say that Barley's was their first retail buyer.

What's remarkable about Barley's, however, is that from day one, the pub didn't sell a single U.S. domestic beer. "No Bud. No Coors. No Miller," Jimi

The exterior of Barley's Pizzeria & Taproom, one of Asheville's first bars to offer multiple craft and imported beers on draft. *Photo by Anne Fitten Glenn.*

said. "It was a steep learning curve, especially for our customers to learn to appreciate what he had."

When the taproom first opened, there weren't many craft beers available. What Barley's did have back then were nine taps and some bottles of craft beers, including Pete's Wicked Ale and drafts from now defunct breweries such as Blind Man of Athens, Georgia, and Dilworth Brewing of Charlotte. Barley's also regularly offered imports such as Guinness, Harp and Spaten.

As more breweries started to open in the '90s, Barley's added more taps, including French Broad, SweetWater (Atlanta), Cottonwood (Boone) and Thomas Creek (Greenville, South Carolina). As Barley's beer selection grew, the focus shifted toward offering regional brews for several years. Barley's opened its upstairs taproom and pool hall a few years after the restaurant opened on the street level. Then the partners decided to expand. Jimi and Doug opened a Barley's in Greenville, South Carolina, in 1998, and one in Knoxville, Tennessee, soon after that. Then one opened in Spindale, North Carolina. Those restaurants are now all independently owned, though they still share the same moniker.

"We negotiated with area distributors to get Highland, Catawba and other local beers in our restaurants in South Carolina and Tennessee before those beers formally were distributed there," Jimi said. "We wanted our beers there."

Jimi bought Doug out a few years ago, when Doug moved to Kingsport, Tennessee, to start a new business. Now Jimi focuses on complementing his wide selection of regional and North Carolina beers with a wide diversity of U.S. brews. "There are so many local beers and so many restaurants and bars that carry local beers that, while we still have a huge regional selection, we're going out and finding the best of the best beers and putting them on tap," he said.

Too many beer bars to name now call Asheville home, from the Thirsty Monk to Pack's Tavern to Universal Joint to Westville Pub to Jack of the Wood and more. Many of them, even the ones with only six or eight taps, regularly host suds-soaked events such as cask tappings, pint nights, tap takeovers and beer celebrity visits.

THE BIRTH OF BREWGRASS

"Brewgrass wasn't always so successful," Jimi said. "The second year, I had to write an $18,000 check to cover costs. The first four years, we couldn't sell even one thousand tickets." He added, "The first time we sold out was

The sun sets over Asheville and the 2009 Brewgrass Festival at Martin Luther King Jr. Baseball Park. *Photo by Anne Fitten Glenn.*

seven or eight years ago. We were on a beach trip with some friends, and this editor from CNN was there. He put us on the CNN ticker. That's what put us over the top."

The annual craft beer and bluegrass festival has been held in multiple locations, including McCormick Field (home of the Asheville Tourists Triple A baseball team), City-County Plaza, Memorial Stadium and The Block (the Eagle and Market Street area behind Barley's). However, the majority of the festivals have taken place at Martin Luther King Jr. Baseball Park, just a few blocks from the center of town.

Jimi said that it has been a challenge to keep the festival small and with a "boutique" beer flavor—there are only 3,500 tickets sold, and the park can accommodate only about forty tents for breweries. Breweries vie for the coveted spots, and many bring special-release and one-off beers that they tap throughout the day. Breweries must consent to sending an actual brewer or two to pour. One of the reasons the festival is so popular is because it gives beer drinkers a chance to talk in person with so many brewers.

The lineup of bluegrass music, which changes year to year, is also a draw, as are the local food options, including, of course, Barley's pizza. After Doug

left, Jimi brought in Asheville residents Eddie Dewey and Danny McClinton as Brewgrass co-organizers. Danny also became an owner of Barley's in 2012. Part of the proceeds of the festival is donated to Big Brothers and Big Sisters of Asheville.

"We know we could sell twice as many tickets if we wanted to, but we want to keep Brewgrass small, and we want to keep it downtown. We feel like it's a benefit for downtown businesses," he noted. Once Jimi kicks festival attendees out at 7:00 p.m., they swarm downtown restaurants, and yes, some even continue drinking beer throughout the night.

OTHERS ASHEVILLE BEER FESTS

Oktoberfest & DTA5

A number of cities have large Oktoberfest celebrations, but until recently, Asheville wasn't one of them. In 1990, a small Oktoberfest celebration was held on Wall Street downtown for a few years, but it wasn't a beer fest. "It was a traditional, family-style Oktoberfest with flags and lederhosen," said Adrian Vassallo, president of the Asheville Downtown Association. "There wasn't any craft beer, and it didn't showcase local offerings."

The Asheville Downtown Association was formed in the late 1980s by a group of businesses whose goal was to get more businesses to open downtown. At that time, downtown was very different from what it is today—many of the buildings were boarded up and in disrepair. After dark, the place was typically quiet and often pretty sketchy. Today, especially on summer weekends, downtown Asheville's businesses thrum with tourists and locals. Sometimes, traffic on the town's narrow sidewalks can be more congested than the traffic on the roads, which can be pretty intense at the height of tourist season.

A few years ago, after Asheville's central business district started to experience significant revitalization, the ADA leadership wondered what more they could do to showcase local breweries and restaurants, as well as the businesses located on Wall Street. Wall Street is a narrow but charming side street that can get overlooked, even though it fronts a number of vibrant businesses. The ABA decided that bringing back Oktoberfest on Wall Street and making it all about local craft beer and food was the answer.

Steve McKenna and Zane Lamprey compete in a blind taste test of nine beers from nine different Asheville breweries in an episode of the cable television show *Drinking Made Easy*. The episode aired on January 17, 2012. Oh, and Steve won, identifying all nine beers correctly. *Courtesy of Zane Lamprey's* Drinking Made Easy.

Prohibition-era bottles discovered by Nancy Alexander near her home, Whitemont Lodge, in Swannanoa, North Carolina. The Lodge supposedly was built by Asheville businessmen and politicians as a secret "Gentlemen's Club" during prohibition. The bottles have metal screw tops and are embossed with the words "Federal Law forbids sale or reuse of this bottle." *Photo by Anne Fitten Glenn.*

Highland Brewing Company crew in the Asheville brewery's newly constructed taproom in 2010. Highland reigns as Asheville's first "legal" brewery. *Courtesy of Highland Brewing.*

John Stuart, head brewer at Green Man Brewery, in the downtown Asheville brewery's taproom. *Photo by Anne Fitten Glenn.*

Asheville Brewing Company's Doug Riley, head brewer, and Mike Rangel, president, show off a few of the first bottles of Moog Filtered Ale. The American pale ale honors deceased Asheville resident and synthesizer pioneer Robert Moog. Brewed annually since 2010, proceeds from the sale of the beer support the Moog Foundation. *Photo by Anne Fitten Glenn.*

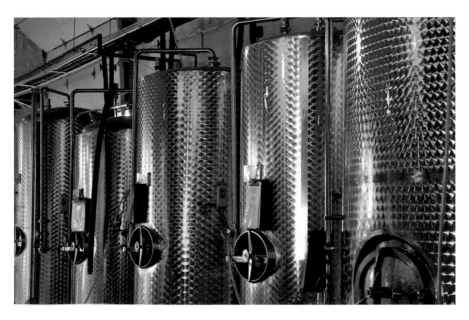

French Broad Brewing's fish scale tanks reflect the brewery's colored lights. *Photo by Anne Fitten Glenn.*

Above: A local band performs on French Broad Brewing's small stage inside the brewery. French Broad's taproom features live music most evenings. *Photo by Anne Fitten Glenn.*

Left: Pisgah Brewing Company opened in 2005 in Black Mountain, North Carolina. It was then and remains the only organic brewery in Western North Carolina. *Photo by Anne Fitten Glenn.*

Billy Klingel, brewer and founder of Oyster House Brewing, which is housed inside Asheville's Lobster Trap Restaurant. *Photo by Max Cooper, courtesy of the* Mountain Xpress.

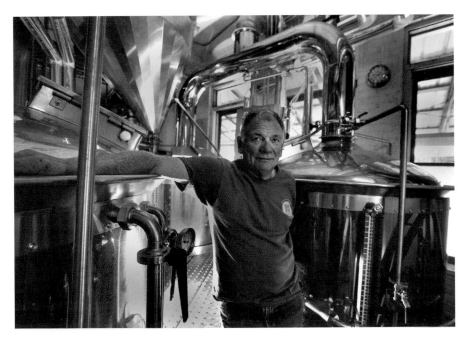

Tim Schaller, co-owner and founder of Wedge Brewing Company in Asheville's River Arts District. *Photo by Bill Rhodes, courtesy of the* Mountain Xpress.

Moving a tank into Asheville's Lexington Avenue Brewery before it opened in early 2010. At left is co-owner Steve Wilmans, and leaning on top of the tank is co-owner Mike Healy. *Photo by Jason Sandford.*

Biltmore Brewing Company started contract brewing beers at Highland Brewing in 2010 for Cedric's Tavern, a new restaurant on Biltmore estate. *Photo by Anne Fitten Glenn.*

Left: Poster advertising an Asheville Beer Divas meet-and-greet with Lauren Salazar of New Belgium Brewing at the Thirsty Monk pub. *Courtesy of the Thirsty Monk.*

Below: Asheville Brewers Alliance members at the ribbon cutting for the "House that Beer Built," a Habitat for Humanity home in west Asheville in 2012. *From left to right*: Andy Dahm, French Broad Brewing; John Lyda, Highland Brewing; Mike Rangel, Asheville Brewing; Barry Bialik, Thirsty Monk Brewery; and Tim Schaller, Wedge Brewing. *Photo by Anne Fitten Glenn.*

Above: Members of Mountain Ale and Lager Tasters home brew club at their tent at Asheville's annual Brewgrass Festival. In the foreground at left is Mark Hebbard, organizer of Just Brew It Home Brew Festival, and at right is Adam Reinke, 2012 Asheville Beer Master Tournament winner. *Photo by Anne Fitten Glenn.*

Left: Poster for the 2011 Brewgrass beer and bluegrass festival. Designed and screen-printed by Brent Baldwin. *Courtesy of www. deaverparkpress.com.*

Norm Penn, brewer for Thirsty Monk Brewery, a nano-brewery in south Asheville. *Photo by Max Cooper, courtesy of the* Mountain Xpress.

Brian Simpson, co-owner of Asheville's Riverbend Malt House, demonstrating the technique of floor malting to separate germinating grain before kilning. *Photo by Anne Fitten Glenn.*

Zaq Suarez gives an Asheville Brews Cruise tour a look at Craggie Brewing's brewery. *Courtesy theAVL.com.*

Ken Grossman, CEO and founder of Sierra Nevada Brewing, North Carolina governor Bev Perdue, and Brian Grossman, co-manager of the North Carolina Sierra Brewery, at Sierra Nevada Brewing's formal announcement that the company will build a second brewery in Mills River, North Carolina. *Photo by Max Cooper.*

At the Asheville announcement of New Belgium's plans to construct a second brewery in the city, the company gave away bottles of Fat Tire Amber Ale with an attached tag listing some of its reasons for choosing Asheville. *Photo by Anne Fitten Glenn.*

Here's what a can of Oskar Blues beer might see from the brewery's tent at Asheville's 2012 Beer City Festival. Oskar Blues Brewery is opening a second brewery in Brevard, North Carolina. *Photo by Anne Fitten Glenn.*

Cartoon from the first Asheville Beer Week Guide published by *Mountain Xpress* newsweekly in the spring of 2012. *Courtesy of artist Brent Brown.*

A flight of beers at Southern Appalachian Brewery's taproom in Hendersonville, North Carolina. *Photo by Anne Fitten Glenn.*

Left: Hops grown at Echoview Farm in Weaverville, North Carolina. *Photo by Anne Fitten Glenn.*

Below: Sister Bad Habit, a character in LaZoom's comedy bus tours, spends the first part of every tour drinking beer at Asheville's Thirsty Monk pub. *Photo by Anne Fitten Glenn.*

Welcome to Asheville's annual Oktoberfest. *Courtesy of Asheville Downtown Association.*

Poster advertising the release of Catawba Valley Brewing's beer in cans. *Courtesy of Catawba Valley Brewing.*

Charlie Papazian, founder of the Brewers Association, drinks a flight of Green Man Brewery's beers during his visit to Asheville in 2011. *Courtesy of Green Man Brewing.*

Part of downtown Asheville, looking over the Beer City Festival, which celebrates the city's status as Beer City, USA. The obelisk in the background, the Vance Monument, was built in 1897 in honor of North Carolina's Civil War–era governor, Zebulon B. Vance. *Photo by Anne Fitten Glenn.*

Altamont Brewing Company co-owners and founders Ben Wiggins and Gordon Kear, with a few of the tanks they purchased from Green Man Brewery. Altamont spent a year and a half as a west Asheville bar and music venue while the business partners raised cash to build the brewery. *Photo by Anne Fitten Glenn.*

Asheville on Bikes, a nonprofit organization cultivating the culture of bicycling, offers regular rides, such as the annual Bike of the Irish on or near St. Patrick's Day. Rides typically end with a beer at Wedge Brewing Company or another local brewery. *Photo by Bill Rhodes.*

Adrian Vassallo, president of Asheville Downtown Association, cheers on a member of the Blue Ridge Roller Girls team during the Oktoberfest games on Wall Street in Asheville. *Photo by Anne Fitten Glenn.*

The fest has been held on the second Saturday in October since 2009. In 2011, eighteen different local craft beers from six breweries were tapped. Part of the fun is that participating breweries field a team for the Oktoberfest games. The games include fun competitions such as keg rolling and stein lifting. Each team must include at least one woman, and breweries can pick from staff and loyal customers to field their teams.

Another Asheville Downtown Association festival that features local beers is Downtown After 5. This street party takes place on the third Friday of each month from May to September and offers a few live music acts and lots of beer. Although DTA5 started in the small parking lot on Walnut Street across from Scully's, the entire lower end of Lexington Avenue now gets blocked off for the party. Initially, the beer offerings were all Budweiser of Asheville products. But after a few years, said Adrian, the ADA realized that it should work to bring local breweries to DTA5. "Everything about our event screams Asheville. We're local businesses embracing other local businesses," he noted.

The breweries pay a sponsorship fee to sell their beer there, but it's been worthwhile, particularly in recent years. At the first DTA5, in May

2012, Pisgah Brewing kicked twenty-eight kegs in four hours, said Pisgah's marketing and sales manager Jeremy Austin.

Winter Warmer Beer Festival

The first Winter Warmer Beer Fest was held in January 2008 and organized by the folks who own Asheville's Brews Cruise. The first three festivals were held in the ballroom of the Haywood Park Hotel, but because of high demand, the festival was then moved to the lower level of the building formerly known as Asheville's Civic Center (now the U.S. Cellular Center Asheville). The festival features all southeastern breweries, although in 2012, Deschutes Brewing of Oregon made an appearance. Deschutes isn't distributed in North Carolina, but Brews Cruise co-owner Mark Lyons now lives in Bend, Oregon, and works part-time at that brewery. Part of the proceeds of the festival are donated to Asheville's Riverlink, a nonprofit that spearheads the revitalization of the French Broad River.

Also, for the first time in the spring of 2012, Asheville Brews Cruise organized a Firkin Festival in the meadow next to Highland Brewing Company. A firkin is basically a cask, and a firkin beer undergoes secondary fermentation in the container from which it is served. The theme of the festival was pre-prohibition, and in that spirit, old English ploughman's lunches were sold and an old-timey band provided the tunes. It wasn't quite the pre-prohibition Wild, Wild Western North Carolina that I write about in earlier chapters, but it was fun nonetheless.

Just Brew It Home Brew Festival

One of the most creative local beer festivals features only homebrews—and more than one hundred of them. Home brewer Mark Hebbard works for Just Economics of Western North Carolina, home of Asheville's Living Wage Campaign, and he came up with this idea to give his homies a way to showcase their beers while raising funds for the organization. Two of its three years, Just Brew It has taken place in the parking and patio area in front of Wedge Brewing.

In 2012, it was part of Asheville Beer Week, and tickets sold out more than a day beforehand (only sixteen dollars for a membership to Just Economics gets you in). I've been honored to be a judge and to give out the "Brewgasm"

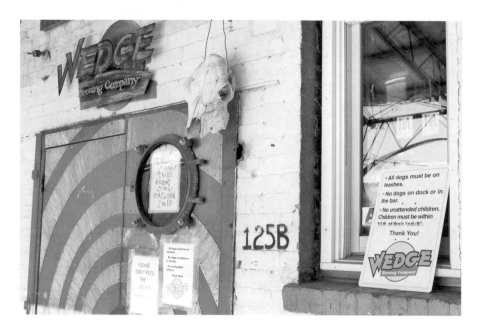

Wedge Brewing Company rules. *Photo by Anne Fitten Glenn.*

award the past two years. Choosing just one beer from so many creative ones is challenging. There are just so many fabulous home brewers in this part of the world. Several local breweries also choose a winning beer that they promise to brew later in the year. It's a great way for home brewers to get one of their concoctions commercially produced, even as a small batch.

Beer City Festival

After Asheville won the first Beer City, USA, poll in 2009, the Asheville Brewers Alliance and the organizers of Brewgrass decided to hold a celebratory beer festival. That festival, which takes place the first Saturday in June at Roger McGuire Park downtown, touts itself as a locals-only festival. Thus far, no tickets have been sold online; they have only been available from Asheville Brewers Alliance breweries, Barley's and Bruisin' Ales.

The festival features local rock bands and a variety of southeastern breweries, plus a few nationally known ones as well. As with Brewgrass, brewers are encouraged to attend, pour their beers and bring special releases to share with festivalgoers.

This festival also supports Big Brothers and Big Sisters of Asheville, although in 2012, the ABA donated an additional $10,000 of festival income to help build a Habitat for Humanity house in west Asheville. Dubbed the "House that Beer Built" by French Broad Brewing's Andy Dahm, the house was completed at the end of the summer of 2012.

BEER CITY, USA

Not to crow too much, but did I mention that Asheville has won the Beer City, USA title every year that the online poll has been around? Our beer-loving town now stands at two ties and two wins for the informal online Beer City, USA, poll, administered for the past four years by Brewers Association founder Charlie Papazian and examiner.com. In 2009, Asheville shared the title with Portland, Oregon, and then went on to win it flat out the next two years. In 2012, Asheville tied with Grand Rapids, Michigan, with both cities receiving 32 percent of the vote.

In 2012, the voting seesawed throughout the polling between Asheville and Grand Rapids, but the finish was a dead heat. Both cities received 7,849 votes, Papazian said. Overall, 55,926 votes were cast from 90 countries. As soon as the vote was final, the Asheville Brewers Alliance reached out to Grand Rapids and invited the city to serve some of its craft beers at Asheville's 2012 Brewgrass Festival.

In an article written on MLive.com, Garret Ellison noted, "Although the honor is largely symbolic, the new crown bestowed on Grand Rapids by the power of the Internet may have some very real economic benefit." There's little doubt that the unscientific poll has influenced both beer tourists and the interest of breweries, both large and small, in the WNC region.

In 2012, Lonely Planet Travel Guide picked Asheville as the fourth-best beer city in the United States, and the Travel Channel put the city in its "Top Seven Beer Destinations." This book's foreword writer, Zane Lamprey, picked Asheville as the sixth-best beer city in the world. In other words, Asheville is now an amazing place to drink beer.

In 2011, I wrote an article for the Brewers Association's online magazine titled, "How Does Lil' Ole Asheville Keep Winning the Beer City USA Poll?"

An Intoxicating History of Mountain Brewing

It's a damn good question. How exactly does a small city with no nationally known beers win the Beer City poll for four years in a row? A lot of the answers are traced in this book. But below are a few excerpts from that article that explains more of the whys and wherefores:

In truth, there are many answers. My favorite comes from Oscar Wong, president of Highland Brewing Company, "Part of it is this community is relatively new to the craft beer world. We're like teenagers. We're enthused, and we have lots of energy…"

The city's teenage enthusiasm may be one reason our big brother-in-beer and rival in the poll, Portland, Oregon, looks upon us with some disdain. After all, teenagers can be annoying know-it-alls.

Portlander Billy Night of "It's a Pub Night" blog has written about the "silliness" of the poll for the past two years, but he offers a caveat: "Even though I think the poll is meaningless, now that it has Asheville and Portland looking at each other, it's a good opportunity for someone to do something that draws positive attention to both of them. Maybe get a contingent of Asheville beers at the Oregon Brewers Festival in 2012 and send some of our beers out Carolina way. We'll probably both be pleasantly surprised at what the other town is up to."

To extend the teen metaphor and offer another answer to the "how" question, I can tell you that Asheville has a well-connected beer community, most of whom communicate with one another regularly, both in person and via social media. To wit, there were about 14,800 votes cast in the 2011 Beer City poll, and around 7,000 went to Asheville. That's not a whole lot of votes in the scheme of things, but to put it in perspective, only about 17,000 folks cast a vote in Asheville's 2009 municipal elections…

"For Asheville, this is a big deal—probably a bigger deal than it would be for other bigger cities that have a lot of other stuff going on. [The Beer City poll] has become a community focus, not just a beer focus," says Tim Schaller, owner of Wedge Brewing Company.

And yes, Asheville can be like a big high school. Everyone knows everyone else—people buy local because by doing so they're supporting their friends and neighbors.

"The city is not only behind its small brewers, but behind local business," wrote Papazian in his blog post about the poll. He went on to note that: "The Beer City USA poll is about community pride. Not just beer…It's about Main Street, grass roots, community support, not mainstream data and statistics…"

Western North Carolina brewers and craft beer industry folks gathered to toast Asheville's third Beer City, USA, win in 2011 at Barley's Pizzeria & Taproom. *Photo by Anne Fitten Glenn.*

Asheville's teenage love affair with craft beer has compelled folks who aren't from around here to take notice. In the past few years, a number of beer luminaries have visited the town, including Papazian, Larry Bell of Bell's Brewery, Greg Koch of Stone Brewing, and Rob Tod of Allagash Brewing. And of course, Ken Grossman of Sierra Nevada and Kim Jordan of New Belgium are now regular visitors. New Belgium Brewing brings their Clips of Faith Tour film and beer festival to Asheville—it continues to be one of the smaller cities the tour visits.

Finally, one of Asheville's primary industries is tourism and Asheville residents aren't ingenuous enough not to understand how important the beer industry is to our town, especially as other industries move away or shut down. Thus, the tourism branch of Asheville Chamber of Commerce promotes polls, especially the Beer City one, because they can, in turn, use it to attract those elusive animals known as tourists, and, in this case, beer tourists.

"We've come a long way, baby," says Jimi Rentz of Barley's Taproom. "In truth, I have no idea how Asheville keeps winning the poll. Yes, there's community support, but there are only so many of us. It's amazing, really. If San Diego or Portland wanted to take it, they'd take it no problem."

What Asheville does have is a commitment to great craft beer. "This win gives our brewers a challenge and a responsibility," Schaller said. "When tourists come here, they better be able to drink good local beer."

Overall, as Night noted, beer city rivalries can only help the American craft beer movement. The Beer City USA poll stirs up interest in these communities—and a little light-hearted ribbing increases that visibility. When organizers of Philadelphia Beer Week proclaimed themselves "best beer-drinking city in America," beer lovers in San Francisco responded by starting their own beer week to show Phillies how it's done. These little quarrels turn out to be beneficial to the cities and their breweries and beer-related businesses.

Thus, the breweries plus the beer bars plus myriad beer festivals plus the somewhat silly but influential Beer City title have propelled Asheville into beer tourist stratosphere. But before we get ahead of ourselves, let's go back in time again to trace what happened to mountain brewing in the 2000s.

Boom! Pop the Cap
Brings More

Pop the Cap (North Carolina House Bill 392) gave a huge boost to mountain brewing by raising the legal alcohol by volume limit for beer from 6 to 15 percent in 2005. It had the opposite effect that the Will Harris murders did; while that tragedy pushed Asheville into the arms of prohibition, Pop the Cap offered a change that a whole new slew of North Carolina and Asheville breweries could embrace.

"North Carolina had such a great beer culture, even then. This was just one of the last vestiges of prohibition that was handcuffing the state," said Sean Lilly Wilson, founder and chief executive optimist of Fullsteam Brewery in Durham (that truly is his job title).

Sean and Julie Johnson of *All About Beer* magazine spearheaded the change. In 2003, the two organized a statewide meeting of beer industry folks to drum up support. Oscar Wong of Highland and Tony Kiss of the *Asheville Citizen-Times* attended that meeting. It would take another two and a half years to get the bill to the General Assembly and have it signed into law, but it when it happened, it happened to the accompaniment of corks popping out of caged and corked beer bottles all across the state. "I didn't start Pop the Cap with the expectation that I would start a brewery. I had no idea that would happen," Sean said. "I'm just honored to have played a part."

In Asheville, Highland Brewing's Tasgall Ale, a Scotch ale of 8 percent ABV, would be the first "legal" high-gravity North Carolina beer released after Pop the Cap. However, there were likely small-batch beers produced by local breweries that exceeded the 6 percent limit before then. Carl

Melissas noted that a couple of his Belgian beers brewed at Dirty Jack's were advertised as being 5.999 percent ABV, but they *might* have been closer to 8 percent.

Even before the cap was popped, a few new breweries entered the fray, early in the 2000s, before the post-Pop influx.

SOUTHERN APPALACHIAN BREWERY

Chicago-based photographers Andy Cubbin and Kelly Cubbin hadn't ever heard of Rosman, North Carolina, so it would be a bit of a surprise when they ended up there in 2006. "I was looking at the Seibel Institute," said longtime home brewer Andy, "and I realized I could buy a small brewery for the cost of going to school."

The brewery would turn out to be one that a couple of local guys had started in a Rosman barn in 2003 and called Appalachian Brewing. The early beers, a Copperhead Amber and Black Bear Stout, were sold on tap from several spots in nearby Brevard and a few places in Asheville. But after a few years of brewing, the owners decided to sell.

The Cubbins arrived in Western North Carolina the day before the 2006 Brewgrass Festival and spent the day of Brewgrass handing out tastes of beers that they hadn't brewed. After years of city living, they thought that it would be fun to live in the country, but Kelly said that they realized soon after arriving in Rosman that they needed to move the brewery.

The couple renamed the brewery Appalachian Craft Brewery to avoid confusion with Appalachian Brewing Company in Pennsylvania. They moved the brewery to a warehouse in Fletcher, North Carolina, just south of Asheville, and started brewing like crazy while continuing to work as photographers. Soon they had a couple dozen accounts and started looking for a space for a brewery and taproom closer to downtown Asheville.

"One day, I was downtown and saw a fermenter going into what's now Craggie Brewing. Kelly and I met at Green Man for a beer. We realized there had been four new breweries in Asheville in about four years, so we decided to start looking elsewhere," Andy said.

Hendersonville, an up-and-coming town twenty-six miles south of Asheville with no local brewery, seemed to fit the bill. After a search, the Cubbins found a large warehouse near downtown with a concrete floor

Andy Cubbin, co-owner and brewer of Southern Appalachian Brewery in Hendersonville, North Carolina. *Photo by Nick Gillespie Photography.*

and a parking lot. They decided to stop brewing for a while to get the new brewery up and running. The couple renamed the brewery again, deciding to call it Southern Appalachian Brewery. Soon, however, they learned that moving the brewery was the least of their concerns.

Both Henderson County and the City of Hendersonville had some antiquated blue laws. Even though they already had brewing licenses, the permit for Southern Appalachian's new home took more than six months. At that point, only restaurants in Hendersonville could sell beer or wine. After months of delays and a year and a half of planning, the Cubbins opened their brewery taproom as a "private" club in 2011. Then, after more than a year of beer activism, the Cubbins helped push the historically "dry" county into calling a special alcohol-sales referendum vote. More than 75 percent of the Hendersonville vote said "yes" to beer and wine sales on-site. It was the first such countywide vote since 1955, when alcohol sales were soundly defeated. "The city has been very helpful, but it was an educational process—for all of us," Kelly said.

Thus, the Cubbins helped pave the way for Sierra Nevada Brewing to open in Henderson County. "I'm really looking forward to Sierra being

nearby," Andy said. "I think it will help us and Hendersonville in general. When everyone's talking about beer, it's good for everyone making beer."

Andy brews on a fifteen-barrel system. He also works as the delivery person and business accountant, while Kelly manages the taproom and oversees marketing. Southern Appalachian will produce about seven hundred barrels in 2012, and Andy's goal is one thousand the next year. Andy plans to hire an assistant brewer in 2012. At present, not much SAB beer makes it outside the brewery's doors (except to the outdoor seating area); 90 percent is sold in the taproom.

"We're doing three or four times more business in the tasting room than we thought we would," Kelly said. "It's become a local hangout with a great sense of community. We feel like we really filled a void in Hendersonville."

HEINZELMÄNNCHEN BREWERY

Heinzelmännchen, located in Sylva, forty-five miles southwest of Asheville, was the first brewery to open in the westernmost corner of North Carolina. Braumeister Dieter Kuhn and his wife, Sheryl Rudd, opened the brewery in 2004. Dieter grew up near Germany's Black Forest and remembers being sent to the local brew house to pick up the family's beer when he was a boy. Not surprisingly, Dieter brews mostly German-style beers.

Dieter and Sheryl moved to Sylva from Chicago in 1991. At that time, Dieter was a nurse, and he'd had an affection for the area since visiting as he traveled from Camp Lejeune to Chicago in the late 1970s. Soon after moving to Sylva, Dieter started home brewing because, "I didn't like Budweiser and that's all that was available then."

A chef friend asked him to help start a brewpub in Sylva, but Dieter said that first he needed to go to school. So he attended a two-week program at Seibel Institute and then interned at Goose Island Brewery back when it was merely a Chicago brewpub. "My beer was saleable, so they sold it. That was kind of neat," Dieter said.

He returned home educated, but he and his friend decided that a brewpub wasn't the right thing for Sylva at that time. Instead, Dieter and Sheryl started looking for a space for a brewery and soon found the spot where they still reside today. After months of renovations, they opened Heinzelmännchen in the spring of 2004.

Dieter Kuhn, braumeister and co-owner of Heinzelmännchen Brewery in Sylva, North Carolina. *Courtesy of Deep Creek Arts.*

Dieter currently brews on a fairly labor-intensive system that consists of a seven-barrel mash tun, a two-and-a-half-barrel cooker and a ten-barrel fermenter. He wants to upgrade to a bigger, more efficient system. The couple are researching new locations in order to expand production. Sheryl works as president of the company.

Heinzelmännchen currently offers a small taproom, with just a few tables. The brewery mostly focuses on take-home growlers and both five- and fifteen-gallon kegs. The beer is also on tap at a number of Sylva and Asheville restaurants. The growlers are imported from Germany and have porcelain flip-top lids to preserve freshness. Dieter also brews old-fashioned root beer and birch beer.

The name of the brewery springs from the myth of the Heinzelmännchen—gnomelike creatures that live in the Black Forest. According to folklore, the Heinzelmännchen visit proprietors during the night to assist with chores so that when the business owner awakes, he has more time to give back to his community.

Dieter likes to brew flavorful but mild, easy-drinking beers that pair well with food. To that end, the couple published a cookbook in 2009. *Your Gnometown Cookbook: Heinzenmannchen Brewery's Favorite Recipes* includes lots of information about cooking and pairing food with beer. The book was edited and compiled by Sheryl's mother, Elizabeth Rudd.

Following the small brewery trend, Dieter now brews specialty beers regularly. He offers a different beer every weekend to "keep the beer geeks coming in." He hopes the Heinzelmännchen understand.

PISGAH BREWING COMPANY

Pisgah Brewing was and remains Western North Carolina's only mostly organic brewery—"mostly" because, while all of its regular lineup of beers and most of its seasonals are organic, every once in a while the Pisgah boys will brew a beer using local ingredients, such as honey or berries, that aren't certified as organic. They do a pretty amazing job of using as much organic and locally sourced stuff in their beers as possible.

Co-owners and founders Jason Caughman and Dave Quinn became friends when both were working in Folly Beach, South Carolina, back in 2002. Dave was into home brewing, and Jason became interested. Soon,

Jason Caughman, owner and co-founder of Pisgah Brewing Company in Black Mountain, North Carolina. *Photo by Anne Fitten Glenn.*

Jason started developing a business plan to open a brewery in Charleston, which at that time had only one. "But when I started researching it, the three-tier system blew me out of the water. It was too expensive to start a brewery and have to pay a distributor right away," Jason said. He had considered moving to Asheville after graduating from Clemson University. He told Dave, "Asheville's a cool town. Let's start a brewery there."

So they moved to Asheville, and a year later, in 2005, opened Pisgah Brewing Company in Black Mountain. They chose Black Mountain because they found an unassuming but large complex of warehouses where the rent was affordable. Ubiquitous local beer supporter Jay Stewart owns the Eastside Business Park, where Pisgah is located. The site was previously home to a Drexel Furniture Manufacturing plant, which was the site of a 1998 shooting spree by a disgruntled employee that left two dead and three wounded. Since 2005, however, it's been a place "of happy beer," Jason said.

Jason and Dave scraped together $50,000 in cash to buy a seven-barrel system, which they picked up from New South Brewing in Myrtle Beach. "We realized no one was doing organic beer here, but organic was hot. We realized we could instantly distinguish ourselves in the market," Jason said. But he noted that designing and brewing consistent beer was "like getting a

graduate degree in brewing. Luckily, we were geeks and treated it like a big science project."

The first beer the two brewed was their flagship Pisgah Pale, which continues to be the brewery's best-selling beer. "Our first two kegs of Pale went to Barley's on Friday, and they called and ordered more on Monday. We felt like we were living our dream," Jason said. He added, "The Pale Ale isn't bitter by design. It's not a competition beer. It's made for drinking."

Not all of their beers came out so well. "The first batch of wheat beer we brewed sucked. It tasted like shrimp," Jason said. He added that the first porter was just okay until he tweaked the recipe and then put it on nitro. Nitrogen pours use a combination of nitrogen and carbon dioxide to pump beer from the keg. The nitrogen gives the beer less carbonation and a creamier mouth feel than just carbon dioxide.

Pisgah Brewing opened its doors for business a few months before Pop the Cap was signed into law but with the knowledge that the cap was gonna be popped. "We made a big double IPA in anticipation of Pop the Cap and put it on draft at Barley's," Jason said. That beer would become Pisgah's seasonal Vortex I Imperial IPA, still billed as the hoppiest beer in WNC.

At first, Pisgah opened the brewery for tastings and to sell pints only on Thursday afternoons. Beer lovers lined up in the dark hallway leading to the brewery and then sat outside on the concrete pad or wandered down to the meadow behind the brewery. It was a hot local spot to hang out on Thursdays. Soon, the owners had a little cash and decided to open a real taproom, with multiple taps and a stage for live music acts. They expanded hours, put a fire pit in the yard and cleaned up the meadow. After a few years, Dave decided that he was ready to move on. He remains a part owner of the brewery but lives out west now.

Jason continues to both manage the business and brew fairly often. He's expanded the inside taproom and makes sure that there are always several small-batch Pisgah beers there that typically aren't available anywhere else.

In 2010, Pisgah added a huge outdoor stage in the meadow that has since featured nationally known musical acts, including Lucinda Williams, Karl Denson and Grace Potter. Jason continues to focus on quality and a strong commitment to buying local, including ingredients such as cocoa nibs from French Broad Chocolate Lounge, coffee beans from a few local roasters, fresh hops and blueberries from Van Burnette's farm and malt from Riverbend Malt House.

"It's a circle—we're local and we're grateful for local support, and we want to give back to the locals who drink our beer," Jason said. "That's why we

only distribute around here and put our money back into the brewery and the music." Pisgah still self-distributes to almost two hundred regional accounts.

In 2012, Pisgah will produce about three thousand barrels of beer with its ten-barrel brew house, almost all of which will be imbibed in WNC. "And we're expanding. I'm not sure exactly when, but I've got big plans," said Jason.

WEDGE BREWING COMPANY

Wedge Brewing can best be described as Steampunk meets the railroad tracks meets Belgian yeast. The small brewery in Asheville's funky River Arts District opened its doors in 2008, and those doors have since been propped open by lines of beer lovers waiting for a taste of brewer Carl Melissas's beers.

Both owner Tim Schaller and Carl had been kicking around Asheville for a few years—Tim as a home renovator and Carl as head brewer for Green Man Brewery—but it took the two of them combining their powers to create beer magic in the form of Wedge Brewing.

Eclectic Asheville artist and inventor John Payne and Tim liked to throw down both beers and ideas at Green Man Brewery. Between afternoon beers there and morning coffee at Clingman Café, they came up with the idea of putting a brewery in the basement level of the Wedge building, then owned by Payne.

"I liked the laidback scene at Dirty Jack's. I loved Carl's beers, and I liked the artistic, community environment Payne was creating down in the RAD," Tim said. "We were sitting at Dirty Jack's guessing that Carl wouldn't be there forever. It seemed like an opportunity to do something that would be fun and a great 'last' job."

Carl claimed that Tim originally wanted to call the brewery River Dog Brewery, after a beloved pet that had died, but Carl convinced him that there were already too many breweries with the word "Dog" in the name, and Wedge would cement their desire to be simply "a neighborhood brewery."

Step by step, the Wedge Brewing vision came to fruition, despite a few early mishaps. Carl located a "dream" brewing system in Florida, and he and Tim drove down to pick it up. When they got there, they saw that a restaurant hostess desk had been built in front of the brewery, so they had to break the whole thing down into tiny pieces in order to extract it. Then during renovations, Tim, a longtime contractor, fell off a stepladder and

fractured his spine and left arm. He opened the brewery wearing a Wedge logo sticker on the front of a hard-shell plastic back brace. Tim said that he spent most of the time he should have been recuperating pulling a cart of fresh beer around to bars and restaurants to try to win accounts.

Payne died suddenly soon after the brewery's soft opening, which traumatized everyone involved. "John loved beer and was a huge part of this. He'd walk in the brewery with a big smile on his face and say, 'This is like a dream come true,'" Carl said. Soon after his death, Tim named Payne's Pale Ale in his honor. There's a rumor that some of John's ashes may have found their way into that first batch of Payne's Pale, but the tale can't be confirmed and will likely remain apocryphal.

One of Wedge's first taps was with Barley's Pizzeria & Taproom, though Wedge beers are no longer sold there. In fact, almost all the 1,300 barrels brewed in 2012 were sold from the Wedge's taproom. While at one point in time Wedge had forty-four accounts around Asheville, Tim said that he consciously decided to decrease those and now only has a handful, one of which is nearby Clingman Café. "We only have enough beer for retail sales at the brewery. I can't make the parking lot any bumpier, but people still keep coming," he quipped.

Tim has expanded the brewery some since opening, adding a few thirty-barrel fermenters in 2011, but he said that he really doesn't want to grow much more. This attitude rubs some local restaurant and bar owners the wrong way, but only because they know how well Wedge beer would sell for them.

Tim and John Payne originally envisioned a tiny taproom with a few old guys sitting around drinking good beer and telling tales. Wedge's taproom is pretty small, but since opening, Tim has had to upgrade much of the outdoor space to support the multitudes who show up on the Wedge's doorstep every afternoon. Tim built a concrete pad to serve as handicapped parking and put tables out front in addition to those on the patio, which is surrounded by John's otherworldly metallic sculptures. He put up a fence between the parking, the outdoor areas and the railroad tracks.

The beers run the gamut from a strong Belgian (Golem) to a hop-forward IPA (Iron Rail) to a crisp Pilsner (Julian Price Pils). The Pilsner, pale and IPA are always on in the taproom, plus, typically, two Belgian beers. Others change seasonally or more often, depending. Carl brews a fairly unique hemp beer called Derailed in the spring. Carl blames his obsessive-compulsive cleanliness for the popularity and consistency of his brews. "I'm pretty fanatical," he said.

Carl Melissas, Wedge Brewing Company brewer, in the Asheville brewery. *Photo by Julie Atallah.*

Although the Wedge has, by all accounts, done a brisk business from day one, Schaller said that the first time he hadn't plowed all the money he's made back into the business was in the summer of 2011. Eight investors, including Schaller, own the brewery at varying percentages.

Neither Tim nor Carl wants to expand the Wedge much. They're happy with the brewery's current production and have no plans other than upgrading equipment and perhaps bottling a few Belgian beers at some point. Tim and a group of other investors purchased the Wedge building from John Payne's heirs in 2012. "Carl likes to have a hand in every batch of beer we make, and I like that, too," Tim said.

Carl added, "Asheville really is going to be the Disneyland of beer. We like to joke that we like it the way it is here. I don't want the Wedge to have to explode to keep up with demand."

OYSTER HOUSE BREWING COMPANY

Billy Klingel was bartending at Asheville's Lobster Trap Restaurant in 2008 when, one day, Chef Tres Hundertmark came back from an oyster shucking tournament and told Billy that he'd drunk an oyster stout there. That was all home brewer Billy needed to hear. Over the next year, he brewed sixty-two test batches of oyster stout on his home system in his garage. "I finally got a super dry roasty flavor but with a creamy mouth feel," he said. "Thank God, because that was a lot of beer for one guy and his girlfriend to drink." Billy then hooked the final recipe up to a nitrogen tap and was blown away. He invited the Lobster Trap owners and chefs over to his backyard for a tasting. Even owner Amy Beard, who used to primarily drink Bud Select, loved Billy's oyster stout.

So Billy put together some numbers and took Amy out to lunch. "I told Amy that we will not make any money doing this, but we're a very successful restaurant, so it'll be okay," he said, laughing. He brought a SABCO Brew-Magic system, put it on wheels, and he's still brewing with it today.

Billy noted that the permit process for his "brew house" was a nine-month-long nightmare, but the baby was eventually born. "The state didn't want a brew house on wheels. They wanted a wall around it. I almost gave up," he said. But he didn't, and once he got his permits, he "started brewing like crazy, out of sheer joy and excitement." Billy offered five different beers on the brewery's opening night in the spring of 2009. Those five are still his

"Yeah, we put oysters in our beer." Tap handle for Oyster House Brewing's Moonstone Oyster Stout at the Lobster Trap Restaurant in Asheville. *Photo by Anne Fitten Glenn.*

flagships: Moonstone Oyster Stout, an IPA, Patton Ave Pale, Dirty Blonde and Upside Down Brown.

Tony Kiss and Oscar Wong showed up that first night to taste his beers, and Oscar told Billy, "Don't ever run out of that stout. It's what you're going to be known for." Billy said he's been terrified ever since that he might run out of the Moonstone Oyster Stout, but so far that hasn't happened.

In addition to running the Brew-Magic almost daily, Billy brews a batch about once a month at French Broad Brewing. All of Oyster House Brewing's beers are sold in house at the restaurant. "If I could figure out a way to fit a three- or four-barrel system in here, I would," Billy said. Currently, he brews behind the bar and then rolls the system into the elevator to take it downstairs and keg it off.

There are five pounds of oysters in every fourteen gallons of stout brewed. "Yeah, we put oysters in our beer," reads the front of Oyster House Brewing's T-shirts. They do, indeed.

CRAGGIE BREWING COMPANY

In yet another case of brewer polyamory, Bill Drew worked for Highland Brewing on and off for eight years before branching out to start his own brewery in 2008. While working at Highland, Drew became friends with Jonathan Cort, and the two soon joined forces to open Craggie Brewing Company on Hilliard Avenue.

The brewery offers a small public house next to the brewing operation and is the only brewery around that serves imperial pints (twenty ounces). The tasting room's coziness contrasts with the large warehouse space, which has a simple stage and features local music acts several nights a week. The music often spills out onto the narrow sidewalk when the bar manager opens the garage door.

The Craggie building sits just behind Asheville Brewing's Coxe Avenue location and a few blocks away from Green Man Brewing, making the mostly industrial Coxe Avenue area a great place to walk and drink craft beer. In fact, Asheville's Brews Cruise and Eating Asheville's walking beer tours both regularly hit these three breweries.

History buff Bill said that he and Jonathan named their brewery after a number of local spots, including Craggy Mountain, Craggy prison and

Bill Drew, co-owner and co-founder of Craggie Brewing Company, in the Asheville brewery's public house. *Photo by Anne Fitten Glenn.*

the historic Craggy trolley line. Bill tweaked the spelling slightly to reflect his Scotch-Irish heritage. The taproom, which Craggie calls (in typical Brit fashion) the public house, features old photos of Asheville from the late 1800s and early 1900s.

Bill reminisced about working for Highland in the early days, when it was still based out of the basement under Barley's. "It was a close-knit family, partially because the work was so labor-intensive. It always took four or five people to bottle or keg the beer." The impetus for starting Craggie was based on that experience, "I really want to produce hand-crafted beer. It's only hand crafted if you use your hands. You don't push a button or program a computer."

In its first year, Craggie produced close to 1,000 barrels. That number then dropped off, according to Bill, but he said that the brewery should hit 1,000 in 2012. The brewery's capacity is about 2,500 barrels, or 3,000 if they don't brew lagers.

DJ McCready started as head brewer in early 2011 so Bill could focus more on general management. DJ created a few of the brewery's hot sellers, including the Burning Barrel Bourbon Chipotle Porter and Yo La Mango IPA.

Craggie beers are currently distributed in Tennessee and North Carolina. Bill said that he's considering South Carolina and Georgia as possible states

DJ McCready, Craggie Brewing Company head brewer, works on a small-batch beer. *Photo by Anne Fitten Glenn.*

in which to spread the Craggie beer gospel. The owners are talking to investors to find financing to help with the company's expansion plans.

LEXINGTON AVENUE BREWING COMPANY

Mike Healy and Steve Wilmans are old friends and distant cousins. Now they're also business partners. Steve and Mike started Lexington Avenue Brewery (LAB) in 2010 as a gastropub (a pub that pairs sophisticated fare with its in-house brews).

A sound engineer who had owned a recording studio in Seattle before selling it to a Microsoft executive, Steve first came to Asheville when he agreed to help Mike move here from Los Angeles. While driving around town, Steve spotted an old church for sale in downtown Asheville. He liked the city's vibe and deep musical roots, and he recognized that the church would make a remarkable recording studio. Steve bought the church and opened Echo Mountain Studios there in 2006. He's since expanded, adding

Lexington Avenue Brewing's brewery can be seen through the glass behind the Asheville pub's bar. *Photo by Anne Fitten Glenn.*

a second studio in the former Fletcher School of Dance building adjacent to the church. Oh, and around the same time he was expanding the studio, he and Mike were renovating the 29 North Lexington Avenue building that would become the LAB.

"We used to sit around and drink beer and joke that it'd be great if we had a bar," Steve said. So Mike and Steve pooled resources to purchase the building on what had once been called Water Street because of the underground springs that kept it perpetually wet. Built in 1916, the building originally served as a livery stable and then as T.S. Morrison's, one of Asheville's longest-running retail stores. It took a year and a half, but the business partners transformed the old building into a brewery, restaurant and music venue. On the second floor, they opened a hostel, Sweet Peas, and built condominiums on the top floor.

Healy thinks that the traditional brewpub design, where bar customers can see the fermenting tanks behind glass, plus the location, have helped the business succeed. Patio seating, mid-priced gastropub food, eclectic music and great beer complete the recipe. Most of the breweries in the area give their spent grain to local farmers to use as livestock feed. LAB goes one step further and owns a small cattle farm in Leicester. The cows are fed the brewery's spent grain and then used for beef in the restaurant.

Ben Pierson, former Lexington Avenue Brewing and Green Man Brewing brewer, and David Keller, home brewer and MALT founder, after winning a bronze medal from the Great American Beer Festival for a brown porter. Keller helped Pierson bottle all the competition beers. *Courtesy of Ben Pierson.*

Ben Pierson, who formerly brewed for Green Man, was the LAB's first brewer. He left in the spring of 2012 after a contract dispute. At the time of publication, former assistant brewer Chris Whitted is at the LAB's brewing helm. The LAB became the first Asheville brewery to win an award at the Great American Beer Festival when the brown porter got bronze in 2011.

"I have been proud of all my beers, especially a raspberry wheat ale first made at Blue Ridge Brewing Company, in Greenville, South Carolina, and a recipient of a gold medal at the World Beer Championship while at the LAB," Pierson said. "I'm also proud of my brown porter, made originally with Wolfgang's Brewery in O'Fallon, Illinois."

In the summer of 2012, the LAB was just a few months away from expanding the brewery and adding another taproom in the building next door. The former site of an A&P grocery store will house, at the least, a lot more tanks and, at the most, a second brewery. Mike also plans to include a packaging line as well, and he's leaning toward canning. "I want to start slow, like we did with the LAB. We'll do local self-distribution and get into some

bars and restaurants first, then see what happens," Mike said. Thus far, LAB beers have only been sold on-site at the pub.

The front part of the new brewery will offer a tasting room, with pub food that will offer a "different vibe" from the LAB. Mike plans to furnish it with communal Oktoberfest-style tables and serve quick and easy "beer food." There also will be a sidewalk window, where folks can order a brat to go (a sausage, not a child).

South Lexington Avenue has seen remarkable changes in the past few years, thanks in part to the LAB, which attracts a hip crowd most every night.

NANTAHALA BREWING COMPANY

Nantahala Brewing was founded in 2010 in the far western reaches of the state, closer to Tennessee than to Asheville, in Bryson City, one of the outdoor adventure centers of the Smoky Mountains.

Motorcycle enthusiasts and award-winning home brewers Chris and Cristina Collier stopped in Bryson for a night after riding the nearby Tail of the Dragon, one of the world's foremost biking roads. They were having a beer at the Fremont Inn bar when Mike Marsden, owner of Across the Trax restaurant, wandered in. Mike had been thinking about starting a small brewery in the back of his restaurant, and the threesome started talking beer. They hit it off and spent the evening drawing plans for a Bryson City brewery on a napkin.

Soon after, the new business partners realized that they needed both marketing help and more capital, so they knocked on the door of Joe Rowland, owner of a kayaking company called Paddlefish. Joe had marketing experience and connections from working in the liquor marketing industry. He contacted Greenville businessman Ken Smith for help. Smith became an investor, and remarkably soon, Joe, Mike and the Colliers were buying used brewing equipment from R.J. Rocker's in Spartanburg, South Carolina. They set it up in a ten-thousand-square-foot Quonset hut across from the Great Smoky Mountain Railroad Depot, which offers passenger excursions on the train.

In an interesting related story, the Quonset hut that houses Nantahala Brewing is owned by Tom Hurley, as are a number of downtown Bryson City buildings that house bars. Hurley moved to Bryson from Florida, where

Cristina and Chris Collier helped found (and served as the first brewers of) Nantahala Brewing Company in Bryson City, North Carolina. *Photo by Anne Fitten Glenn.*

he'd owned a number of Cheetah strip clubs, and he spearheaded the "wet" vote for Bryson City. The rest of Swain County remains "dry."

The Colliers kept their day jobs in Atlanta but spent every weekend brewing in Bryson. NBC started selling out of beer almost the day it opened in 2009. The combination of a savvy brand and great product quickly propelled NBC's beers into restaurants throughout WNC. Its tagline, "Water is for quitters," penned by Joe, clearly resonates with beer drinkers.

"We always make a great product despite the cost. It's expensive and time consuming to brew our IPA, and it doesn't sell as well as our blonde, but it's so worth it," Joe said. The Noon Day IPA has gained a following and is now distributed all over the state by Next Generation Beer Company.

Nantahala Brewing's taproom opened in 2010. Soon after that, Joe and Ken bought out Mike and then, a year later, the Colliers as well. Greg Geiger, a longtime home brewer and former industrial engineer, took over as head brewer.

Like most every small brewery around here, NBC is expanding by adding more fermenters and bright tanks to its 10 barrel system. In 2012, it was on track to produce 1,800 barrels, after brewing 1,100 the previous year

and only 500 in its first year. Greg and a friend designed a bottler that fills growlers and 22-ounce and 750-milliliter bottles. The business is also adding another small bar with six taps in the front of its building, which will offer expanded hours.

Oh, and if you want to rent a kayak before happy hour, see Joe. He still owns Paddlefish and runs that business out of the front of the brewery's building.

THIRSTY MONK BREWERY

The Thirsty Monk has become one of Asheville's favorite beer bars, and so it seems natural that the Monk would add a small brewing system and start brewing its own.

Barry Bialik, a former alternative newspaper publisher and real estate developer in Anchorage, Alaska, kept hearing great things about Asheville. In 2007, he flew here for a visit and liked it so much that he put an offer in on a house. He'd planned to start an alternative music club in Anchorage, but the space he had leased was too close to a church for him to get a liquor license, so he turned it into a teen club. After about a year of managing a teen club, Barry was ready to move on.

Barry was interested in Belgian beer, so after arriving in Asheville, he decided to open a Belgian beer bar. The basement of a building on Patton Avenue that had previously housed Hookah Joe's Hookah Bar was for lease. Barry purchased the entire building. He opened the Monk several months later in 2008. A few months after that, the shop that had been renting the ground floor of the building closed, and Barry decided to open that level as an American craft beer bar. The philosophy is to offer constantly rotating taps and never tap the same beer twice in a row. Barry also tries to offer as many rare and unusual beers as possible on the Monk's forty taps. He's helped in this goal by General Manager and Beer Director Caroline Forsman, who makes it her mission to find the best and most unique American craft beers available.

Local home brewer Norm Penn was a regular at the Monk, and he and Barry became friends. When Barry opened a second Monk location, in 2010, the duo cooked up the plan to put a one-barrel brew house in the kitchen area of the Monk Pub South. In October 2012, Norm started rolling out his first brews. Norm releases one or two beers every Thursday. True to the Monk philosophy, it's never the same beers in a row. Initially,

Barry Bialik, owner and founder of Thirsty Monk Brewery, in the Belgian bar area of his pub, Asheville's Thirsty Monk. *Photo by Anne Fitten Glenn.*

Barry wanted to put some of Norm's beers on tap at the downtown bar, but the beers have been so popular that they disappear from the South location faster than Norm can replenish them.

"Adding the brewery gave the South location its own identity," Barry said. "Now it's the Monk Pub and Brewery."

Barry plans to renovate the South location to make it feel more like a brewery by bringing the fermenters out into the bar. He's also considered contract brewing with a local brewery. "Although too much growth kind of defeats the purpose of creating regular one-off beers," he said. The whole nano-brewing movement is part of what attracts Barry. After all, his other business is the Compact Cottage Company, a design/build contractor of tiny houses. Barry is adding a "private" club on the third level of the Patton Avenue building. Nuns on Top will offer flights of high-end whiskey to members.

Scotland on top, America in the middle and Belgium below—it's a veritable United Nations of alcoholic beverages at the downtown Monk.

The Spokes on the Hubcap

C raft beer has become big business in Asheville, and as often happens, beer-related businesses have followed. These businesses, from retailers to home brew shops to a shampoo manufacturer, are the spokes on the brewery hubcap. New hops farms and a micro-malt house work to supply brewers with locally sourced ingredients for their brews. A trade association, the Asheville Brewers Alliance, has become the "voice" of WNC breweries. As a result of that and other beer industry alliances, Asheville Beer Week debuted in 2012. These side businesses may have as important a long-term economic impact as the breweries themselves.

HOPS AND MALTS

What's old can become new again—from fashion trends to beer recipes to ways of producing the ingredients in those brews. While the return of bell-bottom pants doesn't warm my heart, the return of regional hops farms and a micro-malt house does give me a glow—and not just because those businesses equal beer in my belly.

Hops Farming

In the old days, folks would often keep one or two hops bines (bines, not vines) near their homes or farms. They would stuff the fresh flowers into pillowcases to use as sleep aids. Hops tea was also used as a digestive. Nowadays, a number of local farms are growing hops commercially for use in beer. They've had some success with different varieties of the plant, but they continue to look for some of those "native" hop plants to cross them with in order to improve yield in Western North Carolina's damp, insect-laden climate. Hops tend to grow best in the western part of the country (Washington State and Oregon). Western North Carolina is at the southernmost edge of successful hops production on the East Coast. But that's not stopping these local farmers.

Julie Jensen started growing hops at her Echoview Farm in Weaverville, just north of Asheville, in 2007. Hops are a three-year perennial, but she said that she's had success from day one growing nine varieties of hops. A number of local brewers have made small batches using Julie's hops, and she hopes that, as her harvest increases, more will take advantage of the opportunity to create North Carolina–sourced brews. Fresh hops don't stay that way for more than about a day, so most hops are dried and pelletized for use in brewing. Echoview has a drying kiln and a pelletizer, which makes its hops viable for longer.

Van Burnette is another Western North Carolinian growing hops on his family farm, Hop'n Blueberry, in Black Mountain. Since 2009, Van has transitioned from a cattle business to a hops and blueberry farm. Pisgah Brewing makes an annual "wet" hop ale with fresh hops that Van trucks over to the nearby brewery just after picking them. Burnette's Brew often uses most of Van's harvest, but the result is worth it.

Both farms are all-organic, which means no spraying garden pests that want to eat the plants. A few other hops farms have recently opened in WNC, including Blue Ridge Hops in Marshall and Winding River Hops in Clyde.

To learn more about hops, North Carolina State University has partnered with the North Carolina Cooperative Extension office and built a hops yard in Mills River, just down the road from Sierra Nevada's new brewery. There are sixteen varieties of hops being cultivated there, to see which ones do best in this climate. "There are no southeastern hops experts at this time," said Jeanine Davis, professor and extension specialist with NC State. "Local home brewers who are growing their own hops probably know more than anyone else right now."

While hops farming is still in the experimental stages, the hope is that the plant will become a decent cash crop for the region. "After all, hops are a cousin to marijuana, and we know that grows well around here," quipped Oscar Wong when speaking on a panel about local beer.

Riverbend Malt House

Home brewer Brent Manning produces all North Carolina–sourced beers on a regular basis with hops from Echoview Farm. He has access to the only locally produced malt in the area since he's co-owner of Riverbend Malt House in Asheville.

There's no standard definition for a micro-malt house, though Brent said that the micros he's familiar with produce less than 100,000 tons of malt annually. Micros also tend to specialize in regionally grown, specialty and artisan grains. A large part of Riverbend's business consists of providing custom orders for breweries that want to create "grain to glass" brews.

Let's take it back a step. Malt is one of the primary ingredients in beer. It's basically a grain—typically barley, wheat or rye—which has been germinated and then dried in a kiln. The process of malting develops the enzymes necessary to develop the grain's starches into sugars. Malted grains are used to make beer, whiskey, malt vinegar and the malted milk balls that most of us only eat in movie theaters. Riverbend also uses the old-fashioned floor-malting technique to germinate the grain, which is particularly labor-intensive.

After two years of research and study, Brent and business partner Brian Simpson opened the doors to Riverbend Malt in 2009. The former environmental consultants wondered why none of the barley grown in North Carolina was used to make North Carolina beer. In fact, most of the barley grown on the East Coast becomes livestock feed. However, farmers Buddy and Chris Hoffner of Salisbury, North Carolina, are now growing barley and one type of wheat for Riverbend. While maltsters can make malt year round, the grains can only be grown during the warm months. The maltsters start working with regional farmers months beforehand on grain varieties and amounts of acreage dedicated to next summer's crops.

While 100,000 tons of barley may seem like a lot of grain, Brent put it into perspective for me—each ton of malted grain typically supplies one run of beer through a thirty-barrel brewing system. Thus, a brewery with a fifty-barrel system (such as Highland) uses six to eight tons of grain weekly, he said.

From farmer to maltser to brewer to beer drinker—all within a few hundred miles. It's a locavore's dream.

Note: Small portions of this section on local malt are excerpted from an article I wrote on micro-malthouses for craftbeer.com.

Hub Businesses and Organizations Add to Liquid Assets

Home Brew Shops

Andy Dahm, current manager and co-owner at French Broad Brewery, also serves as a lifeline for folks who love to make their own beer. Dahm opened Asheville Brewers Supply on April Fools' Day in 1994 on Wall

Alex Buerkholtz, co-owner of Hops & Vines, teaching a home brewing class in the back of his Asheville home brew and bottle shop. *Photo by Anne Fitten Glenn.*

Street downtown. Andy had been brewing his own beer for years, following a Germanic family tradition, when he noticed that there wasn't "a good, affordable home brew shop" in the area.

The store moved to Merrimon Avenue in 2007 because finding parking and unloading freight was difficult downtown. Andy also sells supplies wholesale to breweries, including many of Asheville's breweries. He travels to consult with microbreweries and brewpubs that are having problems with their beer production. "I basically go in and tell them to sanitize their equipment," he said. "The three rules of brewing are clean, clean and clean."

Another home brew supply store, Hops & Vines, opened in west Asheville in 2008. Owner and award-winning home brewer Alex Buerckholtz once worked at Asheville Brewers Supply. Hops & Vines is also a bottle shop, selling craft beer and wine. Alex regularly teaches home brewing classes there as well.

Nothing but Craft Beer

Julie and Jason Atallah moved to Asheville from Charlotte with the sole purpose of opening a beer-only retail shop. In December 2006, that's exactly what they did. With more than one thousand constantly rotating beers, varying by season, from all over the country, the world and just around the corner, Bruisin' Ales is the best candy store ever for beer lovers. "Our whole identity is just being a beer store," Jason said. "We only found out later that we were only one of a few beer-only stores in the country."

Customers travel from far and wide to sample Bruisin' Ales' wares. The business has regulars from Tennessee, South Carolina and Georgia. Co-owner Julie's social media savvy and sparkly personality also contribute to the shop's popularity (@bruisinales has close to seven thousand Twitter followers). Regular free beer tastings have become a must for area beer connoisseurs. Just remember, the name Bruisin' Ales isn't a boxing reference; it's a play on words. Brews and ales—get it?

Other bottle shops featuring a variety of craft brews include Appalachian Vintner, Asheville Wine Market, Earth Fare Supermarket, Green Life Grocery, Hops & Vines, Ingles Markets and the Weinhaus. One of the pluses of living in Beer City, USA, is that pride in our local breweries means many of the area's grocery and convenience stores carry their beers.

Julie and Jason Atallah, co-owners of Bruisin' Ales, Asheville's first and only all-beer shop. With more than one thousand different beers from hundreds of breweries around the world, it's a beer lover's candy shop. *Photo by Anne Fitten Glenn.*

From the Saloon to the Salon

One of the more interesting hub businesses to debut in Asheville is Broo Shampoo, an all-natural shampoo chock full of Highland Brewing's St. Therese's Pale Ale.

Brad and Sarah Pearsall of Asheville started the shampoo and body wash business in 2011 and now are selling their products in Whole Foods Markets all over the nation. The body wash contains Highland's Oatmeal Porter. Thus, a few Highland beers get national distribution, though not in drinkable form.

During testing, Sarah said that she tried every local beer she could find on her hair, from French Broad Brewing's Kolsch to Asheville Brewing's Ninja Porter. The couple even made a home brew, which they said was a disaster. Ultimately, Sarah decided that her favorite beer, at least for hair, is St. Therese's Pale Ale.

The couple then set up a meeting with Highland's Oscar Wong and John Lyda. "They laughed when we told them we wanted to use the beer they were

making for people to drink [for] shampoo," said Brad. "But Oscar gave us a case of St. Therese's to try it out." Now Highland sells cases of St. Therese's to the Pearsalls to make shampoo. "I think it's pretty cool actually," John said. "We don't do anything special to the beer, and the stuff works great."

"Salon performance with craft beer attitude is our motto," Brad said.

Beer in Your Hand

Another fun and local beer-related business is Oowie Koozie, maker of handcrafted leather "koozies" embossed with brewery or business names. Different sizes work on standard pint glasses, bottles or cans (although I recommend you always drink craft beer from glassware). The business originated the idea of wrapping beer with leather and have a patent pending.

At various times, local businesses have put beer in soap, candles and lip gloss. Our local breweries also help support a variety of merchandise designers, printers and retailers that profit from the ubiquitous beer branding on T-shirts, ball caps, hoodies and more.

Asheville Brews Cruise

Mark and Trish Lyons started Asheville Brews Cruise in 2006. The business, which takes folks on brewery tours and includes tastings, is going gangbusters. Now there are Brews Cruises in Denver, Nashville, Charleston and Atlanta. The Lyonses now live in Bend, Oregon, and Mark works for Deschutes Brewery (which is not opening an East Coast facility in Asheville). Joe Sollazo now owns the Asheville Brews Cruise, although the Lyonses still help organize Asheville's Winter Warmer Beer Festival. Shawna Hart, Asheville Brews Cruise general manager, shows folks who want to learn about Asheville beer a grand tour.

Visit Breweries by Foot

While Brews Cruise offers both walking and van tours, a few other tour businesses require customers to use their feet only. Josh Bailey and Stephen Steibel of Eating Asheville offer walking brewery tours of downtown. Participants visit five breweries, getting tastes of three or four beers at

each one (and snacks at a couple). In addition, walkers get a bit of brewing education, beer history and general Asheville history.

Asheville Running Tours offers "The Original Asheville Beer Run," which also visits five breweries downtown but moves a little quicker than the other tours. The business offers both a 5K distance and a two-mile distance but promises that you'll run "at a social pace."

Asheville Beer Week

Lots of cities have one. Beer City, USA, however, didn't. So some folks who love beer (a lot) decided that we wanted one. Thus was born Asheville Beer Week. While it's not a beer-related business, per se, Asheville Beer Week supports so many local businesses that its story seems to fit in this chapter.

Over a number of pitchers of local brew starting in the late fall of 2012, several regional beer industry people (including me) brainstormed about what we wanted the inaugural AVL Beer Week to look like. First of all, there would be way too many events to fit into a measly seven-day week. Our week must encompass eleven beer-filled days and nights. (Did you know that beer drinkers have the ability to manipulate time? They do.)

Second, we needed a mascot. Since we really don't care, we chose the crazy honey badger, which has nothing to do with beer, but hey, we were drinking, and we like his attitude. (If you're one of the few people with Internet access who has yet to see the viral Honey Badger YouTube video, go Google "Crazy Honey Badger." Be warned that there's inappropriate language.)

Third, Asheville Beer Week needed a mission statement. In a moment of drunken grandiosity, I came up with this: Our mission is to celebrate that nectar known as beer—to taste many different styles and variations of beer; to pair beer with a smorgasbord of delicious foods; to learn about and explore beer in all its delectable complexity; and, most of all, to have fun drinking in the brew-centric mountains of Asheville.

Then (oh yeah) we needed events—dinners, special tastings, tap takeovers, beer education classes, beer celebrity appearances and more. Organizing all of these would prove a bit more challenging than the initial three items mentioned. Luckily, some networking, e-mailing and social media chatter helped populate the Asheville Beer Week calendar. We ended up with an amazing diversity of exciting events: a free glass-trading party, a home-brewing fest, a beer forum with beer sommelier

Greg Engert, a Root Ball beer tourney and the third Beer City Fest. Restaurants, bars, stores and, of course, breweries located all over town (and beyond) got involved.

In addition to myself, the first Asheville Beer Week organizing committee consisted of Julie Atallah of Bruisin' Ales, Caroline Forsman of the Thirsty Monk, T.J. Gardner of Empire Distributors, Mary Eliza McRae of Budweiser of Asheville, Mike Rangel of Asheville Brewing Company, Adam Reinke of Mountain Ale and Lager Tasters (MALT), Jimi Rentz of Barley's Taproom and Simone Seitz, formerly of Pisgah and Craggie Brewing.

It's highly likely that Asheville Beer Week will take place every spring.

Note: Portions of this section are excerpted from an article I wrote for Mountain Xpress.

Beer Clubs

There are even beer cliques and clubs here, and they're all extremely savvy when it comes to social media. Twitter chatter? Yes, indeed—the #avlbeer hash tag is quite popular.

The Asheville Brewers Alliance is one such "club," and it works to promote regional brews and maintain interbrewery peace. A group of women who meet regularly to drink, talk and learn about beer call themselves the Asheville Beer Divas. The Asheville Beer Masters Tournament, a series of tests of beer knowledge and passion organized by craft beer goddess Mary Eliza McRae, has seen two winners: Trevor Reis in 2011 and Adam Reinke in 2012. Then there's MALT, a vibrant home brew club that's been meeting regularly since 1997 and now has more than one hundred members, per founding member Dave Keller.

There's even a group of drinkers with a running problem. The Asheville Hash House Harriers was organized in 2008, although there are "H3" groups all over the world. The noncompetitive drinking, running and social clubs got their start back in the late 1930s when bored British colonial officers were looking for fun while stationed in Malaysia. The Asheville "kennel" has a particular fondness for local craft beer and offers monthly, if not weekly, runs between breweries and brewpubs all over WNC.

Asheville Brewers Alliance

In February 2009, a group of Asheville-based brewers created the Asheville Brewers Alliance, a trade and membership organization dedicated to promoting the fast-growing craft beer scene.

Spearheaded by Asheville Brewing Company president Mike Rangel, the group initially came under fire for limiting membership to Asheville-based breweries. The organization has since expanded to include any WNC brewery that wants to be a member. "We realized that Pisgah is an important player in the area beer scene and needed to be included," Mike said.

The ABA has slowly expanded to include other breweries outside Asheville and now has a few brewpubs and Bruisin' Ales as members. "Asheville" remains in the organization's name because, as Mike said, "Every one recognizes the Asheville name, but not many people know where Western North Carolina is." Indeed, that was the rationale for titling this book *Asheville Beer*.

"The ABA is the most cooperative competitive group ever. Having all these people together in one room is both awesome and like herding cats," said Andy Dahm of French Broad Brewing. Mike was the first president of the group, followed by Tim Schaller of Wedge and then John Lyda of Highland. Part of the goal of the group is to put competitive differences aside and work together to support all craft beer in the region.

"If craft beer is at 5 percent of beer sales, our goal is to push it to 6 or 7 percent, not to grab as much of the 5 percent as possible," said Oscar Wong.

It will be interesting to see how the ABA continues to grow as more and more breweries open and want a slice of the pie. Despite the camaraderie, competition for tap handles, both in restaurants and bars and at local festivals, can be fierce. Of course, these breweries aren't competing just against one another, but against the domestic breweries as well. They'll soon also be competing with a few much larger craft breweries that are opening second breweries here. Of course, while much of that beer will be distributed elsewhere in the nation, it will be intriguing to see how much Asheville beer drinkers embrace the new players on the block as "local."

The Big Boys and Girls
Want to Play Here Too

When an area rife with protected forests, wild rivers and smoky, layered peaks is also home to thousands of enthusiastic craft beer drinkers and an unusually high number of craft breweries, amazing things can happen—like when Sierra Nevada Brewing Company, New Belgium Brewing Company and Oskar Blues Brewery all decided, within about four months of one another in early 2012, to open second breweries in or near Asheville. Holy hops.

"It's as if Asheville landed two major-league baseball teams in the same season, as if the Yankees and Braves both relocated here," wrote Tony Kiss, after the Sierra and New Belgium announcements. Or, to be more geographically appropriate, as if the Giants and the Rockies both relocated here. Then a few months later, when Oskar joined the crew, the greater Asheville area scored another major-league player.

All three breweries are ranked in the top fifty largest U.S. breweries by sales volume by the Brewers Association. In 2012, Sierra was ranked number two, New Belgium number three and Oskar Blues came in at no. 29 (so maybe Oskar rates as a Triple A team). Just for fun, compare these breweries' production numbers to Highland Brewing Company's. Currently the largest brewery in Western North Carolina, Highland produced about 23,000 barrels last year. Only a handful of the region's other breweries are batting 5,000. Sierra plans to start with a brewing capacity of about 300,000 in its new facility, while New Belgium reportedly will go for 400,000 and Oskar Blues about 40,000. And those are just the first-year predictions. In

three fell swoops, these companies will effectively produce more than fifteen times the volume of beer being made by the breweries currently operating in Western North Carolina. Of course, most of that beer will be shipped up and down the East Coast. Otherwise, we'd be drowning in suds.

The big boys and girls will bring an ever-increasing number of beer tourists. They will bring money and jobs and trainloads of hops and grains. They will bring new people, new ideas and research and development labs the likes of which have never been seen around here. But most significantly, for those of us beer lovers who live nearby, they will bring more fresh, locally crafted beers to the area.

"We don't want to come here with attitude of, 'Our beer is way better and let us tell you how to fix your beer,'" said Brian Grossman, co-manager of the new Sierra Nevada facility in Mills River and son of founder Ken Grossman. "We have some equipment that's very expensive, and brewers send us beer all the time to test it. We can offer research and development to smaller brewers that need it. We can offer raw material sourcing and handling. We've got 30 years of manpower, and we don't mind sharing."

By the end of 2012, Oskar Blues will be producing ales in Brevard, thirty or so miles southwest of Asheville. Then, just a year later, Sierra Nevada beer will do the same in the tiny municipality of Mills River, twelve miles south of Asheville. A few years after that, in 2015, New Belgium will start brewing some of its concoctions in Asheville's River Arts District.

It's been quite the roller coaster ride, and here's how it all went down.

WHY WESTERN NORTH CAROLINA?

The big "joke" at the 2012 Craft Beer Conference in San Diego was that there would be a seminar called "So You Want to Start a Brewery in North Carolina." This was right when Oskar Blues let the word out that they, too, were opening a brewery in the state. Perhaps, a more appropriate title would have been "So You Want to Start a Brewery in Western North Carolina."

All three of the big breweries cited similar reasons for choosing WNC as their second homes. All mention the natural beauty of the area and easy access to wilderness. In that, they follow a popular "second home" tradition dating back to the late 1800s.

Let's take a slight step back, though. All three breweries are approaching capacity in their current facilities. Sierra is on track to produce close to 1 million barrels of beer at its brewery in Chico, California, in 2012. New Belgium will produce more than 775,000 barrels in Fort Collins, and Oskar Blues is closing in on 90,000 in Longmont, Colorado.

Then there's the distribution aspect. These three breweries distribute lots of beer up and down the East Coast, and it's expensive to transport heavy kegs and bottles in refrigerated trucks across the country. Sierra's assistant brew master and field educator, Terrence Sullivan, said that the brewery spends about $10 million annually shipping its beer, which is sold in every state in the country. Thus, it makes sense to brew beer at opposite ends of this ginormous country.

There's also the environmental cost, which each of these businesses cares about immensely. "We really wanted to decrease carbon footprint. And so it made sense to build an East Coast facility rather than to expand our existing facility in Chico," said Brian. "Building a brewery isn't cheap, but in the long run, it'll be less expensive and better for the environment to produce beer on both sides of the country."

There are other pros to opening a brewery in WNC as well. "There's great water," Brian added. "Water is between 90 and 95 percent of beer. You've also got an educated craft beer drinking base, and you've got the right mindset when comes to the environmental part." Sierra Nevada drilled for water at its new site and was lucky enough to find a deep, pristine aquifer. The well, which has been lined with stainless steel seventy-five feet down, will provide most of the water needed for brewing at that facility.

Dale Katechis, founder and owner of Oskar Blues, agreed: "The water quality is spectacular. It doesn't even look like we're going to need to do anything to it."

"The water here is similar to Fort Collins," said Jenn Vervier, New Belgium's director of sustainability. "But it's a lot more plentiful here."

It also turns out that all three of the western towns in which these big breweries got their starts—Chico, Fort Collins and Longmont—are similar in terms of being centers for outdoor adventures and progressive lifestyles. Ardent mountain biker Dale said that one of the primary reasons he wanted to put a brewery in Brevard is because of easy access to biking trails.

"We have a young, diverse population here that are into the outdoors," Brian said of Chico. "I'm an avid biker, hunter and backpacker. I wanted to find a city with similar values."

Also paving the way for both Sierra and New Belgium was the passage of North Carolina Bill H796 in November 2011, which allows all licensed breweries in the state to sell their products on-site. This bill was designed specially to make the state more attractive to Sierra Nevada and New Belgium.

Before the law was passed, only breweries that produced fewer than twenty-five thousand barrels per year could sell beer on-site. Thus far, no brewery has surpassed that limit, although Highland Brewing likely will do so in 2013. But the change means that these big breweries can open tasting rooms and sell their beers, even the ones that aren't brewed in North Carolina, from their new facilities. The law helps Oskar Blues as well, even though enticing that brewery wasn't considered when the bill was written.

Sierra Nevada Makes the First Move

Rumors started circulating in the spring of 2011 that Sierra Nevada Brewing Company was hunting for an East Coast location for a second facility and that Asheville might be on the shortlist. However, Brian said that initially, the city was not on that list. "We had heard a lot about Asheville, but we initially ixnayed Asheville because we didn't want to have the stigma of being the big brewery coming in with so many smaller breweries already here," he said.

In fact, the Sierra Nevada team cut its list of cities from hundreds down to twenty. Then the team—which included founder and CEO Ken Grossman, Brian and logistics manager Stan Cooper—visited the five finalists and settled on two potential sites: Knoxville, Tennessee, and Roanoke, Virginia. "Then we got wind that Asheville would be a really good fit and that the brewers already there would be okay with us being there," Brian said. "Initially, one of our criteria was that we didn't want to be within fifty miles of another brewery. Obviously, that flew out the window."

Ken Grossman and Paul Camusi founded Sierra Nevada in 1980. Sierra's Pale Ale is well known and loved nationwide. It's currently second in sales of U.S. craft beers only to Samuel Adams Boston Lager. The team decided that a trip to Asheville was in order because, said Brian, "We didn't want to have buyer's remorse on a decision like this."

From the moment they got off the airplane, the Asheville magic grabbed hold of them. "We said, 'Oh my God, this is Portland meets Berkeley meets Chico.' We fell in love with the area immediately," Brian said. The crew

started doing their due diligence and discovered that perhaps being close to not just one but more than ten breweries might not be so bad after all. "Stan and Dad and me went into bars. We weren't wearing branding at all, but people were so friendly," Brian said. "They kept asking what we did and why we were asking so many questions."

The team looked at all kinds of criteria, from cost of living to schools to crime rates to living wages to recycling programs. Access to an airport and distribution channels via rail and highway were also crucial. After looking all around WNC, Sierra landed on a nearly one-hundred-acre site next to the French Broad River in Ferncliff Industrial Park.

In late spring 2012, site preparation started, and Stan Cooper and his family moved to the area in the summer. Brian and his wife, Gina, will move in the fall. Stan and Brian will co-manage the new facility. Brewer Scott Jennings and family will most likely move to the area next fall as well. Scott will become the head brewer in Mills River. He has worked for Sierra since 2001 and has been in charge of the brewery's ten-barrel pilot brew house since 2004, where most of the in-depth technical research and recipe development takes place. Brian promised that the local taproom will "get a bunch of weird one-off beers that move really fast."

The facility will have a restaurant, a taproom and a gift store. The goal is to get North Carolina–brewed beer out the door by the end of 2013, as least in kegs. Packaging will follow soon. A bottling line, for sure, although canning may be on the agenda as well. "Building a brewery of this size from scratch is a daunting challenge, but we're up for it," Brian said. The new plant will employ 90 to 100 people full-time. The restaurant likely will employ another 50. Initial capacity will be 300,000 barrels a year, building up to 600,000 over time.

When local brewers first heard Sierra Nevada and New Belgium might come to the area, there was a good bit of concern. Feathers were ruffled about potential incentive packages from city, county and state governments for both Sierra Nevada and New Belgium. Schaller emphasized that it's important to the ABA that when these breweries come to the area the jobs they provide go primarily to area residents. "It's not a job creation program if the business brings in all their people from elsewhere," said Tim Schaller. "Although personally, I'm looking forward to drinking more great beer that's brewed here." Sierra will receive about $6.1 million in incentives that will be repaid from tax revenue or go to site improvements such as roads, drainage and lighting. That's a drop in the growler compared to what the company will spend to build the new brewery.

The Sierra team visited several times before the announcement, partially to meet with local brewers and discuss their concerns. "There was a lot of open and honest dialogue," Tim said. "We felt like they really listened." To sweeten the relationship further, Sierra invited a group of ABA brewers and brewery owners to attend a special session of Sierra Nevada Brewing's Beer Camp in Chico, in the summer of 2012.

Ken Grossman had told Tim that Sierra wanted to bring ABA members to Chico to promote partnership rather than competition among its "new family." "They're definitely family now," Tim said. The camp consisted of a three-day intensive course on the workings of the huge production facility. Most importantly, the ABA campers got to brew a couple of beers using Sierra's state-of-the-art equipment. Because the group was so large, it was divided into two brewing groups and brewed two different beers. Each brewery will receive a keg of the beer it brewed.

"We all learned a lot," Tim said. "For me, it was interesting to see how Ken has done everything environmentally correctly for 30 years just because it's the right thing to do, but it's also turned out to be an economic boon for the company."

What Exactly Is a Craft Brewery?

How are these large corporations, such as Sierra Nevada and New Belgium Brewing, which are spending hundreds of millions of dollars to build new facilities and producing so much beer, still considered craft brewers? What exactly is a craft brewery? The Brewers Association, the trade organization that represents the majority of U.S. brewing companies, defines an American craft brewer as fitting three criteria. It must be small, traditional and independent.

This begs the question of how millions of barrels of annual beer production can be considered "small."

The truth is that it wasn't—until recently. The BA's board of directors voted to change the definition of "small" in 2011. They increased the maximum allowable annual barrelage for a "craft" brewer from 2 million to 6 million. It seems that "small" no longer truly defines the industry of craft brewing in terms of growth. The country's largest craft brewer, the Boston Beer Company (maker of the Samuel Adams brand), has surpassed the 2-million-barrel mark. Of course, 6 million seems a long way off for any of these breweries. Even with two breweries up and running

on opposite sides of the country, it's likely to be a good long time before either Sierra or New Belgium come near that ceiling.

"Traditional" means the brewer has an all-malt flagship beer or that at least 50 percent of its volume is all-malt beers (beers that use adjuncts to enhance not lighten flavor). In other words, if most of your beer is brewed with corn or rice adjuncts instead of malted grains, you're not a traditional brewer.

The BA defines "independent" as meaning less than 25 percent of the brewery is owned or controlled by an alcoholic beverage industry member who is not a craft brewer. If InBev only owns 20 percent of your craft brewery, you're okay.

As the craft beer business has grown and evolved, so has its definition. And it probably will continue to be tweaked as brewers push the limits of what it means to be "craft."

NEW BELGIUM BREWING COMPANY

Just two months after Sierra's announcement, New Belgium Brewing Company chose Asheville to be the home of its second brewery and distribution center.

In the parking lot of the Asheville Chamber of Commerce, North Carolina governor Bev Perdue and Kim Jordan, New Belgium's CEO and co-founder, announced to a crowd of officials, media and exuberant beer lovers that the company will build a brewery on the site of the former Western Carolina Livestock Market on Craven Street in the River Arts District. The brewery promises to invest more than $175 million over seven years and create more than 150 new jobs.

"We picked you; we picked Asheville," Kim said, as she toasted those gathered under a large tent during a torrential rainstorm. She joked about the rain and said that the first time she and her team met with City of Asheville representatives, they, "riffed on storm water management, and we felt like we'd met kindred spirits." Less than a month earlier, the Asheville City Council rezoned the site next to the French Broad River from Urban Village back to a less restrictive River District designation. The almost twenty-acre site is a designated brownfield and thus will need to be revitalized.

North Carolina governor Bev Perdue, New Belgium CEO Kim Jordan and Asheville Brewers Alliance president Tim Schaller talk and toast after New Belgium Brewing's formal announcement that the company would build a second brewery in Asheville. *Photo by Anne Fitten Glenn.*

New Belgium started looking at locations for a second brewery in 2009, said Jenn Vervier, the company's director of sustainability and strategic development. She said that the selection team came up with an analytics program that measured thirty different indices—from environmentally focused to progressive community to vibrant downtown to fun. With that tool, the team came up with a list of twenty cities, of which Asheville was one. Jenn then set out to visit each one. She said that she was at The Market Place Restaurant her first day in town, went into the bathroom and texted her team the words, "I heart Asheville."

When Jenn first visited the Craven Street site, she wasn't convinced, however, that Asheville hearted her back. "We were looking for an opportunity for brown field redevelopment, but that site is a challenge. I wasn't even sure at first if we could physically put a brewery there," she said. But she felt like this was the right place, so she persisted. In the fall of 2011, the management team visited its top four cities and afterward decided that the race was between Philadelphia and Asheville. "We're taking the 20

to 30 year long-term view of doing business, however, and Asheville seems more sustainable from that perspective," Jenn said. Ultimately, the site was selected because of Asheville's proximity to East Coast markets, water quality and community commitment to sustainability. "Also, it's a great beer town," she added. She said that once the company found out Sierra Nevada was building in the area as well, New Belgium was too invested in Asheville to pull out.

New Belgium plans to break ground in early 2013 and begin production in 2015. While hiring won't start until the end of 2014, the average annual employee salary will exceed $50,000. The City of Asheville has offered New Belgium $3.5 million in tax reimbursements over seven years. Kim also said that the company will work with the city and the county on public infrastructure improvements in the River Arts District to roads, sideways, bike lanes, greenways and water management consistent with the Wilma Dykeman Riverway Plan.

"The Brewers Alliance welcomes New Belgium. They'll be a great economic asset and should bring in an influx of beer tourists," Tim Schaller said. "Our responsibility as brewers now is to make great beer and continue to educate people about our beer, as we've been doing with our Beer 101 classes."

Kim emphasized the company's commitment to working with the local brewers in "a spirit of collaboration" and "sharing our groovy toys"—a reference to the brewery's research and development equipment.

New Belgium opened for business in 1991. Some of its better-known beers are Fat Tire and Ranger IPA, which currently are distributed in twenty-eight states plus Washington, D.C. The company is 41 percent employee-owned.

Representatives from New Belgium Brewing have been holding community meetings in Asheville to answer questions and to present their design ideas.

Residents' concerns have ranged from traffic to job opportunities to maintaining the creative and artistic integrity of the RAD to environmental concerns to worries that odors that may emanate from the building. Speaking of the latter, NB Director of Engineering Jim Spencer said that most of the brewing vapor will be recaptured as part of the energy recovery program, but a slight aroma may escape now and again. I can't imagine boiling grain could possibly smell worse than what swirled up from the stockyards when they were there.

Like Sierra, NB plans to be just as green here as it is in its original facility. It is shooting for LEED Platinum certification, Jenn said. The site will offer a taproom, or "liquid center," as the New Belgium folks call it, for the public, as well as an outdoor venue for music acts, festivals and films.

Brewing capacity will probably be from about 350 to 400,000 barrels in 2015, but ultimately it will be about 700,000. The brewery will have a bottling line and possibly canning as well. Also, here's an interesting statistic for those interested in the beer tourist equation: the Fort Collins brewery brings in about 100,000 visitors annually. Jenn said that it's the biggest tourist attraction in that town, but it won't be the biggest in Asheville because the Biltmore Estate draws more than one million visitors per year.

Oskar Blues Brewery

I initially discounted the speculation that Oskar Blues Brewery of Longmont and Lyons, Colorado, might be interested in opening a brewery and restaurant in Brevard. I mean, come on! The number two and number three craft breweries had just announced that they'd be building second facilities in the area, so I assumed that people were beer-rumor drunk. It was just too good to be true.

I also heard that Deschutes Brewing out of Portland might be interested in opening a brewery in WNC. Nothing's come of that…yet. Mark Lyons, who works there, said it won't happen. And then, 21st Amendment Brewing out of San Francisco joked on Twitter that it would open a second brewery in Asheville. Months later, I'm still having to tell eager beer drinkers that it was a hoax.

However, when I got a text at 4:00 a.m. from Mary Eliza McRae, craft beer manager for Budweiser of Asheville, who was at the 2012 Craft Beer Conference in San Francisco, saying that Oskar Blues was coming to Brevard, I figured it was true. A few hours later, I got out of bed and started making phone calls, but no one seemed to know anything, not even the City of Brevard or the Brevard Chamber of Commerce.

Finally, I got in touch with John Felty, owner of Looking Glass Entertainment, and he confirmed that Oskar Blues had leased part of a warehouse on Railroad Avenue in Brevard as a brewing and canning facility and was looking for a space for a restaurant/taproom/music venue in downtown. John organizes Brevard's long-running Mountain Song Festival, which OB has sponsored for years. He's also good friends with Dale.

So why Brevard for Oskar? It's true that Dale loves to mountain bike, and Brevard does sit on the edge of Pisgah National Forest. "Certainly

mountain biking is part of the equation," said Chad Melis, Oskar Blues' marketing director. "But Brevard is also similar to Lyons, where we started. It's music rich, it's mountainous and there are lots of outdoor activities nearby. It reminds us of home." Plus, the Longmont production facility was reaching capacity, and OB already ships a good bit of beer to the eastern part of the nation. Its beers, including Dale's Pale Ale and Ten Fidy Imperial Stout, are currently distributed in twenty-seven states. Dale started the brewery in the basement of his restaurant in 1999. In 2002, OB became the first brewery to put craft beer in cans, thus starting what the pundits term the "Craft Can Revolution."

"Just shy of 40 percent of all the beer we make goes to the East Coast," Dale said. "So it makes sense to have a facility there. It looks like this project will pay for itself within two years."

Oskar Blues kind of swooped in, under the radar, and decided to lease a building. "That's what makes small breweries attractive. We're nimble. It's not our style to ask for government grants. We wanted to do this, so we just did it. Maybe they can take all that grant money and balance the budget with it," Dale said.

A few months later, OB moved the location of its planned brewing facility from Railroad Avenue to a newer building at 342 Mountain Industrial Drive in Brevard. That location will offer a taproom, according to Chad. There will still be an Oskar Blues restaurant, music venue and taproom in downtown Brevard, but that location has yet to be finalized. "This was a building we had our eye on originally but wasn't available," Chad said. "Since that has changed, we're getting after it. It's also along the bike trail in town, and we're looking for an Oskar Blues Taproom trailhead to connect into. There is also a BNSF railway there that they say is active; maybe we can get a beer train rolling?"

OB plans to start production in Brevard by December 2012 and will produce forty thousand barrels in its first year. Between the brewery and the restaurant, the business hopes to hire seventy-five to one hundred people, said Chad.

Chad noted that only twelve of the forty-five taps in the two Colorado tasting rooms are Oskar Blues beer, and he added, "What we're really trying to do is support craft beer. We have great relationships with Colorado brewers, both large and small. Our goal is to make that happen in North Carolina as well. We want to be part of the social fabric of the community."

Brewer Noah Tuttle and canning/production manager Eric Baumann have already moved to the Brevard area. A few other folks will be moving

from the brewery's home base in Colorado, but Dale said that OB will hire the other folks they need to get it all going from the local applicant pool.

Plans for the restaurant are still evolving, though Dale said that it will definitely feature a meat smoker, as the company's restaurant in Longmont does. That restaurant, Home Made Liquids & Solids, offers southern home cooking, including North Carolina–style barbecue, to Coloradoans. Dale was born and raised in Alabama.

Dale said that he's looking forward to spending lots of time here, although the father of four probably won't move to the area, at least not while his kids are still in school. OB will also offer some special beers just brewed here, including a collaboration beer with Asheville Brewing Company. Dale and Asheville Brewing Company head brewer Doug Riley knew each other in high school, and they can't wait to brew together. "I love the camaraderie of our business," Dale said. "I like working with other brewers. I also want to establish relationships with local farmers for the restaurant."

Clearly, the big boys and girls are game changers for what we now can call Beer Region, USA.

The Future's So Bright

The year 2012 likely will be remembered as one of the most interesting years in Asheville beer history. In the first few months of the year, three "big" craft breweries announced that they would open second facilities in the region. Five more small breweries fired up their brew kettles. Plus, another seven breweries announced plans to start up in the area. A couple announced in 2011 but took big steps toward that first exchange of dollar bills for pints in 2012. Yes, a total of eleven new breweries hope to get going in WNC in the next few years. All of this, plus the expansions of some of our existing breweries and the addition of an organized Asheville Beer Week is making for an intergalactic 2012 for craft beer around here.

While Western North Carolina stands on the cutting edge of the burgeoning beer business, the craft beer industry continues to expand nationwide as well. The Brewers Association statistics show that dollar sales for craft beer were up 14 percent in the first half of 2012, while sales volume increased by 12 percent in that time. That increase put craft beer on course to log its fastest annual growth in any year since 1996. As of August 6, 2012, the Colorado-based trade group counted 2,126 operating U.S. breweries, the most breweries in 125 years, with more than 1,252 in the planning stages. The country still hasn't caught up to the peak of American brewing in 1873, when there were 4,131 breweries.

As of August 2012, sixty-six breweries were operating in North Carolina, according to Win Bassett, director of the North Carolina Brewers Guild.

One of the most recent breweries to open, Tipping Point Brewing in Waynesville, raised the number of Western North Carolina breweries to nineteen (counting Asheville Brewing Company's two locations as separate breweries, which the state does). Of the twenty-five breweries in the planning stages in the state, eleven of those plan to brew in Western North Carolina.

It's an amazing time to be a craft beer enthusiast in America, for sure.

THE WAYNESVILLE THREE

Waynesville, North Carolina, was brewery-free for almost twenty years. While Smoky Mountain Brewery had a two-year stint as WNC's first

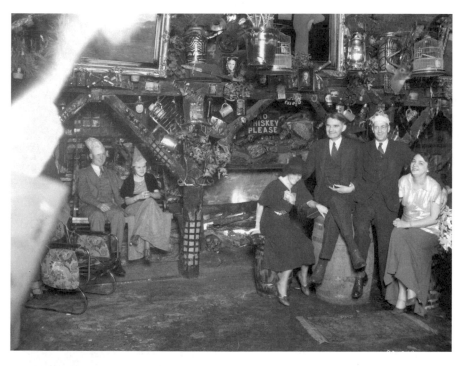

A "dry" New Year's Eve party at the Waynesville Shack, likely in the late 1920s or early 1930s in Waynesville, North Carolina. *North Carolina Collection, Pack Memorial Public Library, Asheville, North Carolina.*

brewery in the early 1990s, there had been no takers in Haywood County since then. Until recently, Waynesville residents had to drive thirty miles east to Asheville or eighteen miles west to Heinzelmännchen Brewery to get straight-from-the-tanks brew. Of course, many regional breweries distribute in Waynesville, so the town wasn't completely craft beer bleak. But over an eight-month span, not one but three new breweries were pouring forth golden goodness in downtown Waynesville. "After years of driving to Asheville breweries most every weekend, it's nice to have three places in Haywood County to drink craft beer," said Heidi Dunkleburg, co-brewer and co-owner of Headwaters Brewing in Waynesville.

FROG LEVEL BREWING

First to open was Frog Level Brewing Company. Owner and brewmaster Clark Williams started brewing on a SABCO Brew-Magic system in September 2011. Within a month, he started distributing kegs to a few restaurants in Waynesville. In December, he opened the sharp Frog Level Tasting Room, featuring four taps of in-house beer. Clark brewed twice a day, five days a week just to keep up, until the end of June, when he purchased a three-barrel system.

A longtime home brewer, Clark spent two years making his dream brewery into a reality while continuing to work his day job at Giles Chemical nearby. He quit in April 2012 to brew full time. The brewery's current flagship brews are Lily's Cream Boy Cream Ale, Catcher in the Rye IPA and Tadpole English Porter. The Tadpole is brewed with Buncombe County sorghum. The fourth tasting room tap consists of a rotating "rare" keg, such as a Smoked Pilsner or Irish Stout.

Frog Level is named for the part of town in which it's located, which was once swampland but then became a warehouse and factory district in the mid-twentieth century. "Everyone is excited about having a brewery here and has embraced us, except for my father-in-law, who is a Baptist minister," Clark quipped. "We're getting a good crowd over from Asheville on the weekends, when we have entertainment."

Frog Level beers likely will be on draft in a few Asheville spots. The brewery has sold its beer at the Thirsty Monk South and the Lobster Trap Restaurant, as well as from several Waynesville restaurants.

Frog Level Brewing in Waynesville became the first brewery in that town in almost twenty years when it opened for business in the fall of 2012. *Photo by Steph Weber.*

Behind the taproom is a large deck next to a creek, which Clark claims is the only commercial spot in Haywood County where folks can legally drink outside.

HEADWATERS BREWING COMPANY

In late March 2012, Headwaters Brewing Company laid claim to becoming Haywood County's second new brewery, started by co-brewers and business partners Kevin Sandefur and Heidi Dunkelberg. A home brewer who previously managed a manufacturing plant in Knoxville and was an emergency room nurse, Kevin got the seed money for the brewery when he won $8,000 in the 2012 Haywood County Chamber of Commerce Business Startup Competition.

Also a home brewer, Heidi co-owns Coffee Cup Café just down the road in Clyde. When Kevin first told her that he was looking for a brewing and

Headwaters Brewing Company opened in the spring of 2012 in Waynesville, North Carolina, near the headwaters of Haywood County. *Photo by Steph Weber.*

business partner, she said no. But she changed her mind about a week later. "I couldn't pass up this opportunity," she said. The only other female brewer in WNC at present is Erica Nelson, who is in charge of quality control at Highland Brewing and brews for that brewery occasionally.

Kevin had spent a number of years trying to get a brewery up and running in Haywood County. Originally, he was going to call the business Pot Likker Brewing, but he later changed the name to Headwaters to reflect the pristine source of water in the area. Headwaters also offers lots of fun options for water-related beer names, such as Stiff Paddle IPA, Rip Current Red and Heady Eddy Pale.

Heidi currently brews three days a week on Headwaters' SABCO Brew-Magic system, and Kevin brews another three days just to keep beer on in their taproom. "It's been crazy—crazy good, but crazy," Heidi said. "I've underpitched the yeast and had to throw out some batches and made other mistakes. But I've learned a lot. Most things I've learned in my fifty years, I've learned from messing up, though, so I'm not scared to mess up."

The taproom opened in April 2012, although the grand opening was held at the end of May during the inaugural Asheville Beer Week. "Haywood

County seemed like the logical choice to bridge some of the craft beer gaps in the region," Kevin said. "Plus, Waynesville has a great growing culinary scene that we felt we could complement."

Heidi also owns a farm that supplies some of the vegetables for Coffee Cup Café, and she's been raising hops there for four years. She's looking forward to using some of her hops in a Headwaters brew. Currently, all Headwaters beers are being sold from the taproom and at special events, although distribution to area restaurants is part of future plans, said Kevin.

Tipping Point Brewing

Waynesville watering hole Tipping Point Tavern planned to join the region's brewvival from the day it opened as a restaurant and bar. It took about a year and a half, but by then, the tavern had already established itself as a great place to eat and drink in downtown Waynesville. Brewer Scott Peterson started brewing from a three-barrel system in July 2012, producing

Tipping Point Brewing has a new three-barrel system that supplies beers to the Waynesville tavern. *Photo by Steph Weber.*

an amber and an American pale ale initially. Scott has a great pedigree, having brewed at Wyncoop Brewing and Ska Brewing previously (both in Colorado). Initially, Tipping Point beers will only be available at the tavern, said co-owner Jon Bowman, and he noted that Scott likely will brew twice a day just to keep customers happy. The brewpub also offers several taps of other local beers.

BREVARD BREWING COMPANY

Brevard Brewing Company threw open its taproom doors to thirsty beer lovers in late April 2012 in downtown Brevard. Brewer Kyle Williams, formerly with Pisgah Brewing, specializes in lager-style beers with a few ales thrown in for fun. He keeps about five beers in the tanks, including a traditional Bohemian Pilsner, his personal favorite.

"I like making lagers because you can't hide behind them," Kyle said. "They take more patience and time to brew and don't have big flavors like

Kyle Williams, owner and brewer of Brevard Brewing Company in Brevard, North Carolina, in his brewery. *Photo by Anne Fitten Glenn.*

ales to cover imperfections." Kyle chose Brevard because of family ties and because "[t]here were too many breweries already in Asheville, but none in Brevard."

Just a few weeks after Kyle opened for business, Oskar Blues Brewery announced that it would be opening an East Coast brewery and restaurant and music venue in Brevard. "The Greater Asheville area really is becoming the epicenter for craft beer the same way Napa is for the wine industry," Kyle said. "We welcome Oskar Blues to Brevard."

Even More Breweries on the Horizon

"If I had a dime for everyone who said they were going to start a brewery here but didn't, I'd be a wealthy man," said "Beer Guy" Tony Kiss. Indeed, in the years I've been writing an Asheville beer column, there have been any number of rumors, and rumors of rumors, of new breweries starting up. It turns out that it takes a good amount of persistence and a decent amount of cash to get even a small brewery up and running. It's not just about brewing beer; it's about starting a business. And it's a business that requires more than just brewing knowledge. It requires marketing and sales savvy, physical and mental stamina and the acceptance that sanitation will be 90 percent of your life.

That said, a number of breweries are in the planning stages—or at least were when this book went to press. Here are a few of those.

The Next Asheville Four

The Altamont Brewing Company

The Altamont Brewing Company owners, Gordon Kear and Ben Wiggins, should win some kind of award for persistence. Altamont opened as a bar in west Asheville in February 2011, with local and regional beers on tap. Good beer plus a comfortable warehouse space, combined with regular live

music acts, quickly gained Altamont a local following. Adding liquor drinks to the mix helped as well, but the goal always has been the creation of a brewery. To that end, Gordon and Ben purchased a few tanks from Green Man Brewing in late 2011. But the duo didn't quite have enough cash to put together a full brew house until the summer of 2012.

That's when an investor/friend and Mountain BizWorks, an Asheville small business support organization, stepped in with loans. A seven-barrel system was delivered in late July, and as soon as permits and licenses are approved, Gordon will start brewing. He brewed for Flagstaff Brewing Company in Flagstaff, Arizona, for six years. There he crafted an array of ales and seasonals. He said that he'll start by making an IPA, an ESB and a porter for Altamont. "Asheville has always been home for me," Gordon said. "I wanted to bring what I learned in Flagstaff back home."

Gordon grew up in eastern North Carolina and came to the mountains to attend Warren Wilson College. He stayed on in the area for a number of years after college before moving to Flagstaff. While at Warren Wilson, he befriended Ben, the other half of Altamont Brewing. Ben previously had been working construction and running a beer and wine shop in Nantahala. While Gordon focuses on brewing, Ben books the music and handles marketing.

Several months after opening just with beer, wine and a ping-pong table, Altamont expanded to include mixed drinks (which makes it a "private" membership club because of a weird North Carolina law that disallows the sale of liquor at places where food isn't served; all that means is that you fill out a membership form once and sign in when you visit).

When I asked Gordon about starting a business in an area with a glut of breweries, he wasn't fazed. "The market here is still not saturated," he said. "The craft-beer market continues to expand because not one brewery is ever going to take over. The beers are all a little different, and more options [means] more education about craft beer."

The brewery's name has to be one of my favorites, although Gordon said that most people don't get the allusions. As I mentioned earlier, Altamont is Thomas Wolfe's fictional name for Asheville.

Initially, all sales will be in house, via Altamont's taps. Growlers will be available, and kegs will be for sale with pre-orders for special events. "Then we'll see what happens," Gordon said, in terms of selling his beer to local restaurants and beyond.

Altamont will be able to lay claim to being west Asheville's first brewery. It's enough to make Thomas Wolfe proud.

Wicked Weed Brewing

The name of the newest brewpub to announce plans to open in Asheville will be Wicked Weed Brewing—but it's not what you think. Supposedly, King Henry VIII banned the use of hops and referred to them as "a wicked and pernicious weed."

Brothers Walt and Luke Dickinson and partner Ryan Guthy want to use a whole lot of this wicked weed to brew their beers. At Wedge Brewing during Asheville's first organized Beer Week, the business partners revealed the name of the heretofore mystery brewery to a large and enthusiastic crowd of beer lovers. The brewery will be located in a large old building at 91 Biltmore Avenue (former site of Asheville Hardware, which is now on Buxton Avenue). The brew house and taproom will reside in the basement, with another bar and restaurant upstairs. The owners hope to have Wicked Weed Brewing open for business late in 2012. Other partners are local entrepreneurs Denise and Rick Guthy (Ryan's parents).

Wicked Weed will be a pretty big brew house in the scheme of Asheville beer, at least until the California and Colorado breweries open their facilities in the region. Wicked Weed will feature a fifteen-barrel system, five fifteen-barrel fermenters, a thirty-barrel fermenter, three brights and ten serving tanks. The team also has purchased an open fermenter to make some big Belgian beers. (I know of several brewers who are having tank envy as they read this.) "We want to focus on hoppy, West Coast–style beers and big Belgians, with some traditional English-style ales and lagers as well," said Walt.

Both Dickinsons are home brewers, but Luke will spend most of his time in the brewery, while Ryan will oversee restaurant operations and Walt will serve as general manager. Walt said that he gave his brother a home brewing kit for his twenty-first birthday, and Luke's been brewing like crazy ever since.

Luke worked part-time as a tour guide at Dogfish Head Brewery in Milton, Delaware. While he said that he's obsessed with brewing, he has little commercial brewing experience (though he brewed his first commercial beer with brewer icon Sam Calgione of Dogfish Head). The brothers will hire another brewer to help out.

Initially, they'll only sell their beers in-house, and though the brewery will have a five-thousand-barrel capacity, Walt said that they certainly won't be putting out that much beer for a while. "First we want to make

Brothers in brewing Walt and Luke Dickinson inside the building that will become Wicked Weed Brewing in downtown Asheville. *Photo by Anne Fitten Glenn.*

sure we're making the best beer we can, then we'll see if we want to sell our beer around town or elsewhere," he said.

Burial Beer Company

Burial Beer Company is a project of longtime home brewer Doug Reiser, his spouse, Jessica Reiser, and Tim Gormley, currently a brewer for Sound Brewery in Seattle, Washington. The three moved from Seattle to Asheville in September 2012 to start brewing commercially.

Burial Beer's goal is to purchase land, in Asheville or nearby, that can support an urban farm, the brewery and a public taproom. Reiser said that the farm will produce fruits, vegetables and herbs, such as sweet potatoes, pears and raspberries, which will be used in the beers.

Reiser, a former lawyer, said that he's looking for a fifteen-barrel brewing system, and he wants to distribute fairly widely. One reason that folks elsewhere sometimes snub their noses at Asheville's beer scene is because they don't have access to Asheville beer. Only a few Asheville

beers are distributed outside North Carolina, and then only in a few other southeastern states.

Reiser said that he's also researching canning lines and will bottle, but only in 750ml bottles. The Reisers and Gormley plan to have two lines of beers, similar to Port Brewing and Lost Abbey of California's dual brands. One, the Burial line, will consist of "robust" American-style beers, such as an imperial coffee stout. The other, their Farmhouse line, will offer "big" Belgian-style beers.

Yellow Truck Brewing Company

Ross and Amanda Franklin of Pack's Tavern are starting a brewery, Yellow Truck Brewing, in the fall of 2012. The brewery will be located in the historic former jailhouse located behind Pack's (in the historic Hayes & Hopson building, a center of prohibition-era bootlegging). Ross has a three-barrel system on order and is in process of hiring a brewer. Initially, beers will be on a few of Pack's thirty taps, but Ross hopes to sell beer from other Asheville restaurants as well.

Plus a Few More

Lookout Brewing Company in Black Mountain currently consists of a SABCO Brew-Magic system in a warehouse, as well as free beer tastings when brewer John Garcia announces them on the brewery's Facebook page. Lookout is a project of Black Mountain Ale House co-owner John Richardson and Ale House bartender Garcia. Because they didn't have space in the restaurant, the partners rented a facility across town, but beers will be on tap at Black Mountain Ale House as soon as permits come through.

Ivory Tower Education Brewery in the Broyhill Events Center at Appalachian State University in Boone, North Carolina, has been working to get started as one of the few nonprofit, student-run breweries in the nation. Professors Brett Taubman and Shea Tuberty have offered a brewing class for a few years and recently received approval for a four-year fermentation degree program at the university.

Blue Mountain Brewing, based in Blue Mountain Pizza, a Weaverville restaurant, has permits and brewing equipment on order.

Jason Schutz is looking for a space for One World Brewing in or near Asheville. He wants to start a community-supported brewery, where members will pay forty dollars per month and get four to five growlers of different beer in return plus three-dollar pints in the One World Taproom (when it opens).

Tim and Steph Weber moved to Asheville from Pennsylvania in the summer of 2012 to start Twin Leaf Brewpub somewhere in Asheville. Like the New Belgium folks, the Webers heart the mountains. Yep, it's a beer blitz, for sure.

One question I am frequently asked is how in the heck all these breweries will survive in a town the size of Asheville—or even in a region the size of Western North Carolina. This is a valid question. Industry analysts note that there probably will be a craft beer shakeout. Some breweries won't make it—both here and elsewhere.

My take, and the take of most who work in this business, is that if a brewery can produce great beer—beer that is itself consistent and isn't off, beer that tastes good and that both locals and tourists want to drink—then that brewery will likely survive. Given enough time, patience, persistence and a dedication to craft, it might even make a little cash.

Yes, Asheville has one of the highest brewery-to-population ratios in the country, but the city also has dedicated craft beer drinkers who enjoy the variety of locally produced brews. And we have tourists. So, with a little bit of luck and a lot of great beer, most of the breweries I've written about in this book should survive. Regardless, they're all now part of the history of Asheville beer.

Guide to Asheville Beer

This appendix is a short guide to Asheville and WNC breweries operating as of August 2012. I've also included a list of a few fun, sudsy watering holes and craft beer retailers. This list is by no means exhaustive. As I mention elsewhere in this book, more breweries are in the planning stages for the area, and it seems that a new bar featuring local taps opens every other month in downtown Asheville. So I've only included the places that I consider particularly craft beer–centric. They're also places where I do much of my own pint lifting.

If you want up-to-the-minute bar and brewery information, you can, of course, find a lot online. Many breweries and beer folks are proficient at social media. Facebook pages are typically more up-to-date than websites, while Twitter has become an excellent interactive tool for communicating beer news and events.

You can follow me on Twitter at @brewgasm, where I relate, in small sips, much of what's happening with Asheville and WNC beer. Great hashtags to watch are #avlbeer and #ncbeer. I also have a blog at brewgasm.com and a Brewgasm Facebook page, both of which I try to update regularly.

ASHEVILLE BREWERIES

Altamont Brewing Company
1042 Haywood Road
altamontbrewingcompany.com
Circa 2012. Taproom with some patio seating and regular live music.

Asheville Brewing Company
675 Merrimon Avenue and 77 Coxe Avenue
ashevillebrewing.com
@ashevillebeer
Circa 1997. Beers are brewed in two locations, one on the north side and
one downtown. Pizza and pub food at both locations. Second-run movies at
the Merrimon brewpub.

Craggie Brewing Company
197 Hilliard Avenue
craggiebrewing.com
@craggiebrewing
Circa 2009. Taproom and regular live music.

French Broad Brewing Company
101 Fairview Road #D
frenchbroadbrewery.com
@frenchbroadbrew
Circa 2001. Taproom and regular live music.

Green Man Brewery
23–27 Buxton Avenue
greenmanbrewery.com
@greenmanbrewing
Circa 1997. Taproom with outside patio and tasting room in new brew
house next door.

Highland Brewing Company
12 Old Charlotte Highway
highlandbrewing.com
@highlandbrews
Circa 1994. Taproom with live music on weekends. Regular brewery tours.

Lexington Avenue Brewing Company
39 North Lexington Avenue
lexavebrew.com
@LAB_Asheville
Circa 2010. Gastropub. Regular live music in the back room. New brewpub opening next door.

Oyster House Brewing Company
35 Patton Avenue
oysterhousebeers.com
@oysterhousebrew
Circa 2009. Serving beer at the Lobster Trap Restaurant only.

Thirsty Monk Brewery
20 Gala Drive #101
monkpub.com
@monkpub
Circa 2011. Currently selling its beer only in taproom/brewery. New beers released most Thursdays.

Wedge Brewing Company
125B Roberts Street
wedgebrewing.com
No Twitter
Circa 2008. Taproom with outside seating. Local food trucks regularly provide fare.

BREWERIES OUTSIDE ASHEVILLE (BUT FAIRLY NEARBY)

Beers made by many of these breweries can be found on draft around Asheville.

Brevard Brewing Company
63 East Main Street, Brevard, North Carolina
brevard-brewing.com
No Twitter
Circa 2012. Taproom with regular live music.

Catawba Valley Brewing Company
212 South Green Street, Morganton, North Carolina
catawbavalleybrewingcompany.com
@catawbavalleybc
Circa 1999. Taproom with regular live music.

Frog Level Brewing Company
56 Commerce Street, Waynesville, North Carolina
@froglevelbrew
Circa 2011. Taproom with outside seating and occasional live music.

Headwaters Brewing Company
130 Frazier Street, Suite 7, Waynesville, North Carolina
No Twitter
Circa 2012. Taproom.

Heinzelmännchen Brewery
545 Mill Street, Sylva, North Carolina
yourgnometownbrewery.com
@heinzelmannchen
Circa 2004. Pick up beer in growlers or kegs.

Nantahala Brewing Company
61 Depot Street, Bryson City, North Carolina
nantahalabrewing.wordpress.com
@nantahalabrew
Circa 2010. Taproom with regular live music. Second smaller taproom opening soon.

Pisgah Brewing Company
150 Eastside Drive, Black Mountain, North Carolina
pisgahbrewing.com
@PisgahBrewing
Circa 2005. Taproom with fire pit and meadow. Inside and outside stages feature regular live music.

Southern Appalachian Brewery
822 Locust Street, Suite 100, Hendersonville, North Carolina
sabrewery.com
No Twitter
Circa 2003. Taproom with outside seating and regular live music.

Tipping Point Brewing
Waynesville, North Carolina
@tippingpointnc
Circa 2012. Brewpub.

Breweries Coming Soon

Blue Mountain Brewing
55 North Main Street, Weaverville, North Carolina
bluemountainpizza.com
No Twitter
Beer will be on tap at Blue Mountain Pizza.

Lookout Brewing Company
Black Mountain, North Carolina
@lookoutbrewing
Beer will be on tap at Black Mountain Ale House.

New Belgium Brewing Company
Asheville
newbelgium.com
@newbelgium
Will have taproom.

Oskar Blues Brewing
Brevard, North Carolina
oskarblues.com
@oskarbluesnc
Will have taproom in brewery and restaurant/taproom/music venue at separate location.

Sierra Nevada Brewing Company
Mills River, North Carolina
sierranevada.com
@sierranevada
Will have taproom. Possibly restaurant and music venue as well.

Wicked Weed Brewing
91 Biltmore Avenue, Asheville
wickedweedbrewing.com
@wickedweedbeer
Brewpub. Will have patio seating and two bars.

Yellow Truck Brewing Company
4 Marjorie Street Asheville
@yellowtruckbrew
Beers will be on tap at Pack's Tavern.

CRAFT BEER BARS IN ASHEVILLE

The Bar of Soap
333 Merrimon Avenue, Asheville
@_barofsoap

Barley's Pizzeria & Taproom
42 Biltmore, Asheville
barleytaproom.com
@BarleysTapPizza

Bier Garden
46 Haywood Street, Asheville
ashevillebiergarden.com
@BierGarden

The Bywater
796 Riverside Drive, Asheville
bywater.com
No Twitter

Jack of the Wood
95 Patton Avenue, Asheville
jackofthewood.com
@jackofthewood

Mellow Mushroom
50 Broadway Avenue, Asheville
mellowmushroom.com/asheville
No Twitter

Pack's Tavern
20 South Spruce Street, Asheville
packstavern.com
@PacksTavern

The Thirsty Monk
92 Patton Avenue and 20 Gala Drive #101, Asheville
monkpub.com
@monkpub

Universal Joint
784 Haywood Road, Asheville
@ujointavl

Westville Pub
777 Haywood Road, Asheville
westvillepub.com
@westvillepub

Beer-Centric Retailers in Asheville

Appalachian Vintner
745 Biltmore Ave, Suite 121, Asheville
appalachianvintner.com
@appvintner

Asheville Brewers Supply
712-B Merrimon Avenue, Asheville
ashevillebrewers.com
No Twitter

Asheville Wine Market
65 Biltmore Avenue, Asheville
ashevillewine.com

No Twitter

Bruisin' Ales
66 Broadway Street, Asheville
bruising-ales.com
@bruisinales

Hops & Vines
797 Haywood Road, Suite 100, Asheville
hopsandvines.net
@hopsnvines

Weinhaus
86 Patton Avenue, Asheville
weinhaus.com
@theweinhaus

The Evolution of Western North Carolina Beer

Prehistorical records: Native Americans likely brew beer using cedar berries and corn.

Late 1700s: First European immigrants settle in Western North Carolina. Mostly Scotch-Irish, they bring their brewing and distilling traditions.

1800s: Southern beer recipes include ingredients such as locust pods, persimmons, spruce, ginger, corn, honey and molasses. Malted grains and hops are hard to find.

1862: North Carolina prohibits using grains to brew beer or liquor to protect food supply during Civil War—repealed in 1866.

1865: State approves first "spirituous liquor" taxation law, following lead of Internal Revenue Service, which approved similar law a few years earlier.

1872: Asheville votes against saloons, and of the four in operation, two close and two move outside the city limits. Saloons reappear in the city a few years later.

1874: "Local Option" law passes, allowing North Carolina towns to instate prohibition via popular vote—later extended to counties in 1881.

1880s: Saloons thrive in Asheville, and regional and national beers flow from taps and bottles. Saloon owner W.O. Muller claims to introduce Anheuser-Busch Lager to Asheville.

1890s: Advertisements in Asheville newspapers and city directories offer a variety of "ale, porter, & beer" for sale, including Budweiser, Pabst Blue Ribbon, Rochester, Everards, Schlitz and Dixie.

1900: More than eighteen saloons and taverns operate in Asheville, mostly clustered just two blocks from the courthouse, earning that area of town the nickname "Hell's Half Acre."

1906: While there's no commercial brewing yet in WNC, local representatives sell East Tennessee Brewing, Knoxville Brewing and Pinnacle Beer of Kentucky brews in Asheville.

1907: Asheville votes "yes" to prohibition, partially influenced by the downtown murders of five men by a drunken desperado in November 1906.

1909: North Carolina becomes first state to ratify prohibition. The national Eighteenth Amendment will go into effect in 1920.

1915: State passes act to allow delivery of alcoholic beverages within state. Whiskey and beer shippers offer Pabst Blue Ribbon; Pabst Red, White and Blue; Chattanooga Brewing Company's Magnolia and Amber Bottled Beer; Royal Pale; and Jung's Cincinnati.

1933: National prohibition is repealed, although North Carolina is one of two states that refuses to ratify the Twenty-first Amendment. State legislators legalize sale of beer up to 3.2 percent alcohol by weight but will not allow sales of stronger liquor until 1935.

1935–36: Writer F. Scott Fitzgerald spends two summers "living" in the Grove Park Inn and drinking up to thirty beers a day while claiming to be on the wagon.

1937: North Carolina Alcohol Control Act creates State Alcohol Board (which becomes the ABC Commission) and a "local option" system—again.

1947: After several votes in the '30s and '40s, Buncombe County finally completely repeals prohibition. The first ABC stores open in Asheville.

1950s and '60s: Ads in Asheville newspapers and city directories list Skyway Distributors, Skyland Beer Distributing and Standard Beer Company as offering Carling Black Label, Falstaff, Lowenbrau, Sparkling Champale and Miller High Life.

1978: President Jimmy Carter legalizes home brewing in the United States.

1983: North Carolina's drinking age is raised from eighteen to twenty-one. Minimum legal drinking age was first established after prohibition.

1985: North Carolina amendment makes brewpubs legal.

1993: Smoky Mountain Brewery opens in Waynesville as Western North Carolina's first brewery but will close two years later.

December 1993: Barley's Pizzeria & Taproom opens, selling only craft and imported beers from day one.

1994: Oscar Wong and John McDermott start Highland Brewing Company in the basement below Barley's Taproom in Asheville.

1997: The Blue Rooster, Asheville's first brewpub, opens next to Barley's and features Highland beers exclusively. It will close one year later.

Laughing Seed Café co-owner Joe Eckert opens Jack of the Wood pub and Green Man Brewery in Asheville.

Barley's co-owners Jimi Rentz and Doug Beatty organize the inaugural Brewgrass Festival in Asheville, which will become one of the top beer festivals in the Southeast.

Asheville Brewers Supply, Asheville's first home brew supply store, opens.

Mountain Ale and Lager Tasters homebrew club starts meeting regularly.

1998: Two Moons Brew 'n' View opens, with brewer Doug Riley at the helm. The next year, Mike and Leigh Rangel buy the business and change the name to Asheville Pizza & Brewing Company.

1999: Catawba Valley Brewing Company is born in the basement of a Glen Alpine antique mall.

MALT starts Blue Ridge Brew-Off home brew competition, which becomes one of the largest events of its kind in the Southeast.

2001: French Broad Brewing Company opens in Biltmore Village, with Jonas Rembert, previously the Green Man Brewer, brewing.

2003: Appalachian Brewing starts up in a barn in Rosman.

2004: Dieter Kuhn and Sheryl Rudd start up Heinzelmännchen Brewery in Sylva, producing German-style beers.

2005: Jason Caughman and Dave Quinn open Pisgah Brewing Company in Black Mountain, producing the area's first certified-organic beers.

Green Man Brewery moves from Jack of the Wood to Buxton Avenue in Asheville and opens tasting room that locals affectionately call Dirty Jack's.

August 2005: North Carolina's Pop the Cap legislation passes, enabling brewers to create beers with up to 15 percent alcohol by volume.

2006: Highland Brewing moves to east Asheville and expands production.

Entrepreneurs Mark and Trish Lyons launch Asheville Brews Cruise, ferrying beer lovers from brewery to brewery.

Andy and Kelly Cubbin purchase Appalachian Brewing and change the name to Appalachian Craft Brewery. They soon move operations to Fletcher.

December 2006: Bruisin' Ales, Asheville's sole beer-only retail store, opens.

2007: Catawba Valley Brewing moves to Morganton and opens a tasting room.

October 2007: Hops & Vines, beer and wine retail and home brew shop, opens in west Asheville.

2007–8: Local farmers, including Echoview and Hop'n Blueberry farms, begin experimenting with growing hops.

January 2008: Inaugural Winter Warmer Beer Festival launches in Asheville.

May 2008: Wedge Brewing Company opens in Asheville's River Arts District. Owner Tim Schaller teams up with former Green Man brewer Carl Melissas.

February 2009: The Asheville Brewers Alliance is formed.

March 2009: Oyster House Brewing Company opens inside the Lobster Trap Restaurant in Asheville.

Spring 2009: Asheville ties with Portland, Oregon, for first place in first Beer City, USA poll, put on by Brewers Association president Charlie Papazian and Examiner.com.

November 2009: Bill Drew and Jonathan Cort open Craggie Brewing Company in Asheville.

January 2010: Lexington Avenue Brewery opens a gastropub/brewery in Asheville with another former Green Man brewer, Ben Pierson, at the helm.

May 2010: The new Biltmore Brewing Company contracts with Highland Brewing to produce two beers for Cedric's Tavern.

The Grove Park Inn Resort & Spa contracts with Highland to brew Great Abbey Ale.

2010: Asheville Beer Divas group begins holding meetings for female beer aficionados.

May 2010: Green Man Brewery is purchased by Dennis Thies and expanded. John Stuart continues as brewmaster.

Nantahala Brewing Company in Bryson City opens.

June 2010: After Asheville wins the Beer City, USA title outright, Asheville Brewers Alliance and Brewgrass organizers put on the first Beer City Festival in Pack Square Park.

Just Economics of WNC holds the first Just Brew It home brew festival.

February 2011: The ABA and North Carolina Brewers Guild entice beer expert Charlie Papazian to speak at an educational event at Highland Brewing's new taproom.

Spring 2011: Appalachian Craft Brewery moves operations to Hendersonville, opens tasting room and changes name to Southern Appalachian Brewery.

Asheville wins Beer City, USA title again.

Nantahala Brewing opens a tasting room.

Highland Brewing employee Trevor Reis wins first Asheville Beer Masters Tournament.

September 2011: Riverbend Malt House opens in Asheville, malting North Carolina–grown grains for local breweries.

October 2011: The Thirsty Monk adds a brewery to its south Asheville location, with Norm Penn brewing.

December 2011: The first local canned beers roll off the line at Asheville Brewing Company.

Frog Level Brewing Company starts selling its beer from Haywood County's first brewery.

January 2012: Sierra Nevada Brewing Company of Chico, California, announces that it will open the company's second brewery in Mills River, twelve miles south of Asheville.

March 2012: Headwaters Brewing Company opens in Waynesville.

April 2012: New Belgium Brewing Company of Fort Collins, Colorado, announces that it will open second brewery in Asheville's River Arts District.

Brevard Brewing Company opens in Brevard.

May 2012: Oskar Blues Brewery of Lyons, Colorado, announces that it will open a second brewery in Brevard.

Asheville wins Beer City, USA title again, but in a tie with Grand Rapids, Michigan.

May June 2012: Inaugural Asheville Beer Week, an eleven-day celebration of craft beer, is held. Adam Reinke wins second Asheville Beer Master Tournament.

July 2012: Tipping Point Brewing opens in Tipping Point Tavern in Waynesville.

September 2012: Altamont Brewing Company in west Asheville starts brewing.

Appendix III

Glossary of Beer Terms

This is an abbreviated glossary of beer terms, many of which I use in this book. To further expand your beer vocabulary, visit the Brewers Association at www.brewersassociation.org. I've defined a few predominant beer styles here, but given that there are currently about 140 different styles, that would take a book in itself. An excellent online source for beer styles is that of the Beer Judge Certification Program, at www.bjcp.org. Many of the terms here are courtesy of Erik Lars Myers and were first printed in his excellent guidebook *North Carolina Craft Beer & Breweries*. Sláinte!

ABV: alcohol by volume; standard measure of how much alcohol is in a beverage, typically represented as a percentage.

adjunct: pretty much anything added to beer other than the four primary ingredients (water, hops, malt and yeast), including fruits, vegetables, chocolate, coffee, corn and so on.

ale: a type of beer than encompasses many styles (the two primary types of beer are ales and lagers); true ales are fermented with top-fermenting yeast.

APA: American Pale Ale (American version of British Pale Ale); typically has more hops flavor and aroma than the pale brewed across the pond.

barrel: one barrel (bbl) of beer equals thirty-one gallons; used as a measurement for a brewery's production and capacity.

beer styles: the three major beer styles are lagers, ales and specialty beers; specialty beers are brewed with various nonstandard ingredients.

Belgian: a beer style that includes a variety of beers originating in Belgium, including Abbey Ales, Lambics and Flemish Reds.

brew house: the set of equipment that deals with the "hot side" of brewing beer, including mashing, lautering and boiling.

brewpub: a combination brewery and restaurant; typically, a brewpub sells at least 25 percent of its beer on site.

bright (or brite) tank: a tank that is used to carbonate beer.

cask-conditioned: beer that has been refermented in the cask; casks are typically served at cellar temperature and drawn using gravity or a hand pump ("bottle-conditioned" refers to refermentation in the bottle).

draft beer: beer served from a cask or keg.

ESB: Extra Special Bitter, a mild British-style pale ale; not typically very bitter.

GABF: Great American Beer Festival, a yearly beer festival sponsored by the Brewers Association in Denver, Colorado, that includes the largest professional brewing competition in the United States.

growler: a refillable glass jug for beer, often with a screw top though sometimes with a ceramic swing-top; in North Carolina, growlers can only be sixty-four ounces (a half-gallon) or less.

hops: the flower and fruiting body of the plant *Humulus lupulus*, used by brewers to impart both bitterness and flavor to beer.

IBU: International Bittering Unit, a measure of the bitterness of beer; the higher the number, the more bitter the brew.

Reinheitsgebot: the Bavarian Purity Law of 1516 that noted that beer could only be made from three ingredients: water, barley and hops; yeast wasn't discovered for another 340 years and so was not included in the law.

seasonal: a beer that is brewed especially for a specific season, such as an Oktoberfest beer in the fall.

session beer: a low alcohol beer; most folks can drink more than one in a "session."

sparge: the act of rinsing grain with hot water during lautering, which assists in removing sugars from the grain.

special release: a beer that's released for a special occasion or only rarely—or even only once, which is also known as a one-off.

stout: a very dark beer often with notes of chocolate or coffee.

taproom: a bar or brewery that serves draft beer; many breweries refer to their taprooms as tasting rooms, but unless they are only giving away tastes (i.e., not selling pints), I refer to these on-site rooms as taprooms.

weizen/weissier/witbier/wheat: light beers made with a high proportion of wheat; witbier often includes citrus or coriander adjuncts.

World Beer Cup: the largest international professional brewing competition in the world; it takes place every two years on even-numbered years.

wort: unfermented beer.

yeast: a living organism that eats sugar and secretes carbon dioxide and ethanol alcohol, as well as hundreds of flavor compounds in beer.

imperial: indicates a high alcohol by volume beer.

IPA: India Pale Ale, a style that's typically more hop-forward and higher in alcohol than a regular pale ale.

keg: a pressurized container for dispensing beer through a tap or faucet.

lager: German for "to store"; refers to beer made with lager yeast.

lauter: the step in the brewing process where sugar is removed from grain in order to make the wort.

malt: grain (usually barley) that has been slightly germinated and then kilned, creating a reserve of sugars and enzymes; malt is the source of sugar in beer.

mash: the step in the brewing process where water is added to grain in order to activate enzymes that will convert starch into sugar

mash tun: the vessel in the brew house where the mash is performed.

nano-brewery: a brewery that makes extremely small batches of beer; while there's no official definition of what constitutes a nano-brewery, it's generally considered to be a brewery that makes batches of three barrels or less at a time.

Pilsner: a type of lager beer, first made in Czechoslovakia in the late thirteenth century.

pitching: adding yeast to the wort in the fermentation tank.

porter: a characteristically dark brown beer of English origin; the bitterness of this beer derives from the use of roasted barley.

primary fermentation: occurring after pitching the yeast and during the first three days on average, this fermentation converts sugars to alcohol and carbonation.

Bibliography

M uch of the material for this book comes from personal interviews. Some of it also derives from articles I've written that have been published in *Mountain Xpress* newsweekly and on craftbeer.com, although I haven't listed all of my own articles below.

I've also gleaned random information from flipping through hundreds of reference books and perusing just as many online reference sites. The bound clippings files and newspaper microfiche at Pack Memorial Public Library contributed much to the jumble of historical knowledge now lodged in my brain.

As a child of the computer age and someone who has spent years doing research online, I was intrigued to discover how much history is not digitized. I have an abiding respect for the libraries and librarians that protect and share so many of the often fragile books and papers, some of which exist only in a few places and may or may not ever make their way into the ever-expanding cloud of online information that so many consider the end-all, be-all of knowledge. Thank you.

BOOKS

Arthur, John P. *Western North Carolina: A History (1730 to 1913)*. Johnson City, TN: Overmountain Press, 1914.

Buttitta, Tony. *After the Good Gay Times: Asheville—Summer of '35, a Season with F. Scott Fitzgerald.* New York: Viking Press, 1974.

The Confederate Receipt Book: A Compilation of Over One Hundred Receipts, Adapted to the Times. Richmond, VA: West and Johnston, 1863.

Davison, J.P. *Asheville City Directory and Gazetteer of Buncombe County.* Richmond, VA: Baughman Brothers, 1883.

Dykeman, Wilma. *The French Broad.* New York: Rinehart & Company, Inc., 1955.

Edge, John T., and Ellen Rolfes. *A Gracious Plenty: Recipes and Recollections from the American South.* New York: HP Trade, 2002.

Fulenweider, Harry W. *Asheville City Directory and Business Reflex.* Charleston, SC: Walker, Evans & Cogswell Company, 1890.

Kephart, Horace. *Our Southern Highlanders.* New York: MacMillan Company, 1913.

Myers, Erik Lars. *North Carolina Craft Beer & Breweries.* Winston-Salem, NC: John F. Blair, 2012.

Neufeld, Rob. *A Popular History of Western North Carolina: Mountains, Heroes and Hootnoggers.* Charleston, SC: The History Press, 2007.

Ogle, Maureen. *Ambitious Brew: The Story of American Beer.* Orlando, FL: Harcourt Books, 2006.

Oliver, Garrett, ed. *The Oxford Companion to Beer.* Oxford, England: Oxford University Press, 2012.

Pettigrew, Timmons. *Charleston Beer: A High-Gravity History of Lowcountry Brewing.* Charleston: The History Press, 2011.

Powell, William S., ed. *Encyclopedia of North Carolina.* Chapel Hill: University of North Carolina Press, 2006.

Tartan, Beth, ed. *North Carolina and Old Salem Cookery*. Chapel Hill: University of North Carolina Press, 1955.

Terrell, Bob. *The Will Harris Murders: November 13, 1906, a Night in Which Asheville Was a Tougher Town than Tombstone and Dodge City Rolled into One!* Alexander, NC: Land of the Sky Books, 1997.

Tessier, Mitzi Schaden. *Asheville: A Pictorial History*. Virginia Beach, VA: Donning Company, 1982.

———. *The State of Buncombe*. Virginia Beach, VA: Donning Company, 1992.

Wilson, Charles R., and William Ferris, eds. *Encyclopedia of Southern Culture*. Chapel Hill: University of North Carolina Press, 1989.

Wolfe, Thomas. *Look Homeward, Angel*. New York: Charles Scribner's Sons, 1947.

ARTICLES

Abshire, Martha. "1,297 Stills Kaput." *Asheville Citizen*, March 1, 1975.

Asheville Citizen. "Asheville in 1843 Is Described in Items from Old Newspaper." November 21, 1941.

———. "Avalanche of Ballots Rides Prohibition on Crest of Victory's Wave." October 11, 1907.

———. "Forks of Ivy Rally Held to Oppose Beer Sales." October 9, 1979.

———. "Negro Kills Two Police Officers." November 14, 1906.

Asheville Citizen-Times. "Beer Was Popular with Asheville People Twenty-four Years Ago." April 9, 1933.

————. "F. Scott Fitzgerald Staying at Hotel Here." July 21, 1935.

————. "Find Scores of Sugar Shacks at 3 Liquor Stills." March 15, 1942. Clippings file, North Carolina Rooms, Pack Memorial Public Library.

————. "How Asheville Looked a Hundred Years Ago." March 26, 1950.

————. "Misery for Moonshiners." August 28, 1987.

Asheville Gazette. "City Settles to Quiet Life After Horror and Suspense." November 16, 1906.

————. "Murderer of Five Is Slain, While Battling With a Posse." November 15, 1906.

————. "Negro Desperado Kills Two Officers and Two Negroes." November 14, 1906.

Barnett, James P. "Carl A. Schenck and the Biltmore Forestry School, Asheville, NC." *Piney Woods Journal*, April 2008.

Bostic, Connie. "Champion of the River District." *Mountain Xpress*, August 27, 2008.

Carter, Ted. "Moonshine Era Is Over." *Asheville Citizen-Times*, January 22, 1978.

Gourley, Bruce. "Hassles Over Liquor in Asheville Date Back to 1907." *Asheville Citizen-Times*, March 15, 1965.

Green, Lewis W. "Liquor Raiders Find Still Hidden Behind Wall Panel." *Asheville Citizen*, May 5, 1962.

Kiss, Tony. "What Started as a Hobby Turned into a Business." *Asheville Citizen-Times*, June 27, 1993.

Naves, Glenn W. "Official Choice of Site Swayed by Good Liquor." *Asheville Citizen*, October 26, 1930.

Parris, John. "Few 'Revenooers' Ever Came This Way." *Asheville Citizen*, May 30, 1974.

Pritchard, Billy. "Package Store in Buncombe, Panel Rules." *Asheville Citizen*, November 27, 1979.

Reed, Doug. "Women, Children Ruled for a Day; They Made the Menfolks Vote Dry." *Asheville Citizen-Times*, July 17, 1960.

Terrell, Bob. "Captor of 6,463 Moonshiners Retiring." *Asheville Citizen-Times*, January 31, 1973.

———. "Grice Waters City's Drinking Habits." *Asheville Citizen-Times*, November 18, 1970.

Warner, Nelson. "F. Scott Fitzgerald's Life Here Is Chapter in Dramatic Story." *Asheville Citizen*, April 1, 1951.

Webb, David. "Not a Cure but a Lifesaving Treatment." *Paris!*, spring 2006.

ONLINE SOURCES

Brewers Association. "Brewers Association Reports 2012 Mid-Year Growth for US Craft Brewers," August 6, 2012. http://www.brewersassociation. org/pages/media/press-releases/show?title=brewers-association-reports-2012-mid-year-growth-for-u-s-craft-brewers.

———. "Craft Brewing Volume Hops 13 Percent," March 26, 2012. http://www.brewersassociation.org/pages/media/press-releases/show?title=brewers-association-craft-brewing-volume-hops-13-percent.

Ellison, Garett. "Asheville's Success with 'Beer City USA' Title Bodes Well for Grand Rapids Craft Beer Community," May 14, 2012. http://www. mlive.com/business/west-michigan/index.ssf/2012/05/ashevilles_ success_with_beer_c.html.

Glenn, Anne Fitten. "How Does Lil' Ole Asheville Keep Winning the Beer City USA Poll?" May 2011. http://www.craftbeer.com/pages/stories/craft-beer-muses/show?title=how-does-lil-ole-asheville-keep-winning-the-beer-city-usa-poll.

———. "The Return of the Micro-Malsters: A Locavore's Craft Beer Dream Come True," December 2011. http://www.craftbeer.com/pages/stories/craft-beer-muses/show?title=the-return-of-the-micro-maltsters-a-locavores-craft-beer-dream-come-true.

Western Carolinian. "Beer and Porter House," April 1, 1823, North Carolina State Archives. http://ncecho.cdmhost.com/u?/p15016coll1/id/18057.

Whipps, Heather. "Beer Brewed Long Ago by Native Americans." Live Science, last modified December 28, 2007. http://www.livescience.com/4770-beer-brewed-long-native-americans.html.

Index

About the Author

Photo by Sean McNeal.

Anne Fitten Glenn first learned about craft beer when she worked for George Stranahan, the founder of Flying Dog Brewery in Woody Creek, Colorado, in the early 1990s. Her most memorable beer experience was having writer Hunter S. Thompson yell at her in the middle of the night because she'd left the cover off the Stranahans' hot tub. He was naked, and she was holding a beer. Because she and her friends had previously imbibed half a keg of Doggie Style Pale Ale, she was not as scared as she should have been.

Anne Fitten moved to Asheville in 1997, soon after the town's craft brewvival began (yes, it's a double first name). She started writing about beer and the beer business in 2006 while freelancing for both Asheville newspapers. Her regular "Brews News" column for Asheville's *Mountain Xpress* newsweekly debuted in 2009. Since then, she's written articles for craftbeer.com, the national Brewers Association's online magazine. Her online alter ego, Brewgasm, blogs, tweets and Facebooks obsessively about all things beer.

About the Author

With support from the Asheville Brewers Alliance, Anne Fitten developed and regularly teaches Beer 101 classes for both restaurant industry workers and the beer-loving public. She also regularly speaks at conferences and special events and on panels about the world's favorite alcoholic beverage. She's a member of the North American Guild of Beer Writers, the Pink Boots Society and the North Carolina Writers' Network. She serves on the organizing committees for both Asheville Beer Week and North Carolina Beer Month and on the North Carolina Brewers Cup Board of Advisors.

She lives within crawling distance of several of Asheville's breweries and pubs with two kids and too many pets. Her kids often complain that there's more beer than food in the fridge, but she knows that'll change in a few years.